D0079140

REF

N
5305
.H88 13 Styles in art
1978

Cop. 1

Hutter, Heribert.

8.95

DATE			

ART SECTION FORM 125 M
FINE ARTS DIVISION

Cop. 1

The Chicago Public Library

Received 11-21-79

© THE BAKER & TAYLOR CO.

STYLES IN ART

AN HISTORICAL SURVEY

HERIBERT HUTTER
In collaboration with Irmgard Hutter

UNIVERSE BOOKS
NEW YORK

Published in the United States of America in 1978
by Universe Books, 381 Park Avenue South, New York, N. Y. 10016
© Chr. Belser Verlag, Stuttgart
English translation © 1978 by George Weidenfeld & Nicolson, Ltd., London
All rights reserved. No part of this publication may be reproduced, stored in a retrieval
system, or transmitted, in any form or by any means, electronic, mechanical, photo-
copying, recording, or otherwise, without the prior permission of the publishers.
Library of Congress Catalog Number: 73-88460
ISBN 0-87663-205-3
Printed in Germany

CONTENTS

PHOTO CREDITS Ägyptologisches Seminar der Universität, Munich 166 – Akademie der Bildenden Künste, Vienna 270 – Alinari, Florence 26, 30–32, 40, 43, 71, 77, 81, 86, 90, 93–95, 97, 122, 127, 140, 149, 150, 152, 177, 179, 180, 202, 209, 212, 216 – Anderson, Rome 41, 47, 87, 104, 109, 125, 181, 182 – Archäologisches Institut der Universität, Fribourg 7 – Archives Photographiques, Paris 50, 133–135, 156, 157 – L. Aufsberg, Sonthofen 173 – Bayerisches Nationalmuseum, Munich 217 – Bayerische Staatsbibliothek, Munich 226 – Bibliothèque Nationale, Paris 253, 256 – Bildarchiv Foto, Marburg 18, 39, 44, 54, 73, 75, 80, 83, 84, 91, 92, 102, 106, 107, 137, 153, 176, 178, 210, 213 – J. Blauel, Munich 257, 264 – O. Böhm, Venice 155 – British Museum, London 195 – Brogi, Florence 27, 211 – C. J. Bucher Verlag, Lucerne 37 – Bundesdenkmalamt, Vienna 79, 175 – H. Busch, Frankfurt 131 – Georg D. W. Callwey Verlag, Munich 21 – Chicago Architectural Photographic Company, Chicago 111 – Corvina, Budapest 239 – Courtauld Institute of Art, London 207 – Denkmalamt, Prague 105 – Deutsches Archäologisches Institut, Athens 197 – Deutsches Archäologisches Institut, Rome 20, 119, 120 – Documenta Archiv, Kassel 223 – R. B. Fleming, London 159 – Foto Brunel, Lugano 265, 271 – Fototeca Unione, Rome 69, 70, 72, 201 – E. Frodl-Kraft, Vienna 46 – Gabinetto Fotografico Nazionale, Rome 85 – Galerie Louise Leiris, Paris 190 – Galerie Dina Vierny, Paris 187 – Gerlach, Vienna 114 – Germanisches Nationalmuseum, Nuremberg 227 – Giraudon, Paris 215, 220, 236, 259 – Solomon R. Guggenheim Museum, New York 163 – R. Hallensleben, Wuppertal-Elberfeld 56 – Archiv Walter Hege, Karlsruhe 68, 118 – L. Hervé, Paris 162 – Hessisches Landesmuseum, Darmstadt 188 – F. Hewicker, Kaltenkirchen 191 – H. Hinz, Basel 260, 275, 280 – Hirmer Fotoarchiv, Munich 3, 4, 17, 63, 65–67, 116, 128, 132, 165, 167, 194, 196, 203, 204, 228 – Hochschule für Wirtschafts- und Sozialwissenschaften St. Gallen 224 – Institut für Architektur an der ETH, Zurich 53, 57 – A. F. Kersting, London 9, 35, 38, 48, 51, 55, 82, 101, 103, 108, 136, 139 – G. E. Kidder Smith, New York 123 – R. Kleinhempel, Hamburg 247 – W. Kumpf, Darmstadt 279 – Kunsthistorisches Institut, Vienna 151 – Kunsthistorisches Museum, Vienna 214, 266, 269 – Kunstmuseum, Basel 222 – Landesbildstelle, Berlin 110 – Landesbildstelle Rheinland, Düsseldorf 124 – Landeskonservator Niedersachsen, Hanover 25 – Landesmuseum, Trier 121 – Lauros-Giraudon, Paris 219 – MAS, Barcelona 22, 58 – L. von Matt, Buochs 10, 174 – Musée des Beaux-Arts, Lille 272 – Musées Nationaux, Paris 245 – Museum of Modern Art, New York 115 – Nationalgalerie, Berlin 274 – National Gallery of Art, Washington, D. C. 268 – North Carolina Museum of Art, Raleigh 238 – Ny Carlsberg Glyptotek, Copenhagen 186 – Österreichische Nationalbibliothek, Vienna 49 – W. von Poswik, Munich 138 – Preiss & Company, Ismaning 234, 263 – A. Renger-Patsch, Wamel-Dorf 52 – Ritter, Vienna 254 – J. Roubier, Paris 33, 36, 42, 126, 208 – Scala, Florence 230, 232, 233, 250, 255, 258, 261, 262 – W. Schloske, Stuttgart 192 – H. Schmidt-Glassner, Stuttgart 76, 158, 184 – A. Schroll Verlag, Vienna 29, 89 – T. Scott, Edinburgh 235 – Skira, Geneva 231, 277 – Service de Documentation Photographique, Paris 240 – W. Spemann Verlag, Stuttgart 5 – Staatliche Antikensammlungen und Glyptothek, Munich 198 – Staatliche Museen, Berlin 8, 64, 164, 237 – Staatsgalerie, Stuttgart 218 – Stadtbibliothek, Nuremberg, Foto Meier 229 – Stadtbibliothek Trier, Foto Thörnig 251 – Stiftung Seebüll Ada und Emil Nolde, Seebüll 246 – J. Steiner, Munich 96, 154 – C. Strüwe, Bielefeld 24 – Thorvaldsens Museum, Copenhagen 183 – P. Toesca, Storia dell'arte italiana, Turin 19 – Ullstein Bilderdienst, Berlin 13 – USIS, Bad Godesberg 60, 61 – Verwaltung der Staatlichen Schlösser und Gärten, Berlin 241, 273 – Victoria and Albert Museum, London 205 – Wallraf-Richartz-Museum, Cologne 242 – H. Wehmeyer, Hildesheim 206, 252 – W. Wellek, Vienna 221 – R. Wittkower, Art and Architecture in Italy, London 99 – Reproduction rights for 274, 277, 278, 280, 281: ADAGP and SPADEM, Paris, Cosmopress, Geneva.

INTRODUCTION

All conceptions of style are categorizations empirically arrived at through comparisons that determine the characteristic features of an epoch, a landscape, or an artist's work. A comparative history of style must therefore deal with stages of development accepted as typical; the relevance of a comparison is directly proportional to the appropriateness of the common denominator selected. The more germane this is, the more enlightening the process will be. The choice of subjects from the history of art is a didactic and unavoidably restrictive process, since only a few examples can be taken from the wealth of works created and only a few of their relationships can be traced. This book is therefore no substitute for a history of style, let alone a history of art, even though it tries to outline, in compressed form, the development of architecture, sculpture, and painting in the Western world. Each of these subjects is treated separately, and primary creative problems of space, form, and surface are investigated. Their interrelationships, as expressed in architectural forms, wall articulation, and interior space, in the forms and surfaces of reliefs, or in the representation of form and space in the plane of paintings, are taken into consideration. In the juxtaposition of examples, similar artistic problems are confronted with the solutions found to them in different epochs, or within the same epoch, along with variations caused by different cultural climates. The captions point to relevant features, while the text broadly traces the correlations in order to reconcile the inevitable isolation of the various subjects discussed.

This book does not aim at a comprehensive examination of formal problems, and the historical principle adhered to in the attempt to uncover differences between comparable works of art is by no means the only valid one. The aim is rather to encourage readers to look beyond the examples given, to help them recognize within the changing patterns of style and form the common origins and the basically invariable problems of form, and to lead them to a deeper understanding of individual solutions. Admittedly, a work of art contains many complex historical features which cannot be revealed by formal analysis only; its visual impact, however, continues to exercise a greater influence on the beholder than any theories about its historical or cultural background.

ARCHITECTURE

For thousands of years building has been a practical necessity in satisfying the basic human need for shelter; and yet to this day, "practical" building has only rarely been synonymous with "artistic" building. Even in its earliest form, monumental architecture served religious purposes and satisfied the demands of ruler or ancestor cults, while the people had to be content with the most modest of dwellings. In the course of time, the shape, purpose, and ideological implications of buildings have greatly changed, but the basic relationship between society and architecture has remained the same. Artistically designed buildings are always representative; they embody religious ideas, political structures, the demands for power and prestige of the privileged, and they offer superficial satisfaction to the underprivileged. All architecture is a mirror of its time, but it reflects the dreams and ideals of those who produce it rather than their material condition. Populations are nearly always made to carry the burden imposed by the building of prestigious architecture, either by supplying slave labor or by paying taxes. Yet such buildings rarely serve the people: they are erected to the glory of God or emperor, or to serve the representatives of religious or temporal hierarchies; they satisfy the demands of state representation, become cultural status symbols, or serve as places of work or gatherings of an egalitarian mass society. Architecture cannot be divorced from this sociological and ideological background to which it owes not only its existence but also many of its most characteristic features. The ideals of architecture stand for a greater timeless reality and therefore transcend the necessities and norms of everyday life. Monumental architecture aims at overwhelming the beholder and at creating distance between him and the building. Moreover, each monument is appropriate only to the person, object, or idea whose power it was created to enhance. Hence the sometimes quite fantastic discrepancy between pyramids, temples, churches, palaces, theaters, bank buildings, and the dwellings of the people.

However, buildings make their strongest impression because of the artistic conception that gives them their formal individuality and sets them apart from their surroundings.

A work of art is always conceived as a formal unit; it is a unique and individual creation. But unlike other art forms, architecture has non-artistic counterparts which, nevertheless, are of the same material and also occupy and enclose space. The very distance between an artistically self-contained architectural unit and its shapeless or anonymous surroundings enhances its uniqueness and significance. The relationship between a building and its surroundings is often an important consideration in the artistic conception of architecture: a terraced Roman temple precinct, built on a hill, dominates, by its axes and rhythm, the surrounding landscape; the frontage and layout of a stately house determines the organization of large areas, built or unbuilt; a cathedral or a skyscraper breaks the neighborly unity of small dwellings surrounding it; churches, palaces, and theaters dominate squares and streets. Today the original, planned relationship between buildings and environment is sometimes no longer visible; road systems planned toward a center have become blocked; squares have been built over; churches that once ruled the landscape have been dwarfed by skyscrapers. Often the admirer of an ancient building will have to reconstruct the original layout in his mind if he is to fully understand its artistic significance, ideological meaning, and social function.

The tremendous contrast between the three colossal crystalline volumes of the pyramids of Giza *(Ill. 3)* and the wide space of the plain in which they stand makes them readily understandable as expressions of the Egyptian pharaohs' claim to immortality — even after forty-five hundred years. Ordered by pure mathematical law they are the most perfect and absolute abstractions ever created. Never have the hardness, the smoothness, and the weight of stone been more effectively translated into shape and form: pure volume, pure plane, pure line — these fundamental principles of architecture have never again found such unadulterated expression. The mighty temple tower of Mesopotamia, the ziggurat, is also an example of colossal volume, but it rises in several tiers of rectangular blocks, and its walls are rhythmically divided by vertical strips of pilasters and fluting *(5)*. Later on, the Nile culture produced the antithesis of the massive abstract buildings of its earlier period: temples with wide, open, columned halls, great processional roads leading to their entrances via ramps, terraces, and forecourts lined with pillars. The most perfect of such layouts — a wide temple landscape with beautifully divided and proportioned space — forms an unrivaled unity with the walls of rock that rise steeply behind it *(4)*.

Egyptian columns are modeled on plants: palms, lotus flowers, or bunches of papyrus; though stylized, they are recognizable as organic forms symbolizing upward growth. Greek columns are quite different: they are supporting members suited to the weight they carry. The meeting point of the column and the beam it supports is accentuated by the capital and the impost. This architectonic conception of the column corresponds to the ancient Greeks' rational approach to architecture, which aimed at building in accordance with strict theoretical principles. Their architectural ideals reached perfection in the Classical Style of the 5th century B.C. *(1, 7)*.

The Greek temple is a compact unit: the sanctuary of the cella, which encloses the idol, is surrounded by colonnades on a rectangular plan, the two narrow ends of which are crowned by pediments. All parts of the temple and each section of each individual part are related to each other in a precisely calculated way. But there are deviations within the strict mathematical scheme: the distance between columns lessens at the corners; all horizontal lines curve inward, all vertical lines are slightly inclined. These and other minutely calculated corrections of perspective prevent the temple from becoming a rigid, abstract construction and let it appear an integrated organism, full of movement, whose columns combine architectonic firmness with the organic plasticity of a statue. As a consequence of its new dynastic demands, Hellenism enriched not only the practical but also the artistic aspects of architecture. The large Altar of Zeus on one of the terraces at Pergamon, where sacrifices were offered to the gods, lay within a columned courtyard, approached by a great freestanding staircase flanked by Ionic colonnades *(8, 199)*. The Altar of Zeus personified a new extroverted, pathetic approach to architecture, erected as it was on a high podium decorated with reliefs, oriented toward a "display" side and a main axis, and given life by the tensions between massive socles and delicately ranged columns, between architectonic elements and the dynamic, sculptured reliefs.

Roman architecture, although it owed much to the Greco-Hellenistic and Italo-Etruscan traditions, developed a remarkable degree of independence. The spectrum of building ex-

panded rapidly and to the temples for gods and dwellings for divine emperors were added villas, baths *(thermae)*, theaters, law courts *(basilicas)*, and great engineering projects like aqueducts and bridges. The technical innovations of the Romans—construction with bricks and mortar, for instance, which made possible the building of walls of any chosen thickness and the erection of domes and vaults with a much greater span—served structural and practical as well as aesthetic innovations, which were always oriented toward powerful representation and visual opulence. The main features of Roman building are the orientation of the building, including a new evaluation of main aspects, of façades; a new interpretation of the enclosed space treated as a unit, possessing its own artistic value; a new evaluation of the wall and its aesthetic function, and the uniting of columns and arcades with the walls. The huge three-tiered oval of the Colosseum, for instance, is divided into great arcades, regularly spaced, incorporating pilasters in the Tuscan, Ionic, and Corinthian orders. Amphitheaters with spectator galleries supported by a belt of vaulted corridors *(9)* are also typically Roman.

The Roman temple is a compact volume with a deep forecourt and a relief of half-columns on the walls of the cella instead of the surrounding ring of columns; it stands on a high podium which raises it above its surroundings. Access is by an open staircase leading to the main façade. Vista effects are sought not only in the great terraced temple areas but also in huge inner spaces of axio-symmetric design divided into individual units of varying size, above all in the thermae *(2, 6)*. The walls of the open-air pools are treated as façades and their colorfully decorated niches are flanked by colossal columns with statues.

The largest domed building of Classical antiquity, the Pantheon in Rome *(10)*, shows a marked contrast between exterior and interior. A massive, outwardly unadorned domed cylinder conceals the wide, well proportioned interior with its subtle wall construction. The temple front of the vestibule, which unites the pure rotunda with the vertical and horizontal architecture of the columns, constitutes the only exterior adornment and gives the building its orientation.

In Early Christian churches the prime artistic consideration was the interior, an emphasis that served both the practical and the spiritual needs of the Christian cult. The two main types of Western church architecture were developed as early as the 4th century: the basilica, which served the community and had a large interior with aisles oriented toward an altar, and the central building, which served special cult purposes. In both, space and wall structure had an air of bodiless spirituality and hierarchically graded divisions of space *(11, 19, 20)*. In contrast to the temples of antiquity, the exterior of the Early Christian churches had no artistic value of its own; it was no more than a shell, adorned only by paratactical rows of large windows and varied only by the axial or concentric gradations of clear-cut architectural units and the progression of interior space leading from vestibule and atrium to nave and apse.

In Byzantine architecture of the 6th century half-domed units were built on the main axis of a central, domed hall, achieving a perfect synthesis of the rotunda and basilica. The techniques of vault and arch construction used in antiquity were employed with great virtuosity, but without abandoning the principles of the basilica: the division of main nave and aisles and the transparency of the walls opened by windows and arcades *(13, 123)*. In Byzantine building too, the exterior is unadorned, and the structure dominates its surroundings simply because

8

of its massive proportions and the great size of its wide cupola *(17)*. From the 10th century on, the typical Byzantine church was built on a cross-in-square plan; the central square is vaulted by a dome rising on pendentives; the four cross arms are covered by barrel vaults, the small squares in the corners by low domes or groined vaults. This type of church has three apses and a vestibule (narthex). In later periods, the steep rising of clear-cut, staggered cubes and the compactness of the building enhance the monumental aspect of these usually small churches *(18)*.

Western architecture of the early Middle Ages is characterized by a wealth of types that modify both the central building and the basilica. Simple, strict forms were preferred — for example, the cross-type plan with a high tower rising over the central square *(23)*. Byzantine as well as Early Christian models were reinterpreted, but in a more squat and compact style, as may be seen, for instance, in the domed octagon of the palace chapel at Aachen, which assumes a medieval-modern aspect because of its massive porch. The Carolingian palace complex at Aachen functionally unites several buildings on rectangular axes. The chapel and the king's hall balance each other as the main focal points *(21)*. Early Romanesque church architecture also stresses the principle of polarization: the compact, graded units of the eastern section — central tower, transept, apse — are mirrored almost exactly in the western section. This creates a strict rhythm of clearly articulated building elements, which mitigates the tendency toward unrelieved length, yet avoids the creation of a centralized unit *(14, 25)*.

During the late Romanesque and Gothic periods the longitudinal, basilica type of building predominated; centralized, or rotunda, buildings were rarely built, and then almost exclusively in countries adhering to the traditions of Classical antiquity and early Christianity — as, for instance, Italy. The early Florentine proto-Renaissance above all succeeded in reviving the forms of Classical antiquity. Once more, arcades, pilaster and column orders, ledges and window frames were incorporated into walls and horizontals and verticals were held in static balance; but the kind of wall structure in which arches appear in relief on the wall while also bearing an attic or superior story corresponds to Romanesque structural techniques rather than to those of antiquity *(26)*. Romanesque richness of forms — blind arcades, miniature galleries, deep porches, a wealth of sculpted decor (particularly in southern France; *78)*, and multicolored marble facing (in Italy; *24*) — gave exteriors an artistic importance which, since Classical antiquity, they had only had in isolated instances as, for example, in Spain *(22)*. This modeling of the exterior was an integral part of the design of the building as a whole. There is a

1 PARTHENON, ACROPOLIS, ATHENS. Ground plan. 448–438/32 B.C. 34 x 42.5 meters. Hall surrounded by 17 Doric columns on sides and 8 at each end. 6 columns at each end of wide sanctuary, or cella; narrow ambulatories. In west cella, 4 Ionic columns; in east cella, 2-storied row of columns around idol. (See *7, 117*.)

2 BATHS OF CARACALLA, ROME. Ground plan. Dedicated 216. Colossal, axio-symmetric complex. On short axis: *natatio* (open swimming pool); *frigidarium* (cold water swimming pool); *tepidarium* (warm water bath); *caldarium* (hot water bath). On long axis, 2 *palaestrae* (gymnasiums). Each room differs in shape, height, size, and lighting. (See *6*.)

3 PYRAMIDS, GIZA. c. 2550–2500 B.C. (4th Dynasty). Chephren's pyramid (middle height 143 meters, length 215 meters) shows remnants of

original limestone and granite facing and contains king's tomb. In front of pyramids of Cheops (right) and Mycerinus (left) are smaller pyramids and rectangular tombs *(mastaba)*. In front of Chephren's pyramid, mortuary temple with ramp to valley temple (see *116*); next to it, the Sphinx. Isolation and monumentality of king's tomb. Crystalline purity of form and massiveness of stone symbolize kings' claim to power and immortality.

4 TOMB OF QUEEN HATSHEPSUT, DEIR EL-BAHRI, NEAR THEBES. c. 1480 B.C. (18th Dynasty). At left, tomb of King Mentuhotep (11th Dynasty), with pillared hall around pyramid on terrace. Complex consists of extensive terraces: avenue of sphinxes, forecourt, 2 terraces with pillared halls connected by ramps leading to columned hall with open courtyard, sanctuaries, and tomb chambers (now destroyed) in the rock. Temple contrasts splendidly with steep mountain landscape.

5 TWIN TEMPLES OF ANU AND ADAD, ASHUR. c. 1100 B.C. Reconstruction by W. Andrae. Unique doubling of traditional temple form, each having high and low temple side by side. Before them is courtyard with ramparts and entrance gate with towers. In the typically Mesopotamian ziggurat, a tower-temple, each story linked to next by outside staircase. Walls of compact building cubes ornamented with pilaster strips and fluting.

6 BATHS OF CARACALLA, ROME. View from *natatio* toward façade of *frigidarium*. Reconstruction. Space optically widened through niches and vistas. Wall treated as ornamental façade with huge columns serving no architectural purpose; abundant decoration composed of polychrome pillars, marble facing, and statues. (See *2*.)

7 PARTHENON. Acropolis, Athens. Northwest view. Doric temple of high Classical period, an outstanding interpretation of traditional style with profusion of columns, enlarged cella, etc. All measurements conform to scale of 4 : 9. Perspective corrected by strong contraction of corner intervals. Tendency of horizontals to curve outward and verticals to bend inward. (See *1, 117*.)

8 ALTAR OF ZEUS, PERGAMON. 180–160 B.C. Staatliche Museen, Berlin. Restored. Monumental altar on high pedestal framed by colonnade. Frieze ornaments base of high, open staircase. (See *199*.)

9 COLOSSEUM, ROME. Flavian amphitheater, dedicated 80. 188 x 155 meters. Largest Roman amphitheater, with 80 arcades. Mortar walls, with travertine facing; differentiated by use of embedded columns and architraves ranged one upon another in Tuscan, Ionic, and Corinthian orders. Topmost tier is late Flavian.

10 PANTHEON, ROME. 118/19–125/28. Largest rotunda of antiquity; diameter and height, 43.4 meters. High attic hides base of cupola from view. Narrow rectangular portico beyond columned, gabled vestibule with three naves.

1

2

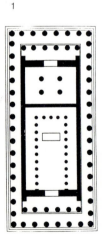

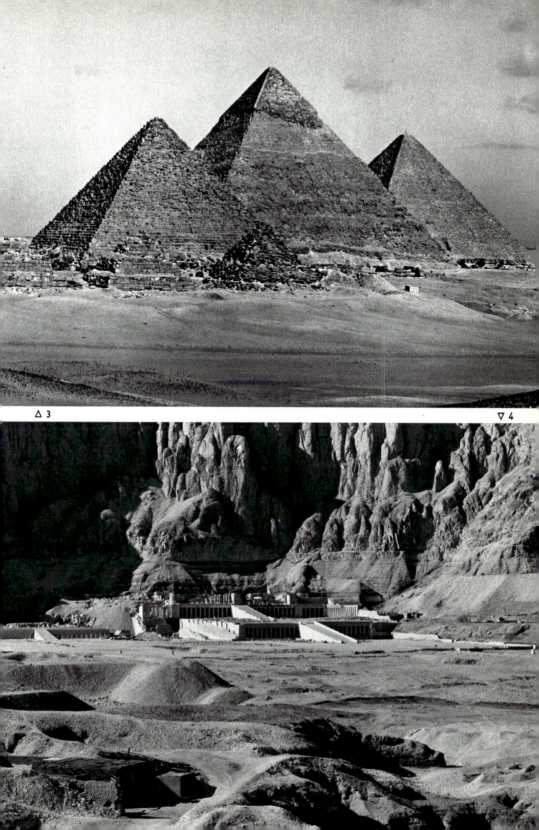

△ 3

▽ 4

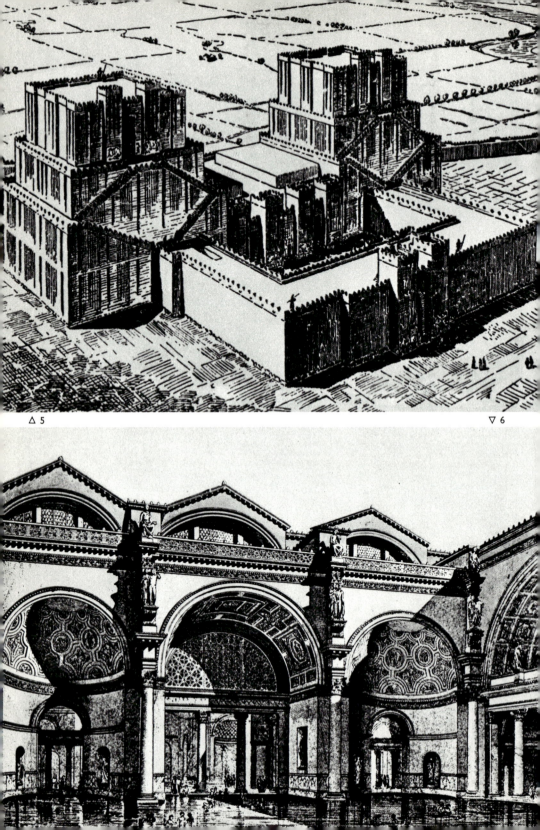

△ 5 ▽ 6

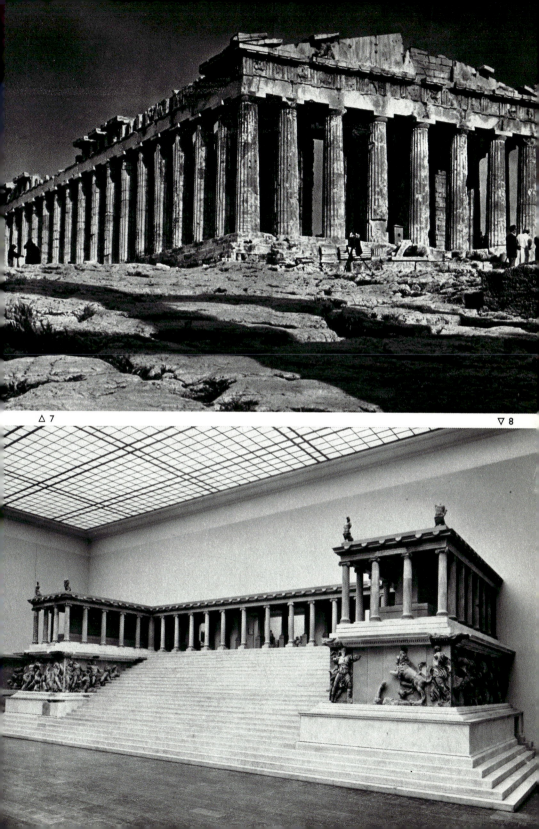

△ 7

▽ 8

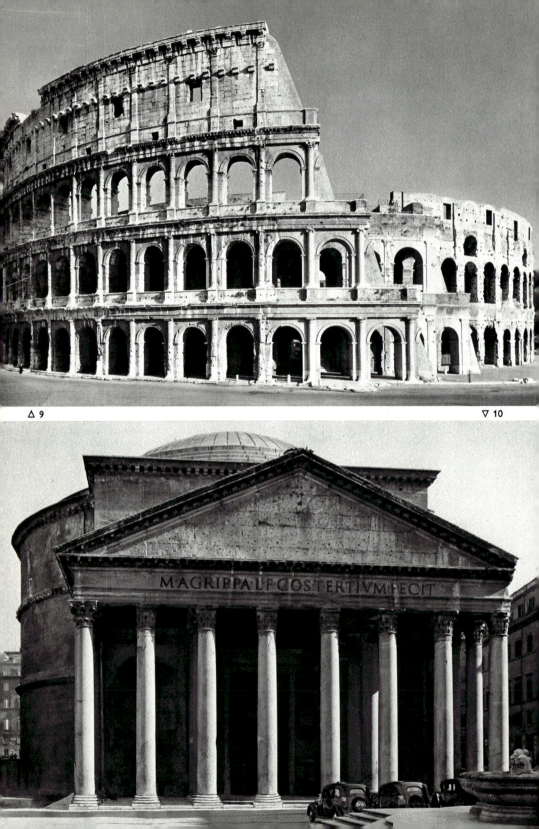

11 S. COSTANZA, ROME. Ground plan. Mid–4th century. Rotunda has inner ring of columns and ambulatory. Interior wall has niches, alternately semicircular and rectangular, enlarged at 4 axes into apses. Now destroyed are the outer, low, columned ambulatory, narthex, and oblong entrance hall. (See 20.)

12 PALACE CHAPEL, AACHEN. Reconstructed ground plan. c. 790–805. Octagon with umbrella cupola supported by pillars and 2-storied ambulatory with 16 bays. Emphasis falls on long axis through alignment of shortened apse (later replaced by Gothic choir), vestibule with high tower, 2 small towers with spiral staircases, narthex, and atrium.

13 HAGIA SOPHIA, ISTANBUL. Ground plan. 532–37. Synthesis of longitudinal and circular plans. Central area, a domed square; longitudinal axis has semi-domed sections at each end, with 3 bays (exedrae) respectively. Surrounded by many side chambers. (See 17, 123.)

14 ST. MICHAEL, HILDESHEIM. Ground plan. 1001–33. Double choir construction; bound system: all dimensions based on square formed by intersection of nave and transepts. (See 25, 131.)

15 S. PIETRO IN MONTORIO, ROME. Tempietto. .1502/03. Donato Bramante. Ground plan, round porticoed court originally intended (transmitted by Sebastiano Serlio). Memorial erected on the site of St. Peter's martyrdom. Modeled on ancient rotunda-temple with 16 Doric columns on elevated socle. Cella has inner and outer axio-symmetric niches. (See 29.)

16 ST. PETER'S, ROME. Draft ground plan by Michelangelo. 1546. Centralized construction with columned forecourt. New streamlining of architectural and spatial components. Dome placed within central square on 4 mighty pillars. Great plasticity in articulation of walls. (See 30, 151.)

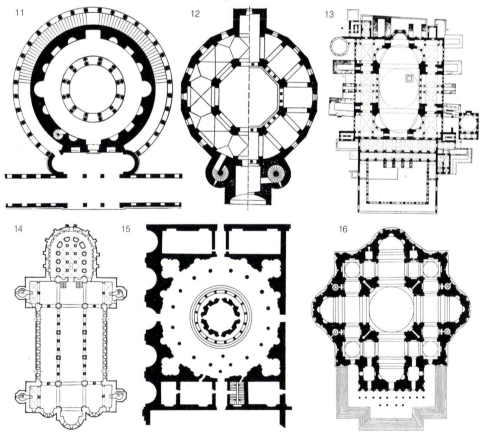

11 12 13

14 15 16

17 HAGIA SOPHIA, ISTANBUL. Southwest view. Almost square building complex dominated by huge cupola. Heavy based exterior gives no indication of interior's quality. Buttresses are Turkish additions. (See *13, 123.*)

18 CHURCH OF THE VIRGIN, GRAČANICA (Serbia). Southwest view. c. 1320. Cross-in-square church with cupola, steep, precisely articulated walls, and staggered cubes.

19 ST. PETER'S, ROME. Section. Founded by Constantine, 324. Main altar built over tomb of St. Peter. Early Christian basilica with transept and 5 aisles, graduated in size; dynamic rhythm of columns leading to altar and apse.

20 S. COSTANZA, ROME. South view. Concentric, staggered building; high drum and tent-shaped roof cover cupola. Finely executed, unornamented brickwork. (See *11.*)

21 PALACE OF CHARLEMAGNE, AACHEN. West view. Late 9th century. Reconstruction by L. Hugot. The chapel (right) and king's hall (left), with its 3 apses, are connected by a long corridor with law court in middle. Administrative buildings and baths are at the far right.

22 S. MARIA, NARANCO, NEAR OVIEDO (Asturias). West view. Before 848. Originally a palace hall; above low ground floor is high hall with loggias on shorter sides. Arcades and ashlar masonry in Roman tradition. (See *128.*)

23 ORATORIUM, GERMIGNY-DES-PRÉS, NEAR ORLÉANS. South view. c. 806. Square, centralized building with dome resting on pillars, hidden from outside by tower. Effect by graduation of simple, vertical blocks.

24 CATHEDRAL, CAMPANILE, BAPTISTRY, AND CAMPO SANTO, PISA. Southwest view. Cathedral 1063 to c. 1120. Nave extended in 12th century. Baptistry begun 1153, campanile 1173. Basilica has 5 aisles, transept with 3 aisles, galleries, and central dome. Faced with white and dark marble. Outside walls have blind arcades and miniature galleries on façade and apse: filigree grids on building with clearly graduated sections. Related reliefs on all façades unify appearance of whole complex.

ST. MICHAEL, HILDESHEIM. Reconstruction. Northwest view. Strict polarization: identical crossing, transept, and round turrets at east and west ends; west apse enlarged through crypt.

Groups of rhythmically ordered, clear-cut, massive building units. (See *14, 131.*)

26 BAPTISTRY OF S. GIOVANNI, FLORENCE. Southwest view. c. 1060–1150; choir 1202. Most important achievement of Tuscan proto-Renaissance. Octagonal building. Dome hidden from outside by high attic and tent-shaped roof. Walls articulated on 2 levels: orders of pilasters and blind arcades form flat relief, attached to walls, which are encrusted with colored marbles. (See *125.*)

27 FLORENCE CATHEDRAL. South view. Begun 1296; enlargement since 1355. Inside, 3 aisles have only 4 wide bays. Trefoil choir has 5 chapels in each of its 3 bays. Exterior, richly encrusted with marbles, mirrors interior. Dominant dome by Brunelleschi, 1420–36, constructed with technical inventions (double shell of dome, flying scaffolds). Upward sweep of elevated dome emphasized by plastic ribs and slender lantern.

28 LEONARDO DA VINCI, STUDY FOR A CENTRAL BUILDING. c. 1490. Paris, Institut de France, MS 2037. Shows customary dominant central dome, towering over lower, axio-symmetric, secondary, domed units.

29 S. PIETRO IN MONTORIO, ROME. West view of Bramante's Tempietto. Renaissance ideal of circular building, demonstrating perfect balance of verticals and horizontals. (See *15.*)

30 ST. PETER'S, ROME. West view. Construction of Michelangelo's central building, the western part of the church, 1546/51–93; dome completed 1588–93 by Giacomo della Porta. Compact, powerfully articulated structure: broad massiveness emphasized by wide cornice and high attic in dynamic contrast to vertical arrangement of Corinthian pilasters, echoed by double-columns around drum, and ribs on elevated dome. (See *16, 151.*)

31 S. MARIA DELLE GRAZIE, MILAN. East view. 1492–97. Donato Bramante. Apses are separately added units and dome dominates this attempt to solve problems of building with central plan. Richly decorated exterior wall relief in Lombard tradition.

32 S. MARIA DELLE CARCERI, PRATO. Northwest view. 1485–91. Giuliano da Sangallo. Built in shape of Greek cross. Articulation of walls clear and flat, well suited to additive character of building units and interior spaces.

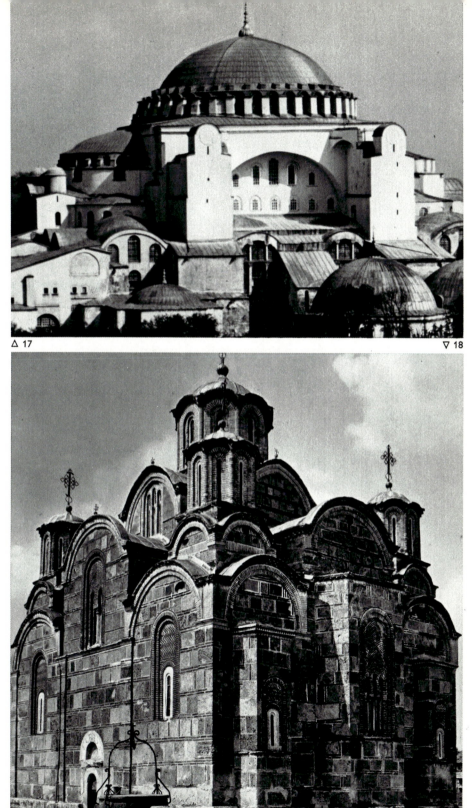

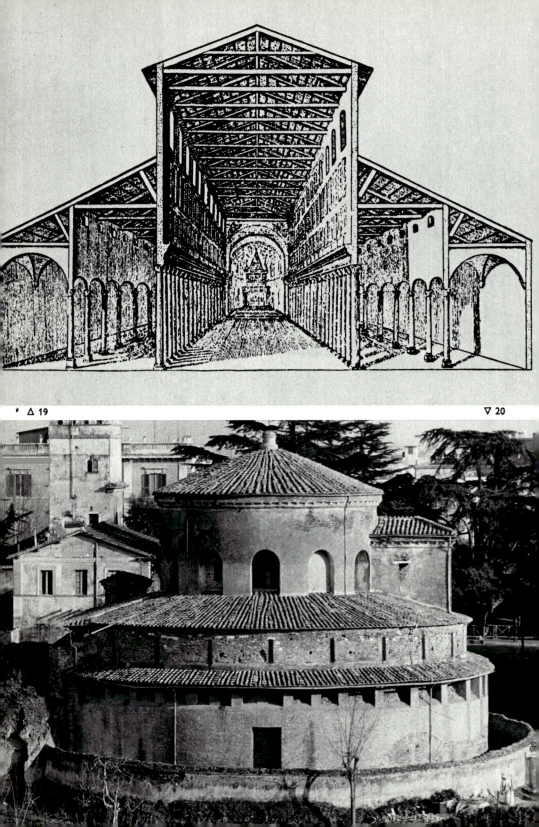

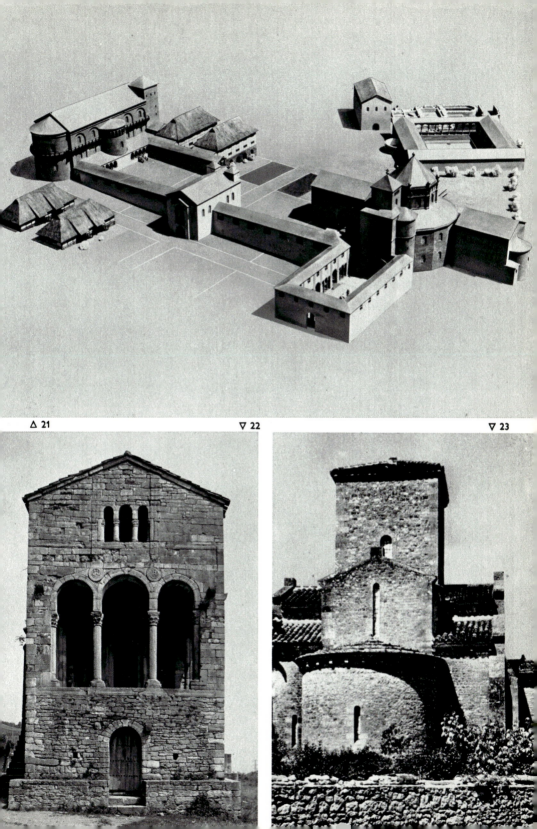

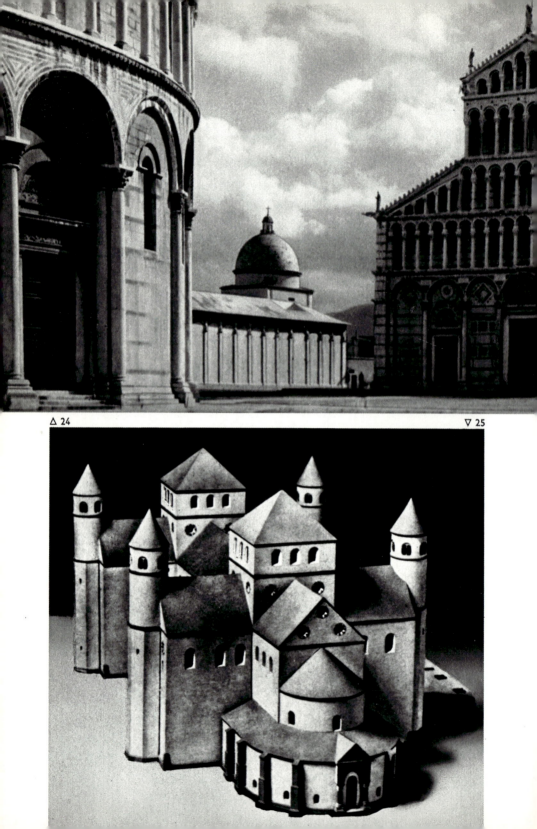

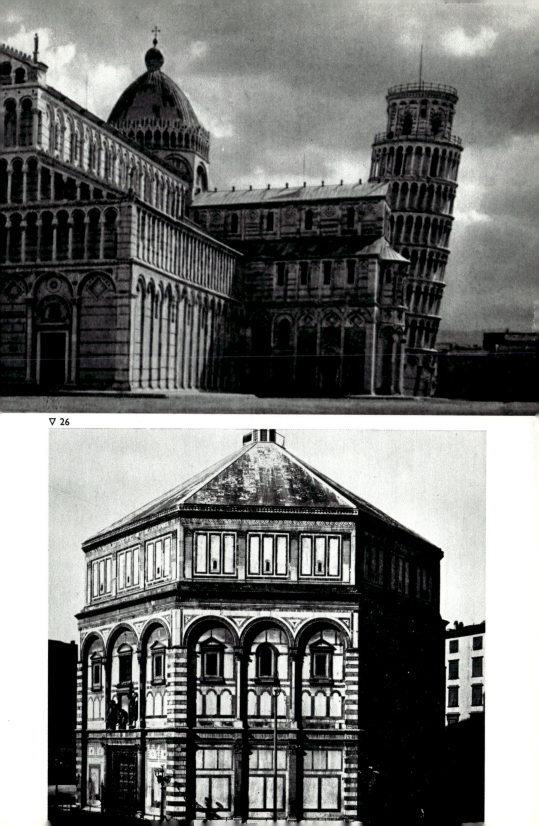

▽ 26

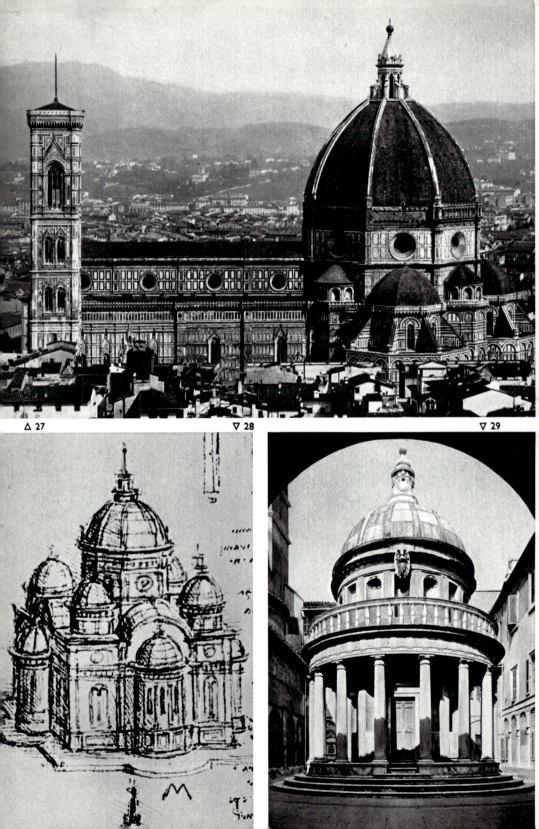

△ 27 ▽ 28 ▽ 29

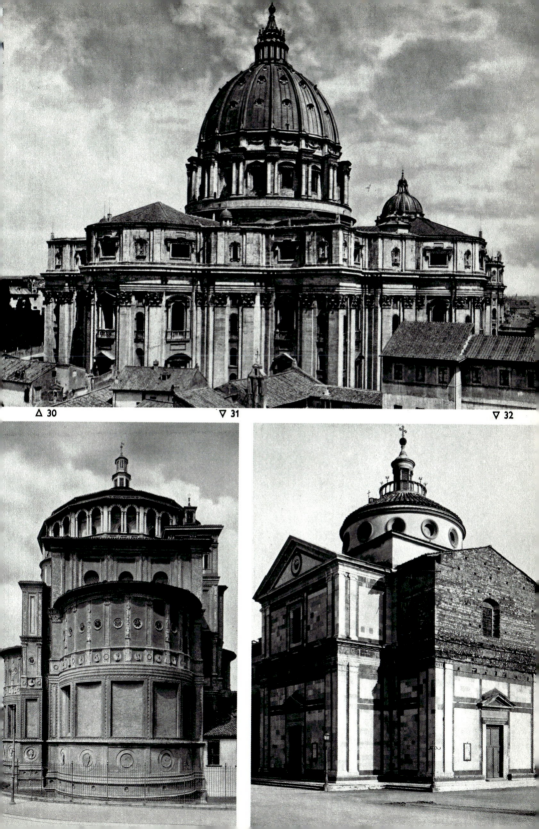

△ 30 ▽ 31 ▽ 32

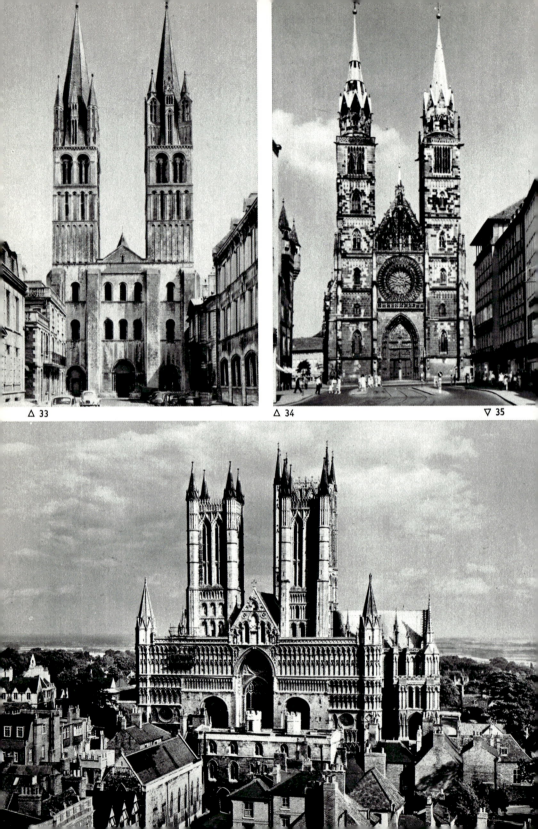

△ 33 △ 34 ▽ 35

rhythmic sequence, a precision in the exterior decoration which emphasizes the architectural structure of nave, choir, and transept, whether it is spread as delicate tracery across the body of the building *(24)* or molded into the wall, accentuating its strength. In some regions, however, façades become showpieces in their own right. Particularly in England, a broad façade, its horizontal orientation emphasized by blind arcading, often contrasts with tall, slender towers abruptly rising immediately behind it *(35)*.

The development of the two-tower façade in Normandy proved to be the decisive step toward organic coordination of horizontal and vertical. Buttresses visually fix the towers firmly to the horizontal block of the façade. Arched window openings become progressively larger with each story, thus optically lightening the towers so that they seem to rise straight out of the ground *(33)*. Graduated buttresses, introduced in the 13th century, brought even greater organic unity *(34)*. In French cathedrals of the High Gothic period the three parts of the façade are brought together by three great portals, which, at the same time, unite the façade and the aisles of the church *(36)*. The Gothic principle of structural articulation based on vertical structures filled in with walls is also applied to the façade in the massive buttresses of the towers, and the blind arcades, the galleries of sculpted figures, the rose window fitted between them, and the arcade openings of the towers. The vertical movement of the canopies and the small Gothic towers strives against the many horizontal lines of the stories. Shapes grow out of each other, static logic is banished, the unreal takes over, and the compact mass of the building dissolves into individual, sculpted forms and currents of movements. The same principle is applied in the flying buttresses and pinnacles that encircle the entire church, so that the façades of towers, nave, transept, choir, and chapels are unified without losing their individual identity.

In the Renaissance, architecture returned to the terra firma of objective architectonic principles. The model is Classical antiquity with its mathematically rational concept of the shape of enclosed space, its orders of columns, and laws of proportion. Its main theme is the centralized building of measured compactness and with a well-ordered hierarchy of rooms and wall space. Early examples of this style show individually articulated units — a domed central space and four barrel-vaulted arms — forming the cruciform ideal. Each wall is geometrically divided and molded by a flat pilaster relief *(31, 32)*.

33 ST-ETIENNE, CAEN. West façade. 1067–77. First systematic two-tower façade. Buttresses stretching up over horizontal block of façade give towers look of rising straight from the ground. Optically, towers are lightened toward top by larger, more strongly articulated window-apertures.

34 ST. LAWRENCE, NUREMBERG. West view. c. 1300. In principle, façade is similar to Caen's, but towers rise in a more organic and plastic way with help of graduated buttressing. Center section is an individual, transparent unit with funnel-shaped porch, rose window, and filigree gable.

35 LINCOLN CATHEDRAL. West façade. c. 1220–30; lower middle section c. mid-12th century. English Gothic display façade, articulated with decorative blind arches, bears little organic relationship to church and abruptly rising towers behind it. Contrast between horizontally flat ornamentation of wall, large linear porch arches, and sharply profiled towers has not been resolved.

36 AMIENS CATHEDRAL. West façade. 1220–36. Rose window and upper tower stories 14th and 15th centuries. High Gothic façade in 3 sections, relating to 3 aisles within. Massive portals span façade. Stories partially screened by canopies and multitude of small Gothic turrets to make sharply profiled yet delicate structure. Double gallery lessens effect of rose window in its flamboyant setting.

37 PALACE, CHAMBORD. Main façade. 1519–c. 1538. Designed by Domenico da Cortona and others. Square, centralized building, flanked by wings: strong corner towers topped by dormers and chimneys in earlier fortified castle tradition. Renaissance influence visible in symmetrical layout, great spiral staircase in central tower, and articulation of stories and walls.

38 BURGHLEY HOUSE (Northamptonshire). Main façade. 1556–c. 1585. Late Gothic and Renaissance elements complement each other: graduated, angular units and windows with perpendicular tracery are arranged with symmetry and emphasis on horizontals. Domed turrets; chimney flues disguised as Doric columns.

39 TOWN HALL, ANTWERP. Main façade. 1561–65. Cornelis Floris. Italian Renaissance elements integrated with Netherlandish Late Gothic-type wall with large windows: socle with rusticated ashlar column orders, horizontally oriented stories. Mannerist decoration limited to center projection.

40 VILLA ROTONDA, VICENZA. West view. c. 1566–80. Andrea Palladio. Perfectly symmetrical ground plan and exterior structure. With domed center and open staircase at each of 4 sides leading to temple-style gabled entrances, everything is in perfect harmony.

41 PALAZZO FARNESE, ROME. Main façade. Begun 1514/41 by Antonio da Sangallo the Younger. Portal axis and parts of courtyard, dating from 1546 onward, by Michelangelo. Most important High Renaissance palace in Rome. Strong molding of window frames adds plasticity to horizontal rows of windows and heavy cornices. (See 88.)

42 LOUVRE, PARIS. Clock tower, west wing. Begun 1546 by Pierre Lescot. Broadly based façade rhythmically broken up by projections and pavilionlike towers. Rich wall relief mostly flat except at pavilions. (See 92.)

43 S. AGNESE, ROME. West façade, 1652–72. Carlo Rainaldi and Francesco Borromini. Façade with its concave sweep stretches between vertical frame of 2 plane towers. Light, airy towers complement massive central cupola. Church façade forms rich display wall of ancient square.

44 ST-LOUIS-DES-INVALIDES, PARIS. West view. 1676–1706. Jules Hardouin-Mansart. Rationally organized, dynamic approach to architectural problems is characteristic of French High Baroque style. Subtle, mathematically calculated acceleration of forms from sides to middle and from square central mass to steep dome. Great plasticity gives lively effects of light and shade.

45 ST. PAUL'S CATHEDRAL, LONDON. West view. 1675–1710. Sir Christopher Wren. 2-tower façade masks building's cruciform, longitudinal body with classical central dome. Articulated structure and movement of towers contrast with solemn, static temple-front façade.

46 KARLSKIRCHE, VIENNA. North view. 1715–33. Johann Bernhard Fischer von Erlach. Linked heterogeneous units. Dominant is dome resting on steep drum, with severe temple façade below; connected and strongly contrasting pavilion wings broadening the façade, and 3 triumphal columns.

47 ESCORIAL, NEAR MADRID. Northwest view. 1563–86. Juán Bautista de Toledo and Juán de Herrera. Enormous building complex: monastery, church, and residence. Austerity rules the bland façade.

48 TOWN HALL, AMSTERDAM. 1648–65. Jacob van Campen. Most important architectural achievement of 17th-century Dutch Classicism; large, compact, rectangular block, accented by projections in center and at corners. 2 stories of identical articulation with colossal pilasters.

49 BENEDICTINE MONASTERY, GÖTTWEIG. 1719–c.1780. Plan for reconstruction of late medieval complex by Johann Lucas von Hildebrandt. West view (by Salomon Kleiner). Large, palacelike layout, with several courtyards, situated on mountain, and dominating landscape. Differentiation of various units gives life and character to massive building complex.

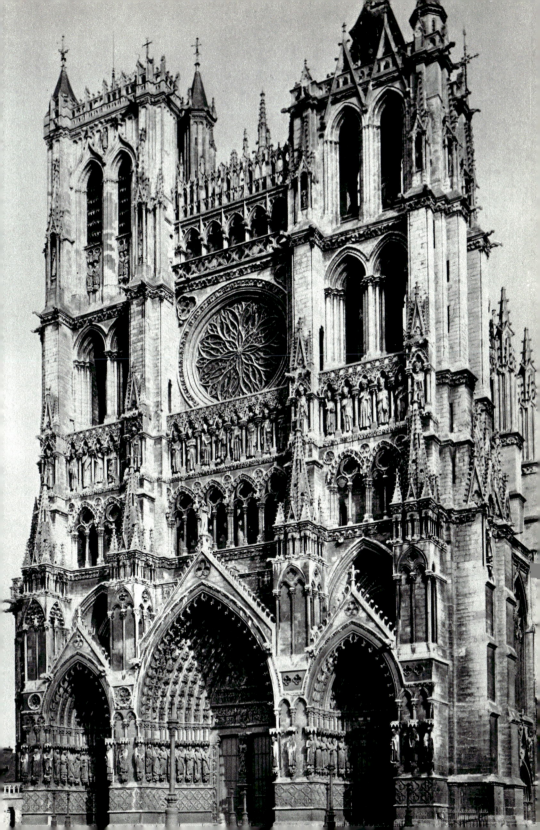

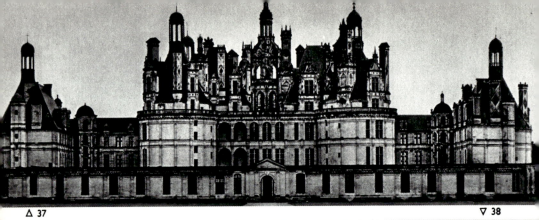

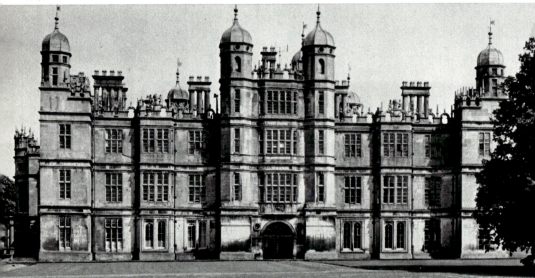

37 △

38 ▽

39 ▽

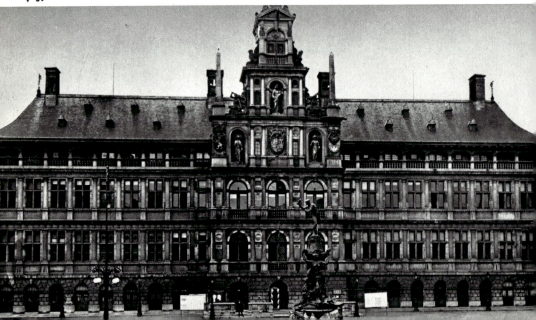

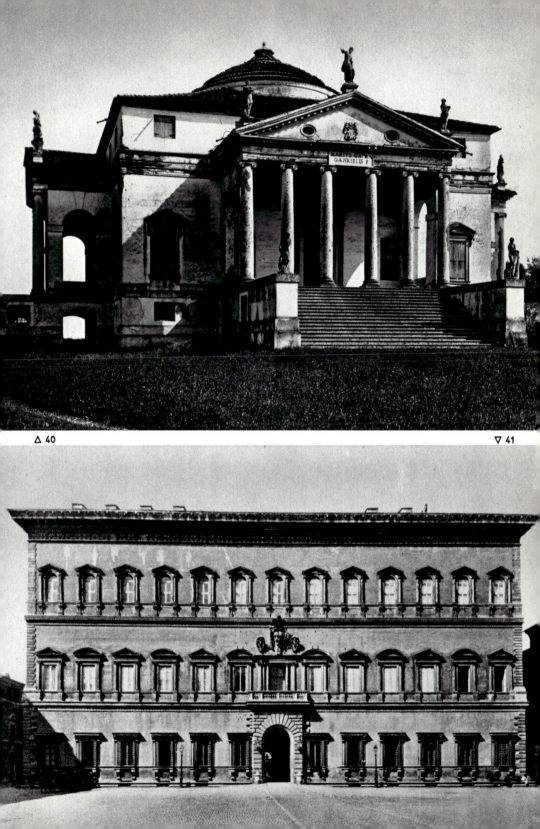

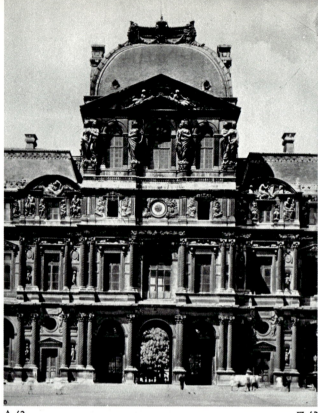

△ 42

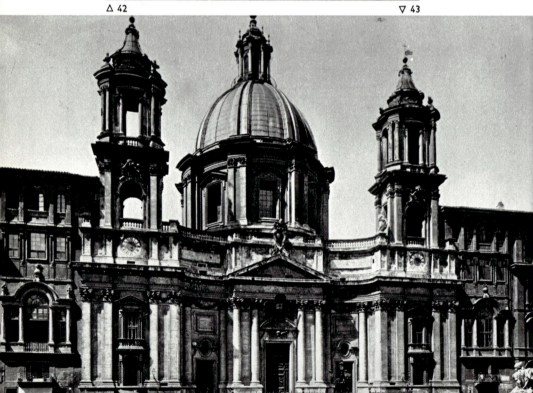

▽ 43

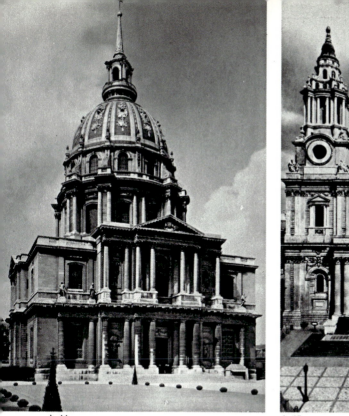

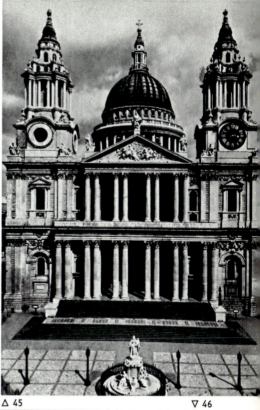

△ 44 △ 45 ▽ 46

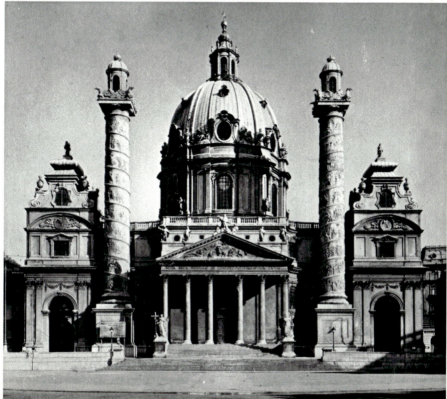

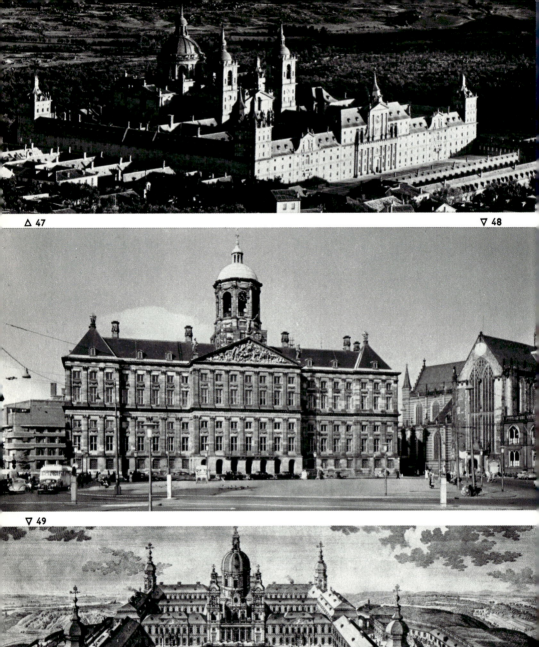

△ 47 ▽ 48

▽ 49

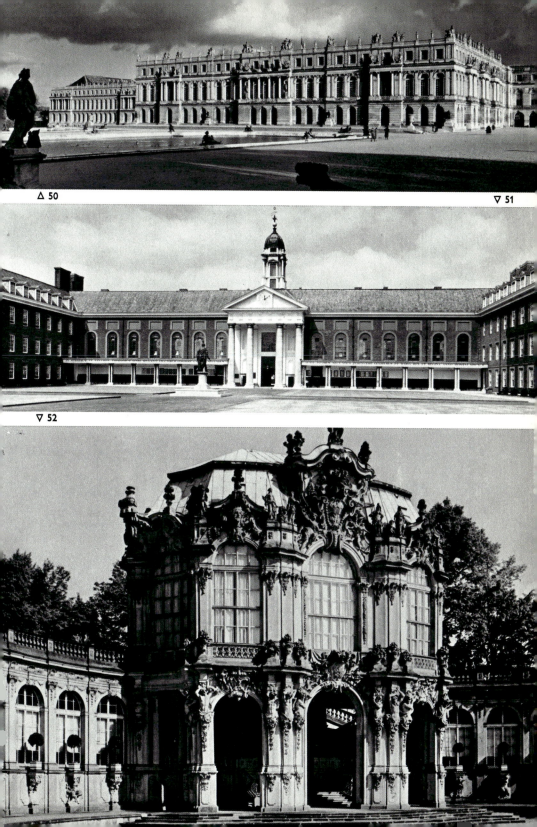

△ 50

▽ 51

▽ 52

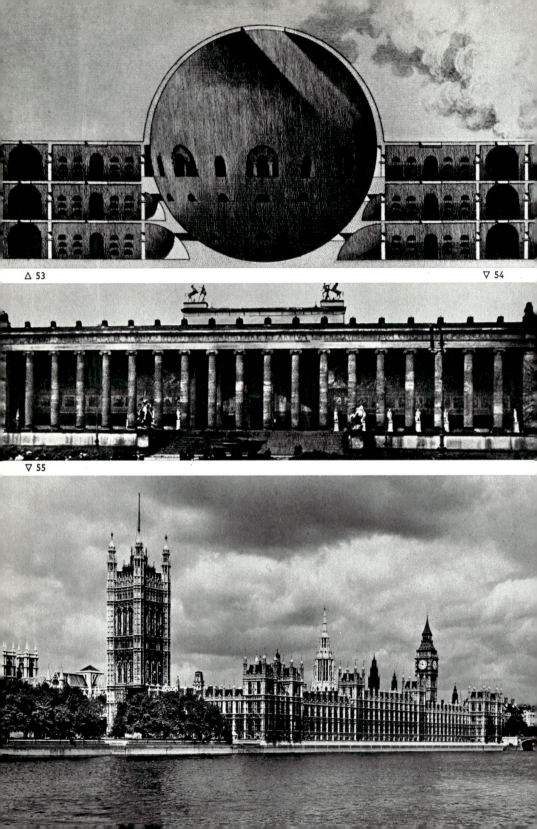

△ 53

▽ 54

▽ 55

In contrast to the complicated, subtle, much subdivided and graded building style of the outgoing Quattrocento (28), High Renaissance architecture strives for monumentality and seeks to simplify and tighten the structural elements. A pure rotunda, surrounded by a ring of columns and crowned by the pure semicircle of a dome, takes on the character of a harmoniously self-contained sculpted monument (15, 29). At the west end of St. Peter's in Rome (30), executed after a design by Michelangelo (16), the tendency toward monumentality and purity of form reaches its culmination and its limit. The arms of the crossing, powerfully accentuated by huge pilasters and massive window arches, are emphasized in their weight and importance by a wide ledge with attic. Their horizontal movement is coupled with the vertical lines provided by the pilasters, the double columns of the drum, and the ribs of the dome leading to the lantern. The dome, modeled with two shells on the first great cupola of the Early Renaissance, has a powerfully molded profile emphasized by strong ribs; but in contrast to the gentle rise of the cupola of the cathedral at Florence (27), the dome of St. Peter's expresses dynamic energy, integrating all parts of the structure.

Secular buildings — which now achieved the same importance as sacred buildings — also adhere to the ideal of the centralized style: a square basic block with a central domed space is fronted by four temple façades above an open staircase. The measured regularity of these buildings projects a sense of quiet orderliness across the surrounding countryside (40). For practical reasons, most palaces and mansions are massive rectangular complexes, incorporating one or several courtyards. In Italy it is often the simple, strict rhythm of several rows of windows with sculpted, arched, Classical frames on an otherwise smooth wall that gives the desired monumentality to a palace façade (41). In northern countries indigenous traditions were mixed with imported novelties. France retained the strong round towers and the perforated roof contours of its medieval castles (37), and England the sharply cut axes and barred windows of the Late Gothic Perpendicular style (38), even when regularity of the ground plan, of stories, and of general proportion has been achieved. There are, however, many examples of a successful synthesis between Renaissance style and national artistic aims. French rationalism is clearly expressed in the longitudinal, well-proportioned and flatly molded

50 VERSAILLES PALACE. Garden front. 1661/78–84. Louis Le Vau and Jules Hardouin-Mansart. Horizontally oriented building masses, with uniformly arranged flat decoration; even column projections do not jut out very far. The buildings, their gigantic façades, and the gardens are conceived as a single artistic whole.

51 ROYAL HOSPITAL, CHELSEA, LONDON. Main façade. Begun 1682 by Christopher Wren. Decorative temple front lacks organic relationship to rest of sober, utilitarian building.

52 ZWINGER, DRESDEN. West pavilion. 1711–22. Matthäus Pöppelmann. This spectator pavilion on main axis of wide courtyard was used on festive occasions. Rococo ornamentation.

53 CLAUDE NICOLAS LEDOUX, DESIGN FOR A CEMETERY AT CHAUX. Before 1789. Part of plan for ideal city, never executed. In so-called Revolutionary architecture, abstract forms (in this case, a sphere) were supposed to symbolize mankind purified.

54 ALTES MUSEUM, BERLIN. Main façade. 1822–28. Karl Friedrich Schinkel. Broad façade of 18 Ionic columns; square structure masks 2-storied, domed rotunda in analogy to Pantheon in Rome.

55 HOUSES OF PARLIAMENT, LONDON. 1840–65. View from the Thames. Charles Barry. Late Gothic Perpendicular style applied to enormous building complex.

façade of the Louvre; only the pavilions are more heavily sculpted *(42)*. In the Low Countries an indigenous tendency toward much small, detailed ornamentation tempered by the pure lines of Classical orders often produced a fusion of the Nordic gable house and the Italian palace façade into a richly decorated yet well balanced unity *(39)*.

In Baroque architecture, completely new dynamic elements become evident. A system of usually strictly symmetrical, optically and physically linked units relating to a dominant central space develops. The wall-relief, whose components were hitherto molded into the surface *(42, 93)*, is now broken up into layers and groups of sculpted shapes rhythmically concentrated toward the center and the top *(44, 94)*. Buildings appear as organisms composed of architectural, sculptural, and linear elements, each integrated into the whole. In this way a cupola rises steeply on its drum from a square building, whose two-story temple front, with deeply shadowed groups of columns molded into the façade, prepares the eye for the upward sweep of the drum and dome *(44)*. The central dome can also create a concave counter-movement to that of the façade, which is anchored in the vertical frame made by flanking towers, although the high cupola is firmly linked to the façade by the gabled entrance and attic and relates to the towers through a contrast between compactly closed and delicately open sculpted forms *(43)*. Even when the individual units — central dome rising steeply behind temple front, two triumphal columns set before concave flanks, open side-pavilions — are individually articulated, the vertical and horizontal unity is preserved through an optical re-

56 REICHSTAG, BERLIN. 1884–94. Paul Wallot. Typical example of international "historicism": conglomerate of heterogeneous architectural styles, with generous proportions and relatively pure arrangement of component parts. Overabundant ornamentation prevents it from being truly monumental.

57 CRYSTAL PALACE, LONDON. 1851. Joseph Paxton. Altered, reconstructed version at Sydenham, Kent, destroyed by fire in 1936. Exhibition hall for first World's Fair. First glass and iron building constructed with prefabricated units. Enormous dimensions and linear purity made its interior space a new experience: boundaries between interior and exterior seem suspended in huge, light-filled expanse.

58 CASA MILÀ, BARCELONA. 1905–7. Antonio Gaudí. Building and walls form integral organism full of movement, eliminating static structure. Walls, windows, entrances, and moldings merge in complex unity of great plasticity. Extreme example of Art Nouveau architecture.

59 BAUHAUS, DESSAU. 1925–26. Walter Gropius. Complex of connected, stereometric units formally differentiated according to purpose of each unit–a clear, functional concept. Façades are horizontal strips of windows and masonry alternatively, or grids of balconies, or made transparent through use of glass with flush steel supports.

60 ROCKEFELLER CENTER, NEW YORK. 1930–40. Reinhard & Hofmeister; Corbett, Harrison & MacMurray; Hood, Godley & Fouilhoux. Architecture on urban scale. Unity of stereometric style creates formal affinity between buildings of varying size and orientation. Crystalline structure of group compensates for anonymity of each individual building.

61 STADIUM, RALEIGH (North Carolina). 1950–53. Matthew Nowicki and others. Generously proportioned structural forms concentrated in optical elegance of 2 intersecting curves, transparent tracery of middle section, and fluid sweep of roof. Accomplished use of constructive and aesthetic possibilities offered by steel and concrete.

62 HABITAT, MONTREAL. 1967. Designed by Moshe Safdie for Montreal's Expo '67 World's Fair. A model of urban building: synthesis of individual and multiple dwellings achieved by use of boxlike, self-contained units fitted onto and into each other.

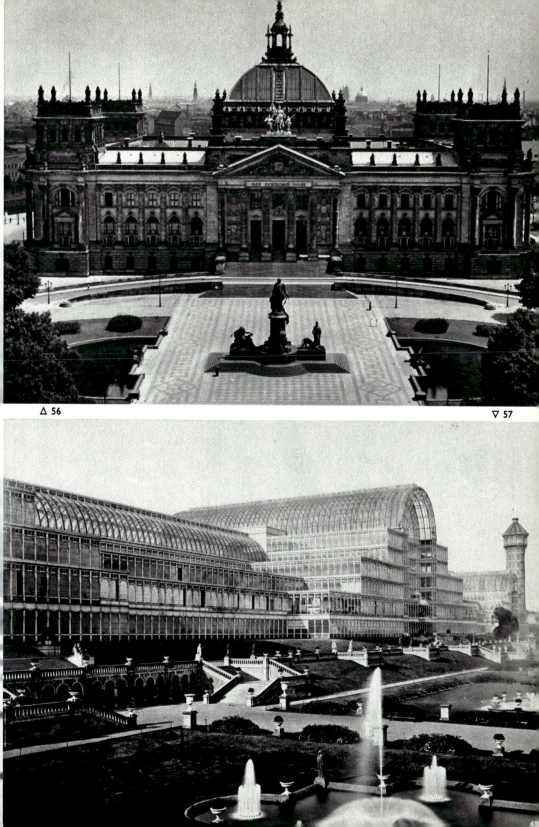

△ 56

▽ 57

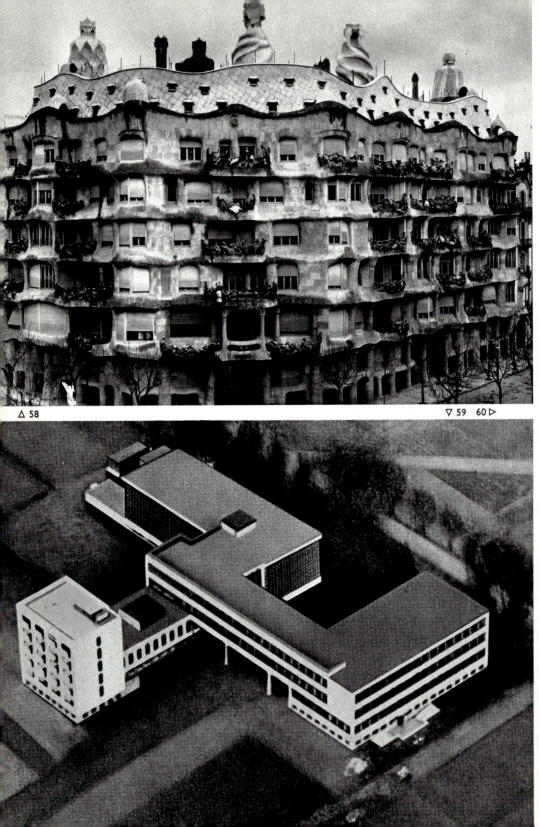

△ 58　　　　　　　　　　　　▽ 59　60 ▷

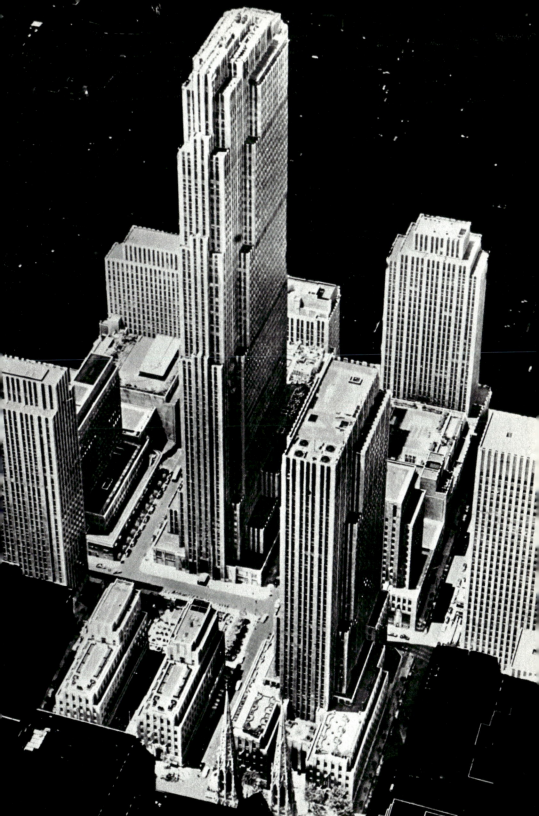

Individuality (sometimes extreme), functional design, sculpted as well as flat linear architecture, and many variants on and permutations of these themes remain the hallmarks of 20th-century architecture. In the cities, iron, steel, and concrete structures with stereometric box and tower formations, steep verticals and sharp contours, are supplying the demand for large, functional building complexes *(60)*. Such structures can also be used to solve individual tasks, and from their interlocking building blocks, façades of great variety and sometimes of almost total transparency can be created *(59)*. Concrete has brought many different creative possibilities: compact, sharply edged box-type blocks can be fitted together to form differentiated individual living units *(62)*, and the material's ability to span large areas permits the construction of wide roofs which appear to float above transparent walls, whose fluid curves emphasize a building's lightness and elegance *(61, 161)*.

WALL ARTICULATION

The idea of a building, or a room, immediately brings to mind the concept of wall. According to its function, a wall is a barrier between one room and another, or between inside and outside. The dimensions, shape, and distribution of walls determine the interior as well as the exterior character of a building. Generally speaking, a horizontal barrier has to be added to the vertical barriers of walls — a ceiling, roof, or dome — in order to give an enclosed space the character of a room and a building that of an enclosing body; but many ruins show that roof or ceiling are not always necessary to convey the feeling of a room or a building if the walls are impressive enough to encourage a mental picture of the missing roof, or if they possess so much character of their own that they compensate for a roof through their structural stability. Such extreme cases are proof of the fact that walls are not simply neutral, functional constructions. They represent abstract ideas, chiefly the concepts of "standing upright" and "supporting". Vertical and horizontal lines are the coordinates that express the relationship between standing upright and supporting, and their relationship to each other is directly related to man's instinctive feeling for dimensions. Even in our mostly anonymous living quarters, our "own four walls" decide by their measurements, by the relationship between length and height, and by the distribution of "broken" and "unbroken" areas whether we experience a room as well-proportioned and harmonious or cramped.

While in the preceding chapter the wall figured as an integral part of a building, and while in the following chapter we shall consider its functional aspect as a means of separating rooms, here we shall consider the wall mainly for its own sake, limiting our investigation chiefly to its external appearance.

A factor often given too much weight in artistic evaluations is the material from which a wall is made. Naturally, considerable differences in formal aesthetic effect are caused by differences in the type of material used. Walls of stone, wood, concrete, glass, or brick will have very different features. But materials and building methods do not determine style; it is rather the artistic idea that decides the choice of material, which then adds its characteristics to the final result. In an articulated wall with a structural skeleton — perhaps stone, brick, or steel — of different material than the skin of stone or glass *(80, 110, 111)*, the structural relationship will be greater than that between, for example, a Romanesque and a Gothic stone wall *(75, 78-80)*. Early examples of monumental architecture have walls whose construction was not developed from stone, but was a translation into stone of the structure of reed, mud-brick, and log *(63-66)*. Even the Greek — that is to say, the Doric — temple retained the post and lintel structural technique of its wooden forerunners.

With the creation of the monumental wall certain basic themes of wall articulation came into being: the shallow modeling of the wall *(65, 66)*; the combination of wall and decorative figure *(64)*, as well as the smooth, mathematically determined surface *(3, 116)*. In Mesopotamian and Egyptian buildings, massive cubic forms encouraged the articulation of walls, but Greek buildings offered no such inducement. In the Greek temple, however, column orders with entablature enclose the shrine (cella); the walls of the cella are hardly molded at all and have no particular significance, the greatest importance being given to the orders of columns,

the entablature, the pediments and porticos, and to the space occupied by colonnades (67, 68). Only with the advent of Roman architecture does the wall become important for its own sake. Column and wall combine to form a structural unit and walls open up to form arcades. This dualism of mass and articulated surface was to dominate almost the entire range of Western architecture. Roman architecture had already developed many variations: the division of high walls into stories, which repeat or vary the basic theme through, for instance, diverse column orders (9, 70); the delicate range of rhythmically spaced columns which accompanies the movement of a wall or gives it a contrapuntal effect (70); the massive, curved wall with an embedded column order, its imposing weight emphasized by the plastic surface relief (9); the heavy bonding of wall and breasted columns of varying height, which add contrast as well as light and shade (69). Early Christian church architecture, however, rejects the physical plasticity of the façade type of wall: it displays a smooth, often completely unadorned brick wall to the outside world, its uniformity broken only by a series of arched windows (74, 20) and perhaps by a few, flat arches (73). Even in the complex construction of Byzantine churches the walls remain mere shells, enlivened by different colors and patterns of stone, blind alcoves, and the curve of the roof (71, 72).

Romanesque architecture returns to the really substantial wall, generally of hewn stone with a rich layer of relief either superimposed on it or deeply embedded in it. Blind arcading, friezes, and miniature galleries often encircle a Romanesque building. Deep porches and window arches break up the wall, and series of niches with carved figures and rich ornamentation lend it even greater importance. Especially in the south of France, broad display façades present a magnificent array of forms and figures with their patterns of light and shade (78). The compact, static shape of rounded arches and the horizontal orientation of the stories give the wall and the whole building an earthy, calm weightiness (75). The importance of the building is often underlined by an arcade with three triumphal arches in the center of the façade, a theme borrowed from Classical antiquity (75-78). Attempts to lighten walls optically were made, and a singularly beautiful example of flat, colored surface decor survives from as early as the Carolingian era (76). In Tuscany, walls were often decorated with a delicate, filigreelike net of miniature galleries (particularly on the façade and apse) in different colors of marble (24). The Florentine proto-Renaissance, on the other hand, used marble incrustation in geometric patterns on the wall surfaces as well as Classical arcades. Nevertheless, the layered structure of these walls shows that they belong to Romanesque architecture (77).

It is only with the beginning of the Gothic period, which initiated articulated building, that the compact coherence of walls is broken up. Solid wall is reduced to the structured minimum of narrow stripes, reinforced by buttresses inside and outside the building. Between the buttresses are remnants of thin walls and windows. Not only the massiveness, but also the clumsy heaviness of the walls is gone: verticals dominate and break the horizontals of stories with canopies and miniature Gothic towers (79, 80). In Late Gothic architecture vertical buttresses remain the dominant structural axes of walls, even when they are carried by horizontal stories (84), or merge, clustered with miniature towers and statues, into the mass of decorative wall facing (83). At the same time, compact, "closed" façades retain their validity, although they show Gothic influence only marginally. Horizontal and vertical rows of niches

with statues were used to heighten the "serial" effect — as on display façades of English churches *(82);* or these façades were richly decorated with tightly packed surface ornamentation, as in Italy *(81).*

Inspired by the buildings and the architectural theories of Classical antiquity, the Renaissance returned to mathematical relationships of weight and its support: each unit stands in perfect balance with all other units and with the building as a whole *(85, 89).* Once again the wall is seen as a homogeneous body and the stories — visually obeying structural laws — rest in harmony one upon the other and become lighter toward the top *(86).* Window openings, double half-columns, balustrades, and entablature *(41, 87)* give the wall strong, sometimes crowded, relief; but this rhythmic molding is soon interrupted when individual units assume separate forms and proportions *(88).* Eventually, the classical dictum of the rational objectivity of forms and their relationship was discarded, and willful individuality came to dominate: the sections of a tunnel-shaped room have disproportionate dimensions; columns are embedded without purpose in a wall; consoles do not support anything; pediments cut radically across other units *(90).* In northern countries, where concepts of form are pictorial and decorative rather than structural, façades became overgrown with statues and ornamental work *(91);* only French rationality knew how to contain such richness and spread it in well-proportioned orderliness across the surface *(92).*

The Baroque rearranges the tensions within a wall by making the best possible use of decorative and structural values. Renaissance builders broke two-story pedimented façades with symmetrically placed niches and pilasters *(93);* the same style reappears in the Baroque in a tighter form: projecting elements jut out more toward the front and are crowded closer to the center, giving the double-columns, pediments, and niches a more concentrated effect *(94).* The next step changes the technique of modeling a wall in parallel layers. The Italian architect Borromini gives concave and convex movements to the body of the wall itself, to which columns, niches, windows, and ledges stand in a contrapuntal relationship *(95, 99).* The curved wall, with plastic shapes following its sweep, becomes, particularly in southern Germany and northern Italy, the most effective means of reflecting the movement of interior space in the outer shell of church as well as palace buildings. Such walls are usually firmly anchored by flanking towers or wings *(96, 98, 105, 107).* France and northern Europe, on the other hand, preferred cubic buildings with integral façades. The dynamic power of this aesthetic lies in the well-proportioned relationship of all building elements, in the center projection, in which plastic forms crowd each other, casting deep shadows, and in the monumental column order that stretches across stories from base to roof, its verticals harmonizing with the horizontal rhythm of the windows *(100-103, 106).* Even immensely long façades gain an impressive monumentality and all-over unity from the strict rhythm of equal axes, or from the interplay of compact projections and open galleries *(50, 108).* Only later, when stories became overloaded with decoration and structures bearing no relationship to the whole, did the wall begin to lose the dynamic interplay of tensions and its monumental aspect *(109).* Exaggerations of historical styles in the 19th century were not able to restore it.

New impulses arose with Revolutionary architecture and Neoclassicism. Walls appear as massive bodies *(53),* column orders as autonomous borders *(54),* and wall surfaces as flat

spaces divided horizontally and vertically into mathematically detailed units *(110)*. Long, narrow, vertical strips of wall reveal the supporting skeleton, to which the use of steel construction can lend almost unlimited heights *(111)*. The horizontal strips of wall between the vertical ribs of the skeleton no longer carry any structural load and can be used as window space. Their width can be adjusted according to the function of the building. But apart from this merely functional structuring there is room enough for individual interpretations of wall space, whether in a seemingly haphazard distribution of windows of various shapes *(112)*, in the abstract-visual interplay of solid and transparent surfaces *(114)*, or in the organic curvature of a smooth curvilinear wall around a compact building *(113)*. One extreme — the completely closed, compact wall — is confronted with another, of total transparency; here the wall, freed from all load-bearing functions, becomes a lucid, almost invisible frontier of glass between interior and exterior *(115)*.

63 SANCTUARY OF EANNA, URUK. c. 2900 B.C. Mosaic pattern of yellow, blue, and black clay pegs pressed into mud of enclosing wall imitates a wall facing made of reed matting.

64 INANNA TEMPLE, URUK. Frieze. c. 1400 B.C. Reconstruction. Vorderasiatisches Museum, Berlin. Oldest known architectural sculpture of brick; in niches are images of god and goddess, pouring out water of life. Alternating high relief and bas-relief.

65 PYRAMID OF KING ZOSER, SAQQARA. Enclosure wall. c. 2600 B.C. Beginning of monumental stone architecture, imitating older brick walls showing strictly linear articulation of wall with sharp-edged, shallow modeling.

66 SARCOPHAGUS FROM GIZA. c. 2600 B.C. Cairo Museum. Decorative blind door of painted limestone imitates wooden palace door with flatly molded door posts.

67 OLYMPEION, ATHENS. Southwest view. c. 175 B.C., completed A.D. 130. Of 104 columns, 13 have survived. First Corinthian column order used in Athens. Play of light and shade on deeply carved leaf capitals harmonizes with light effects and spacious openings of double ring of columns. Columns maintain their independence from cella.

68 ERECHTHEION. Acropolis, Athens. North portico. Begun c. 421 B.C. 4 slender, delicately ornamented Ionic columns on the long front and 2 on each short side support the coffered ceiling. Flower frieze on capitals repeated on wall and doorframe of cella.

69 TEMPLE OF BACCHUS, BAALBEK (Lebanon). Cella, north wall. Mid-2d century. Wall has great plasticity and powerful effects of light and shade achieved by embedding Corinthian columns with projecting plinths and entablatures between niches and blind windows.

70 SCAENAE FRONS OF THE THEATER, SABRATHA (Libya). End of 2d century. Reconstruction. 3-story wall at back of theater with 3 exedrae as entrances, behind lattice work of delicate columns. Space between columns and walls varies, producing sometimes lighter, sometimes deeper shadows and lending movement to almost flat grid of columns.

71 KATHOLIKON, HOSIOS LUKAS (Boeotia). East apse. Early 11th century. Walls of angular building units stand out in flat relief around large windows.

72 APHENDIKO CHURCH, MISTRA. East apse. Early 14th century. Walls of semicircular building units with sweeping contours are lightened by groups of slim windows and niches. Stones of different color give painted effect.

73 ORTHODOX BAPTISTRY, RAVENNA. South view. c. 458 Smooth, octagonal walls of precise brickwork with double blind arches producing an almost graphic effect.

74 S. SABINA, ROME. Southeast view. 422–32. Smooth walls without ornamentation enclose basilicalike thin membrane. Large, rounded windows without frames spell out wall's horizontal and vertical proportions.

75 FORMER ABBEY, MARMOUTIER LES TOURS. West view. c. 1150. Façade's symmetry is notable: flush portico and flanking towers; clearly distributed verticals and horizontals. Portico wall supported by 3 arches resting on stocky columns. Ashlar masonry. Rhythmically repeated relief of blind arcades and consoles.

76 FORMER ABBEY OF ST. NAZARIUS, LORSCH. Gateway. 774. Triumphal arch type: 3 wide arches on heavy pillars with projecting columns and cornices topped by blind arcades with triangular gables. Wall's red and white stonework facing lends lightness and richness.

77 BADIA, FIESOLE, NEAR FLORENCE. West façade. Mid-12th century; overlaid with 15th-century masonry. 2 thin layers: outer carried by 3 round arches in antique style. White and green marbles incrustated in flat, tilelike pattern.

78 NOTRE-DAME-LA-GRANDE, POITIERS. West façade. Second quarter of 12th century. Display façade of great plasticity. Rich, sculptured decorations fitted into rows of blind arcades. Supported by main portal with blind-arch niche on each side and flanked by small towers.

79 CHURCH OF THE CISTERCIAN MONASTERY, HEILIGENKREUZ. Choir, north view. Begun 1295. Austere exterior. Wall articulation limited to barest structural necessities: plain, narrow, graded buttresses between high, narrow windows with geometric tracery.

80 NEVERS CATHEDRAL. Choir, north view. 1308–32. Glass predominates. Solid wall mass almost completely dissolved. Slim flying buttresses encircling ambulatory and chapels are trimmed to optical verticals by small Gothic turrets. Canopies

rising from cornices do away all earthbound horizontals.

81 SIENA CATHEDRAL, West façade. 1284 to second half of 14th century. Supervised by Giovanni Pisano, among others. Display façade composed of well-balanced and proportioned individual sections. Closely ranged group of 3 portals flanked by supporting towers; square middle section, with rose window and flanked by small Gothic turrets, unrelated to vertical lines of lower section. Rich plastic decoration.

82 WELLS CATHEDRAL. West façade. c. 1200–39. Broad display façade unrelated to body of basilica. Statues in rows of niches and rich Gothic ornamentation seem flat, as if glued to surface of wall.

83 TOWN HALL, GHENT. South façade. 1518–27. Rombout Keldermans. Rich, Late Gothic ornament and tracery on windows and walls. Unbroken vertical lines of buttresses adorned with small towers and statues.

84 TOWN HALL, MÜNSTER. First half of 14th century. High gable towers over 2 horizontally oriented stories with arcaded ambulatory and council chamber. Windows have tracery; between them small towers with statues. Gable's expanse graduated vertically by tall pilasters and windows; surrounding framework is delicate by contrast.

85 S. FRANCESCO (TEMPIO MALATESTIANO), RIMINI. Lateral façade. Begun 1446. Leone Battista Alberti. 7 pillared arches frame niches containing sarcophagi. Carefully calculated proportions of loads and support and of all elements to each other and to the whole. Reflects return to antique Roman concept of organic, structurally sound wall articulation.

86 PALAZZO MEDICI-RICCARDI, FLORENCE. 1444–c. 1460. Michelozzo di Bartolommeo. Rectangular block with arcaded inner courtyard. Clearly defined stories and regularly spaced windows with round arches. Heavy cornice. Stories grow lighter and less elevated toward top. Rusticated stonework of ground floor (originally with open arches) becomes flatter in middle story; upper story has ordinary ashlar masonry. Harmonious proportions throughout.

87 PALAZZO VIDONI-CAFFARELLI, ROME. c. 1515. Raphael. Highly 3-dimensional façade organization. Ground floor has rusticated stonework in horizontal layers; window openings

with balustrades in upper story alternate with embedded double-columns on protruding plinths. Angular, well-defined contours.

88 PALAZZO FARNESE, ROME. Main portal. Begun 1546. Michelangelo. Portal's axis integrated into Renaissance façade by Antonio da Sangallo the Younger (see 41). Deliberate contrast between materials and proportions: high rusticated portal and wide plastic balcony window squeezed between adjoining features.

89 PAZZI CHAPEL, FLORENCE. Begun 1430. Filippo Brunelleschi. Portico has high arch flanked by columns supporting cornice, which mirrors wall molding of interior (see 149). Rectangularly divided walls and gallery form segmented but harmoniously proportioned and delicate structure.

90 BIBLIOTECA LAURENZIANA, FLORENCE. Vestibule. 1526–71. Designed by Michelangelo, executed by Ammanati. Staircase of plastically articulated individual units ends tunnel-shaped steep room. Classical proportions and ideal balance between loads and supports are discarded: double-columns embedded in wall without functional purpose; volutes used for dynamic effect.

91 HEIDELBERG PALACE. Ottheinrich Wing. South view. 1556–59. Italian Mannerist elements in wall articulation and arrangement of stories. Pilasters and niches united by rich decor in Netherlandish style.

92 LOUVRE, PARIS. Clock tower. West wing. Begun 1546 by Pierre Lescot. Quietly balanced proportions and flat projections. Unobtrusive plasticity even in double-columns, decoration, and statues (latter confined mainly to mezzanine). Coolly elegant overall effect. (See 42.)

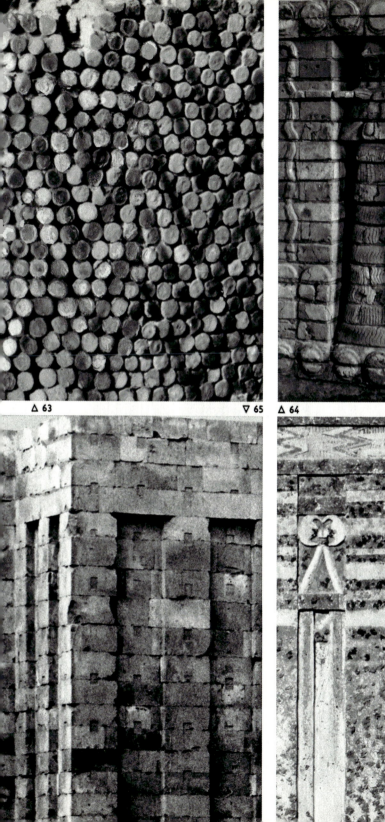

△ 63

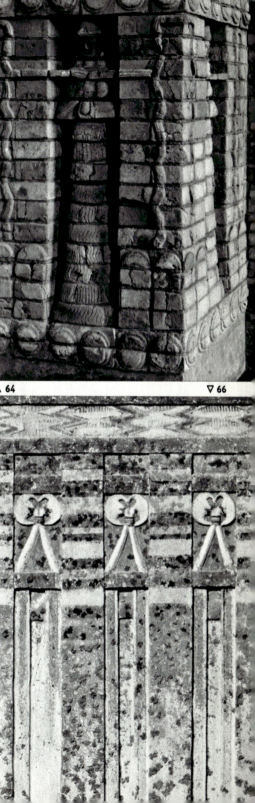

△ 64

▽ 65

▽ 66

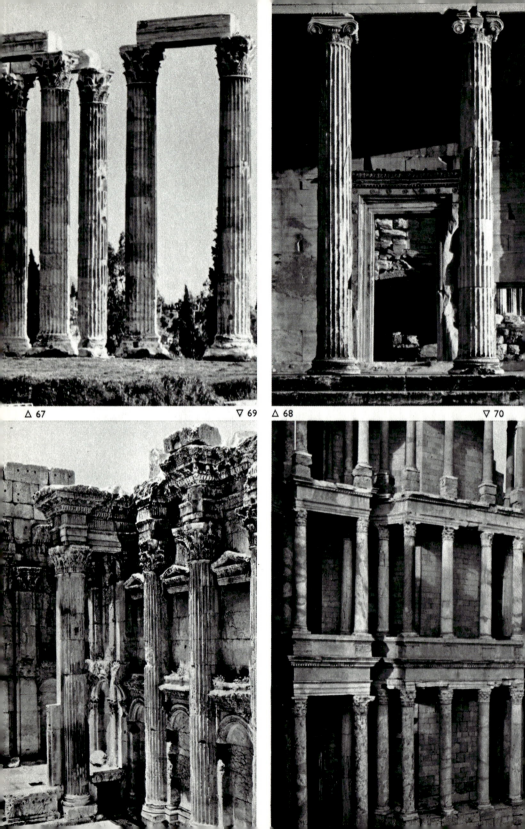

△ 67 ▽ 69 △ 68 ▽ 70

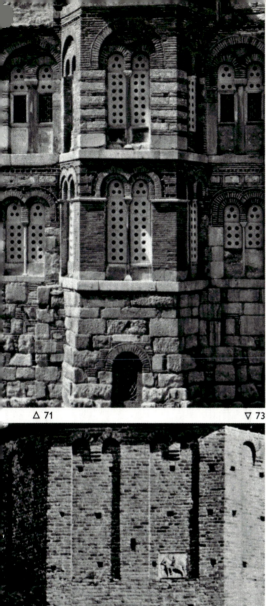

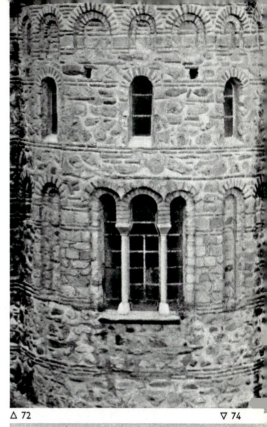

△ 71 ▽ 73 △ 72 ▽ 74

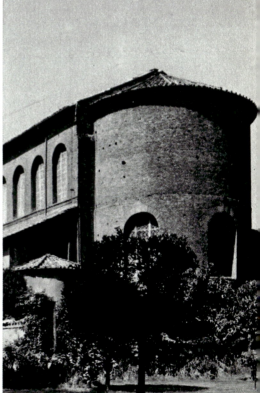

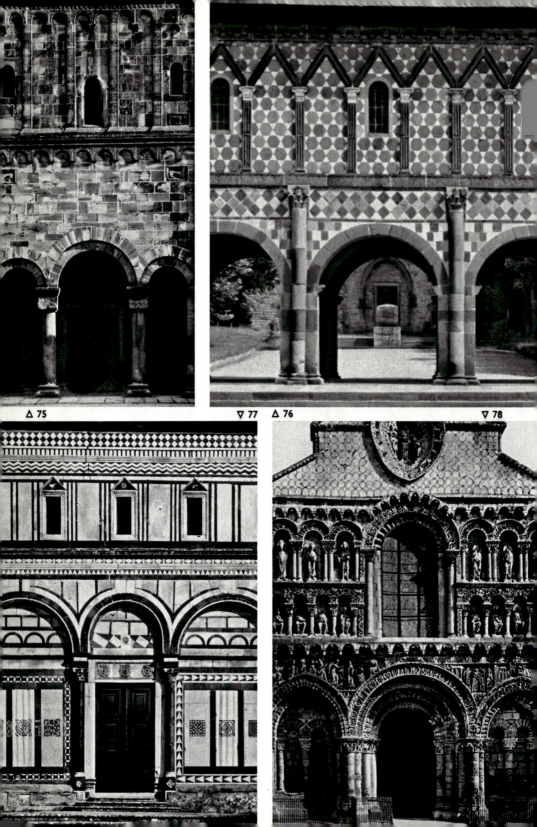

△ 75 ▽ 77 △ 76 ▽ 78

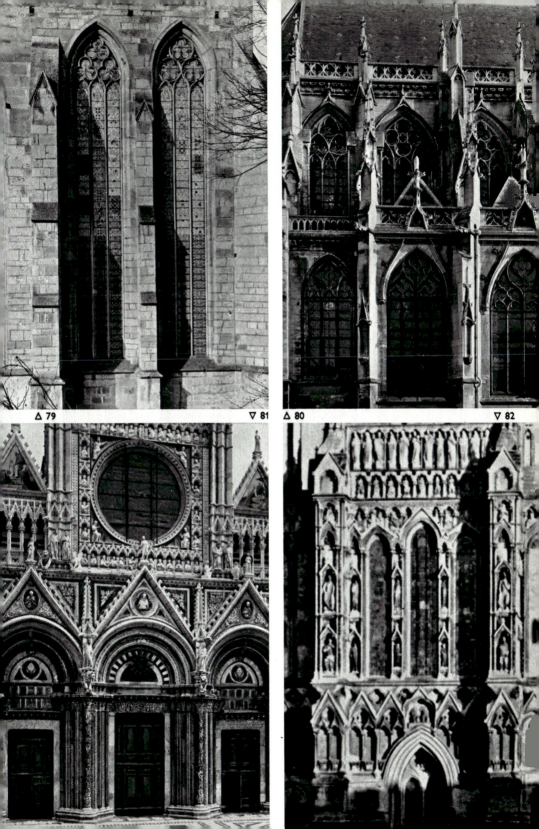

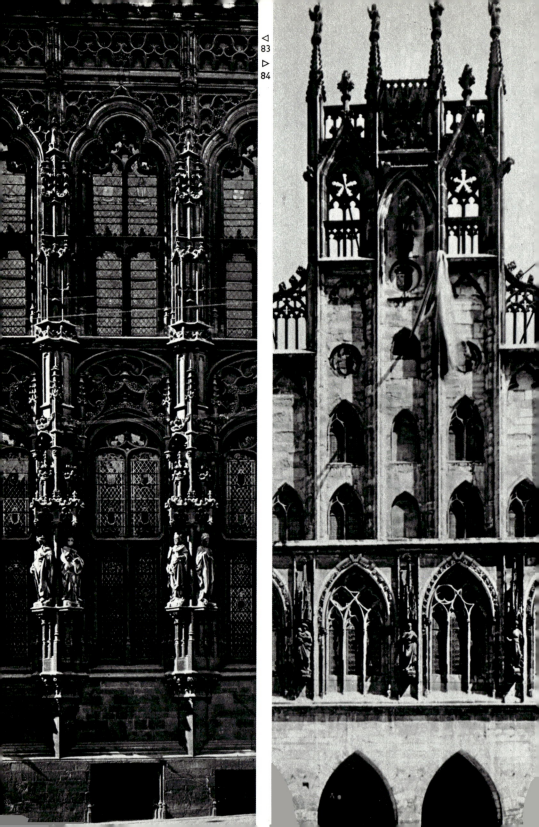

◁ 83
▷ 84

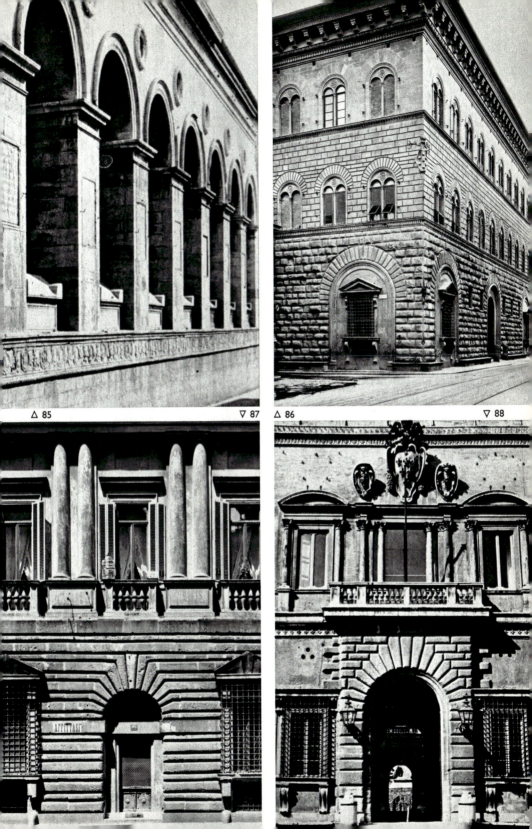

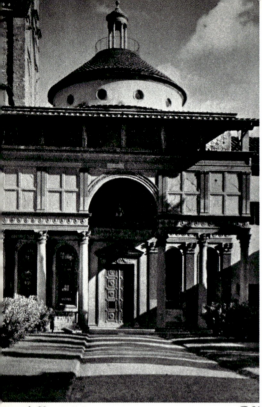

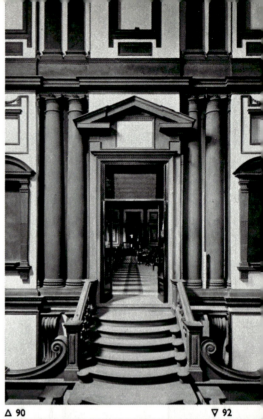

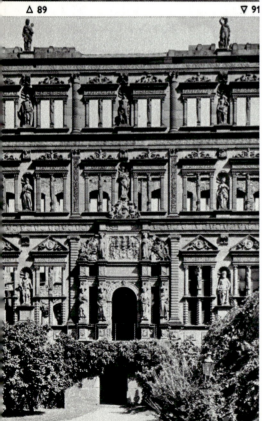

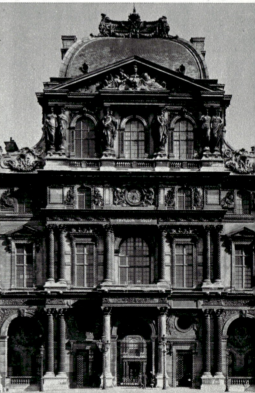

93 S. SPIRITO IN SASSIA, ROME. North view. Begun 1538. Antonio da Sangallo the Younger. Façade unrelated to comparatively irrelevant body of church. Uniformity achieved through closely similar articulation of both stories with pilasters, niches, and emphatic central section. Flat, layered, linear structure.

94 S. SUSANNA, ROME. West view. 1596–1603. Carlo Maderna. Traditional 2-story façade with pediment. New, characteristically Baroque tensions and plasticity employed in structuring of wall grading and emphasizing elements toward the center. Width and richness of individual wall sections, as well as distance they project, increase toward middle section, which itself is characterized by double-columns or pilasters and sharply profiled pediments.

95 S. CARLO ALLE QUATTRO FONTANE, ROME. Begun 1655. Francesco Borromini. Whole façade seems to be in motion without any even element. Ground floor is concave-convex-concave curve; upper story has 3 concave sweeps, with flat convex tabernacle filling middle section. Harmonious balance maintained by steady equilibrium of heavy cornices; columns act as independent joints. Swing of curves repeated in tower. Sharp contrasts of light and shade.

96 PILGRIMAGE CHURCH, VIERZEHNHEILIGEN, NEAR BAMBERG. 1743–72. Balthasar Neumann. Conventional 2-tower façade interpreted in Late Baroque style: central section projects in convex curve, movement of interior (see 154) reflected by exterior. Slim pilasters, delicate window frames, and animated towers topped by transparent lanterns give lightness and measured clarity. Tall façade calculated to be easily visible from great distance. (See 148, 154.)

97 PALAZZO BARBERINI, ROME. Central section of façade. Building begun in 1628 by Carlo Maderna, completed by Gianlorenzo Bernini and Francesco Borromini. Loggialike structuring of older inner courts transferred to façade, but with more plasticity and powerful effect of proportions. Upper story window frames produce an illusory perspective.

98 PALAZZO CARIGNANI, TURIN. Central section of façade. 1679–85. Guarino Guarini. Concave-convex-concave façade steadied by even flanking wings. Pilasters and delicately structured window frames follow wall's movement. Counter-move-ment only in tabernacle above portal and in pediment.

99 COLLEGIO DI PROPAGANDA FIDE, ROME. West view. 1662. Francesco Borromini. Wall, tall pilasters, and strongly protruding cornice swing inward only at center of façade. Window moldings and, to a lesser degree, more flatly molded attic repeat same movement. Willful, strongly individual forms act in manifold interrelationships.

100 MAURITSHUIS, THE HAGUE. North view. 1633–44. Jacob van Campen. Severe, nobly proportioned building. Each side has regular row of Ionic pilasters. Unobtrusive projection and pediment underline only central sections of main façades.

101 LINDSAY HOUSE, LONDON. 1640. Inigo Jones. Prototype of representative English town house of formal, classical elegance: rusticated ground floor, equal rhythm of tall pilasters and gabled windows in main story, cornice with balustrade hiding roof. Carefully balanced proportions.

102 BERLIN PALACE. South front. 1698–1706. Andreas Schlüter. Delicately articulated façade gains monumentality and structured plasticity through portico's 4 massive columns with large cornice, which rest on high, sharply profiled plinths.

103 LOUVRE, PARIS. East front. 1667–78. Claude Perrault. Horizontally oriented, uninterrupted façade. Main story with double-columns rests on plain base. Columns stand against wall only in front of middle and corner projections; otherwise they stand free before open galleries.

104 PALAZZO MADAMA, TURIN. 1718–21. Filippo Juvara. Flat pilasters and 4 central columns balance each other as perfectly as 3 main building sections and dominant main story in relation to rusticated ground floor and high cornice.

105 PLOSCHKOWITZ PALACE (Bohemia). 1720. Octavian Broggio. Contrast between solidly balanced basic structure and façade's playfully decorative articulation: concave, wavy movement of center projection; upturned cornices; detailed, decorative window pediments. Delicate wall relief contrasts with massive portico arches.

106 PETIT TRIANON, VERSAILLES. Garden front. 1762–68. Jacques-Ange Gabriel. Small, intimate building of crystalline compactness, with restful, elegant proportions. Economical, strict row of pilasters confined to broad projection.

107 SANSSOUCI, POTSDAM. 1745–47. Frederick II of Prussia and Georg Wenzeslaus von Knobelsdorff. Low, horizontally oriented pavilion with domed, projecting central room. Symmetrical façade with French windows and double-pilasters is luxuriously overrun by ornament of great plasticity.

108 ROYAL CRESCENT, BATH. 1767–75. John Wood the Younger. Building complex of 30 houses ranged in massive half-oval, manifesting uniform façade with articulation of Ionic columns. Harmonious contrast with wide lawn.

109 PALAZZO DELLA CONSULTA, ROME. 1732–37. Ferdinando Fuga. Return to a compact, uniform façade crowded with small detail. Pictorial rather than monumental effect enhanced by use of stone of different colors.

110 BAUAKADEMIE, BERLIN. 1832–35. Karl Friedrich Schinkel. 4 identical façades of equal squares mirror cubic structuring of interior. Pillars, stretching up to roof cornice, are optical, as well as technical, supports; thin, windowed walls suspended between them. Sparse terracotta decoration.

111 GUARANTY TRUST BUILDING, BUFFALO. 1894–95. Louis H. Sullivan. Steel construction. Dominating verticals form closed wall surface with horizontals of base and cornice. Walls reduced to narrow bands as new relationship is sought between skeleton and narrow windows. Functional harmony between interior and exterior.

112 WILLOW TEAROOMS, GLASGOW. 1904. Charles Rennie Mackintosh. Each section and window treated individually with subtle relationship of all elements to each other and of barred windows to delicately articulated, lively façade.

113 EINSTEINTURM, NEUBABELSBERG, NEAR POTSDAM. 1919–21. Erich Mendelsohn. Concrete walls make this architectural sculpture look as if cast in mold. Deeply cut windows emphasize parallel curves of monolithic structure.

114 HAUS DER WERKBUNDSIEDLUNG, VIENNA. 1932. Gerrit Rietveld. Group of 4 attached houses shows geometrical arrangement of vertical and horizontal window and wall spaces, transposed at entrance and balcony into space. Strict linear relationship.

115 MODEL FOR A SKYSCRAPER. 1919. Ludwig Mies van der Rohe. Interpenetration of exterior and interior carried to extreme, by transferring supporting structure to interior and thus achieving total transparency. Apparent weightlessness of each story and flexibility of glass walls give building aspect of honeycomb.

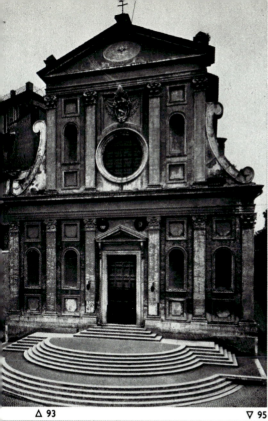

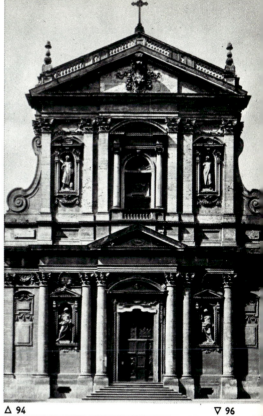

△ 93 ▽ 95 △ 94 ▽ 96

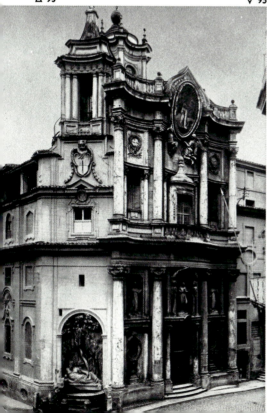

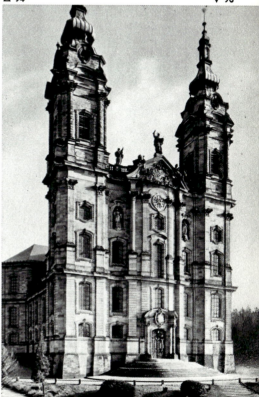

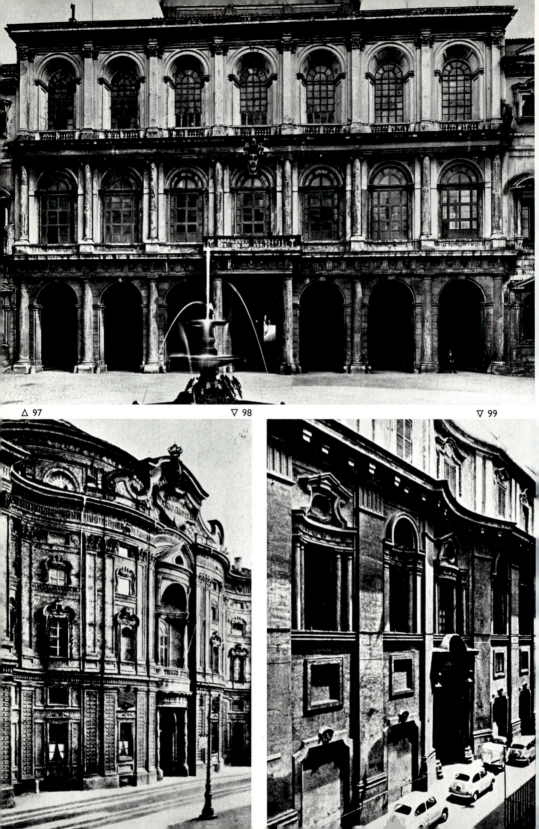

△ 97 ▽ 98 ▽ 99

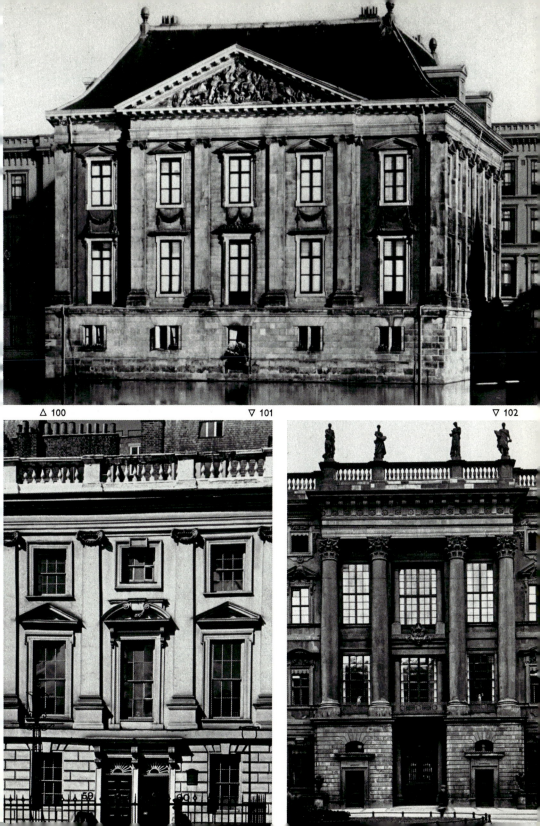

△ 100 ▽ 101 ▽ 102

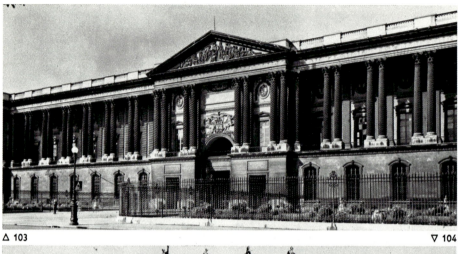

△ 103

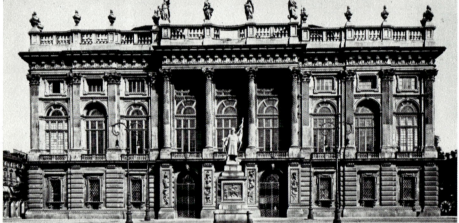

▽ 104

▽ 105

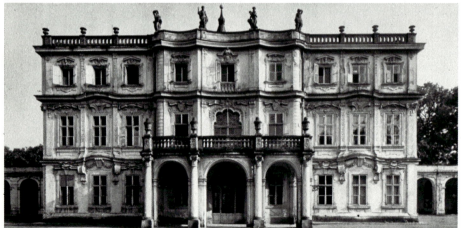

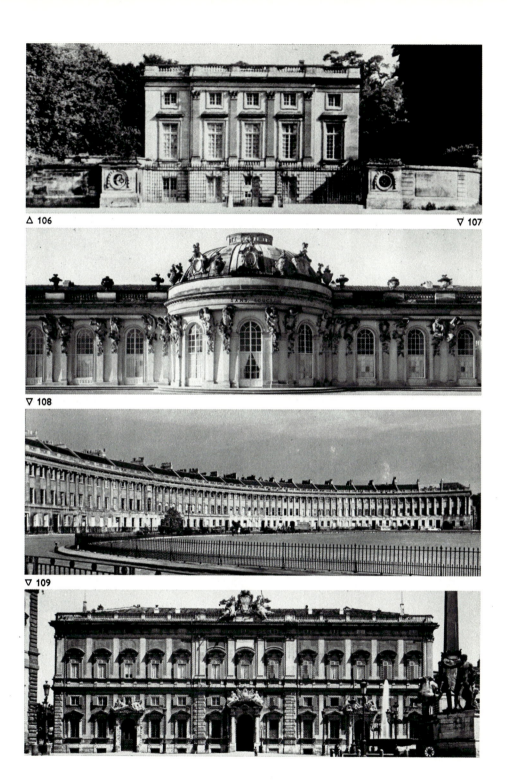

△ 106

▽ 107

▽ 108

▽ 109

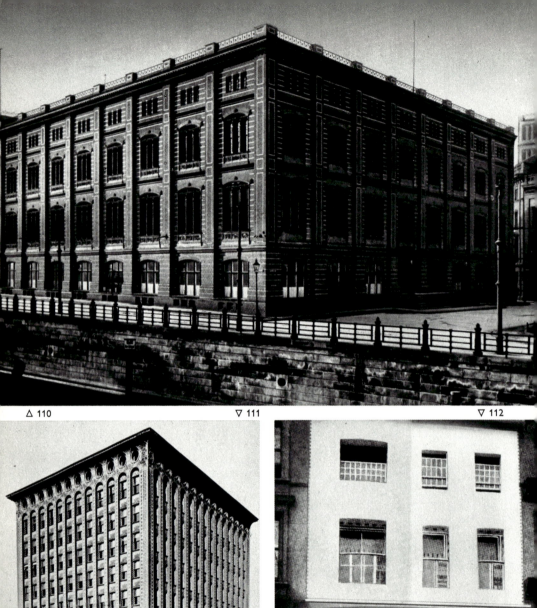

△ 110 ▽ 111 ▽ 112

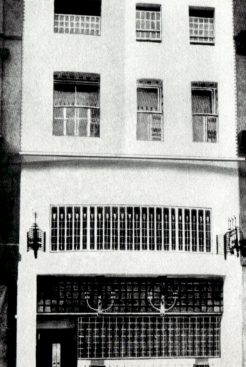

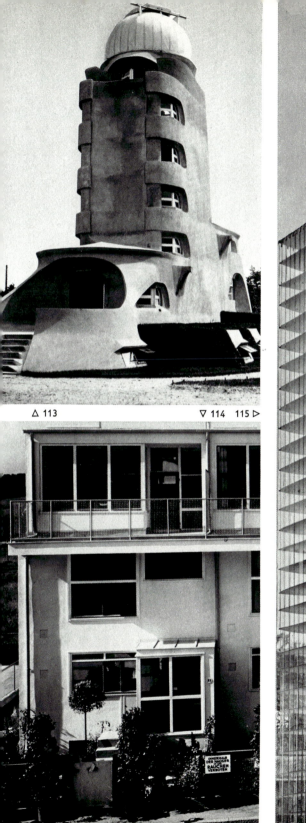

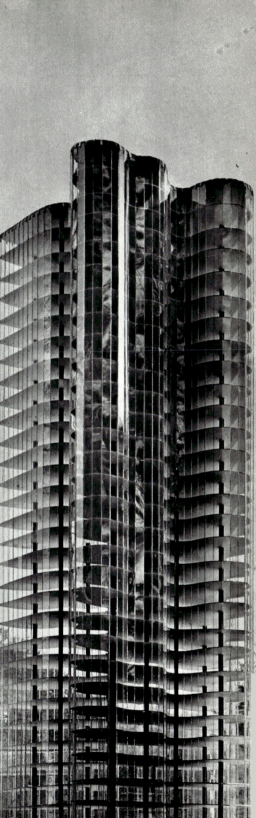

△ 113 ▽ 114 115 ▷

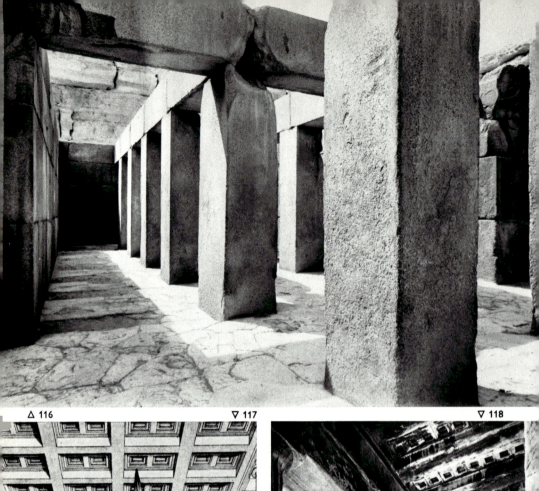

△ 116

▽ 117

▽ 118

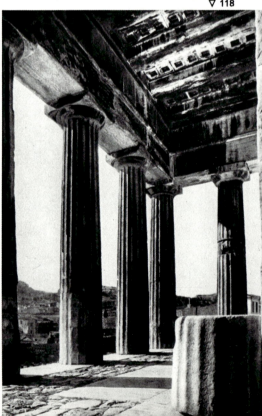

INTERIOR SPACE

Like the building itself, every room has a function to fulfill. The shape is influenced by ideological as well as practical concerns. A sacred room, in which everything is directed toward a shrine, will differ in principle from a neutral, secular room. The interior of a sacred building that has to provide space for worshippers must be differently organized from a sanctuary containing only the sacred idol, ceremonies in whose honor are performed outside. The throne room of a potentate will have different proportions from a railway station or a living room. Certain parts of an interior can be vital to the purpose of that interior, as, for example, the chancel to the function of a church; other components may be used because they satisfy a symbolic meaning, such as, for instance, the dome which for centuries has expressed the idea of heaven, or of universal harmony. The shapes of sacred buildings differ according to the religions or cults they serve, but even within the same religion, particular customs can affect the interior of a church, temple, or shrine temporarily or regionally: Some churches have double choirs, some have choir lofts or galleries. Changes of court protocol leave their traces, as a comparison between the great hall of a medieval castle and the complex arrangement of rooms in a Baroque palace demonstrate. A Roman villa denotes a different way of life than that expressed by a Renaissance palace or a modern semidetached or detached house. Social and economic demands of our age have posed new building problems.

It would be wrong, however, to imagine that idealistic or practical considerations were the only, or even the most important, factors in deciding the formal appearance of a room. If this were so, we would have no history of the architecture of churches, for the earliest official church architecture had already developed, in the basilica, a form completely adequate to all the ideological and practical demands of Christian worship. Yet the basilica plan has been interpreted and reinterpreted in a variety of styles and with greatly differing results. The second stylistic type of church architecture, the central building, was modeled on the hall of the secular buildings of Classical antiquity. In early periods it was used for commemorative buildings or baptistries; in later centuries it was also used for parish churches, despite the fact that it was quite unsuited to such a purpose: Purpose alone does not determine the shape of a room, however; other factors at work are the artistic concepts of the architect, the period, and the cultural climate.

The character of interior space, and above all artistically shaped interior space, results from the interrelationship between enclosed space and the enclosing boundary — from an immaterial and a material factor. The boundaries of this space — namely, the walls, and a

116 TEMPLE NEAR CHEPHREN'S PYRAMID, GIZA. c. 2550 B.C. 5 pairs of monolithic, polished granite pillars support ceiling. Alabaster floor. Originally 23 statues of king stood in front of wall. Crystalline, abstract, monumental effect.

117 PARTHENON, ACROPOLIS, ATHENS. Reconstruction of cella by Heinz Kähler. Framed on 3 sides by Doric columns in 2 stories, sanctuary contained Phidias's gold and ivory statue of Pallas Athene. (See 1, 7.)

118 HEPHAISTEION (THESEUM), ATHENS. c. 460/50 B.C. Doric temple. Cella set rather deeper than usual into temple, causing east porch to become wide, light-filled hall.

119 NYMPHAEUM, "CICERO" VILLA, FORMIO. Mid-1st century B.C. Broadly based coffered barrel vault supported by Doric colonnade with narrow side passages forming cavelike chamber.

120 CASA DEI VETTII, POMPEII. Atrium and garden peristyle. c. 62—79. Series. of wide, light, open chambers surrounded by darker ones, coordinated to each other in axial system.

121 PALACE, TRIER. c. 310. Rectangular hall with flat ceiling and wide apse has 2-dimensional, linear wall articulation, achieved by large, arched windows and now vanished marble facing.

122 S. APOLLINARE NUOVO, RAVENNA. East view. Early 6th century. Basilica interior with higher, broader, lighter central nave. Long flight of arcades leads to apse and altar. Weightless walls serve only as background for mosaics.

123 HAGIA SOPHIA, ISTANBUL. View from a gallery toward northeast. Wide, oblong, domed space surrounded by diffused light and shadows of ambulatories. Walls and dome seem weightless and airy; arcades make them appear transparent. Precious marbles and mosaics decorate the building. (See *13, 17*.)

124 MINSTER, ESSEN. West choir. 1039–58. Use of 3 polygonal sides modeled on Aachen Palace Chapel, but with sturdier proportions. Pillared arcades (in 2 stories) and gallery with columns divided into 2 sections.

125 BAPTISTRY, FLORENCE. West view. Domed octagon of particularly harmonious proportions. Marble-faced walls in 2 levels: Corinthian pilasters and columns projecting from wall in ground story, and gallery opening between flat pilasters in upper story. (See *26*.)

126 ST-FRONT, PÉRIGUEUX. East view. Begun 1120. Church in shape of Greek cross has 5 domes supported by narrow barrel vaults resting on pillars whose massiveness is moderated by arches.

127 S. MARCO, VENICE. East view. 2d half of 11th century. 5-domed, marble-faced, cross-shaped church girdled by ambulatories. Arched columns and galleries between massive pillars supporting domes.

128 S. MARIA, NARANCO, NEAR OVIEDO (Asturias). West view. Narrow sides of broad hall open onto loggias. Tunnel vaulting with transverse arches and rich wall relief with blind arcades and ornamental medallions. (See *22*.)

129 SPEYER CATHEDRAL. Southeast view. First building phase (1030–61) produced level ceiling with rhythmically spaced, high arches uniting arcades and windows. High Romanesque conversion (1086–1106): new rhythm and structure by reinforcing pillar of each second bay and adding groin vaulting. Walls divided in several levels.

130 ST-PHILIBERT, TOURNUS. East view. Early 11th and 12th centuries. Interior given width through high, columned masonry arcades. Nave has barrel vaulting on pier arches; aisles have cruciform vaulting. Richly articulated ambulatory. (See *142*.)

131 ST. MICHAEL, HILDESHEIM. East view. Unified symmetry of stereometric space units achieved by basing dimensions of ground plan and elevation on square formed by intersection of nave and transept. (See *14, 25*.)

132 ABBEY CHURCH, ST-SAVIN-SUR-GARTEMPE. East view. 1060–85, 1095–1115. Hall-like interior with tunnel-vaulted aisles and slim, lofty arcades, emphasizing orientation toward light-filled ambulatory and surrounding chapels.

133 STE-TRINITÉ, CAEN. Northeast view. 1059–66, 1100–30. Large basilica with rhythmic sequence of equal bays and sexpartite ribbed vaulting covering 2 bays each. Walls' structure and articulation show great plasticity, with bundles of pillars, blind story and splitting of wall in clerestory.

134 STE-MADELEINE, VÉZELAY. West view. 1120–50; choir c. 1200. Powerful wall projections and transverse arches emphasize each vaulted bay as individual unit. Walls have only 2 stories with wide, round arches and rich plastic decoration.

135 ABBEY CHURCH, FONTENAY. East view. 1139–49. Emphasis on hall-like center nave, subordinated transverse-vaulted side aisles. Windowless nave has high, pointed transverse arches and barrel vaulting. Apse rectangular and filled with light. (See *141*.)

136 DURHAM CATHEDRAL. East view. 1093–1133. Square formed by crossing of nave and transept provides dimension for each pair of bays in nave. Alternately bundles of pillars with transverse arches and patterned columns. Gallery and clerestory surmount rounded arcades; ribbed cross-vaulting. (See *143*.)

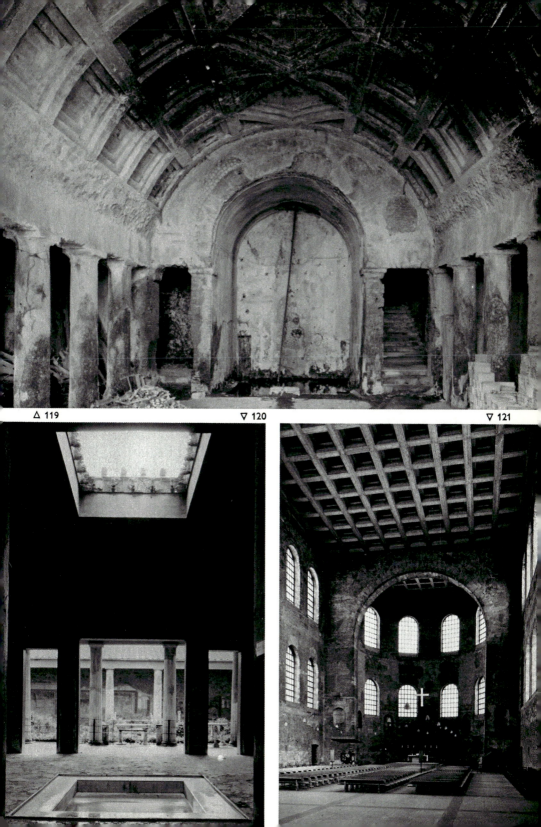

△ 119 ▽ 120 ▽ 121

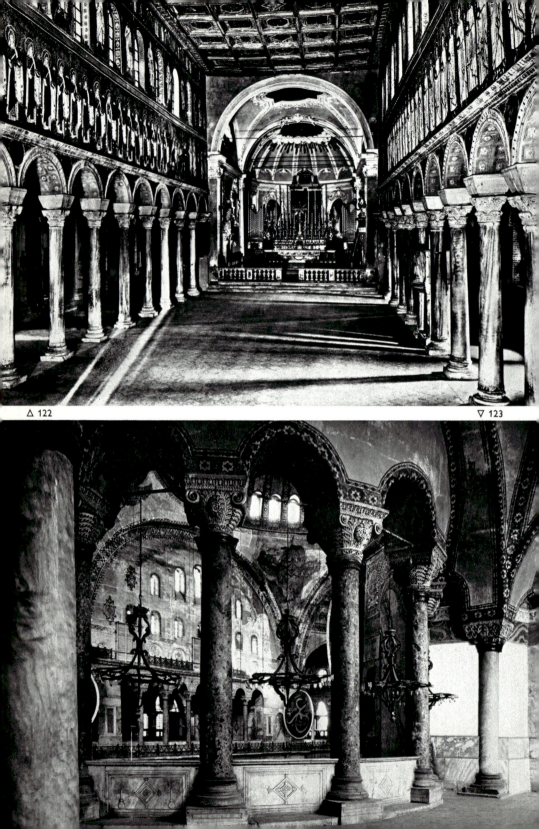

△ 122

▽ 123

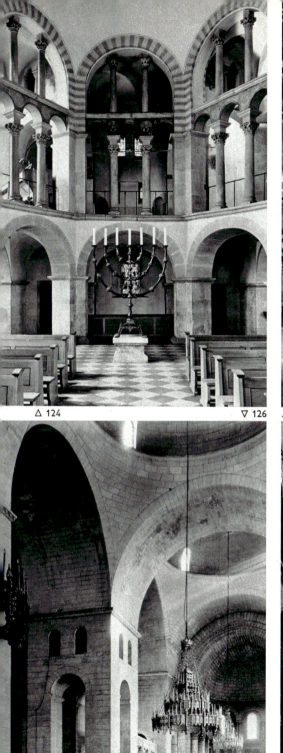

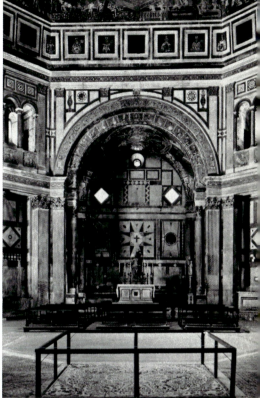

△ 124 ▽ 126 △ 125 ▽ 127

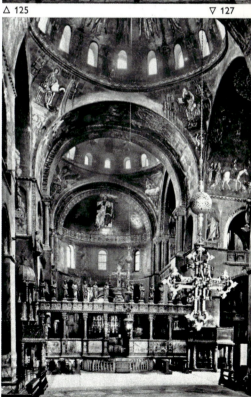

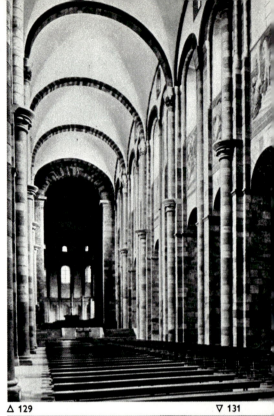

△ 128 ▽ 130 △ 129 ▽ 131

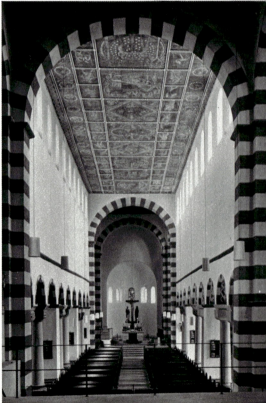

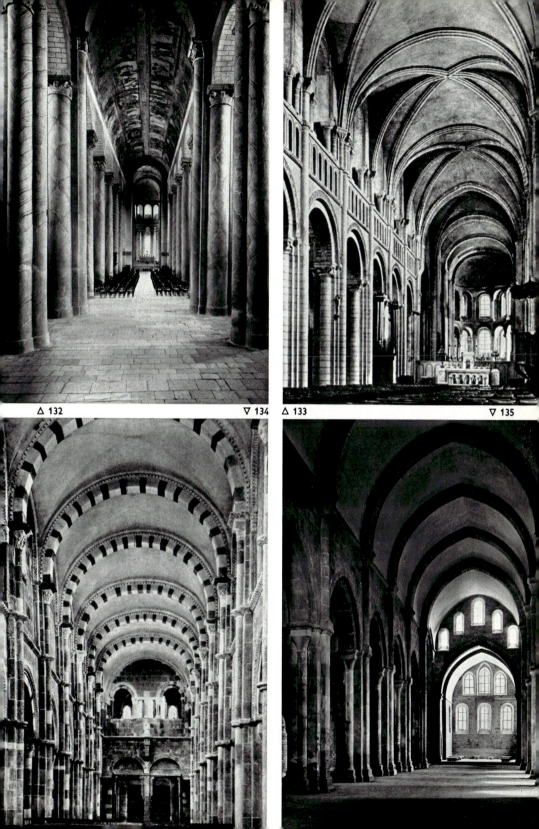

△ 132 ▽ 134 △ 133 ▽ 135

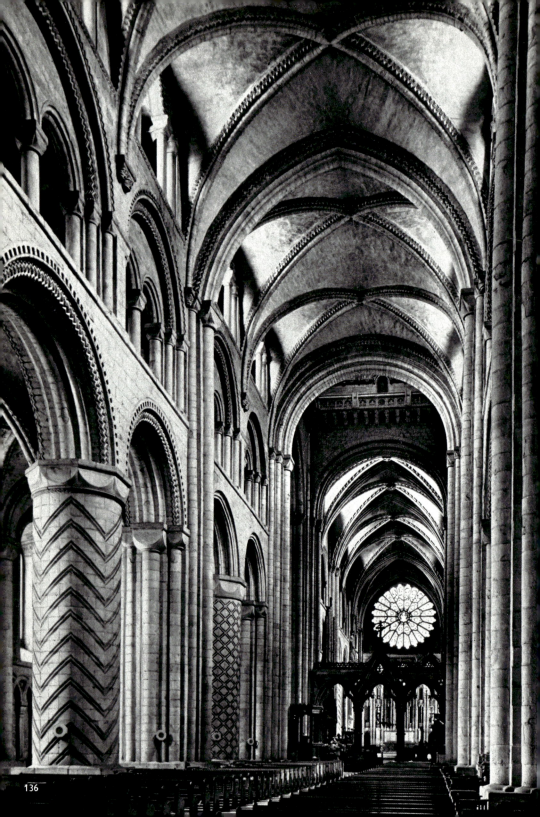

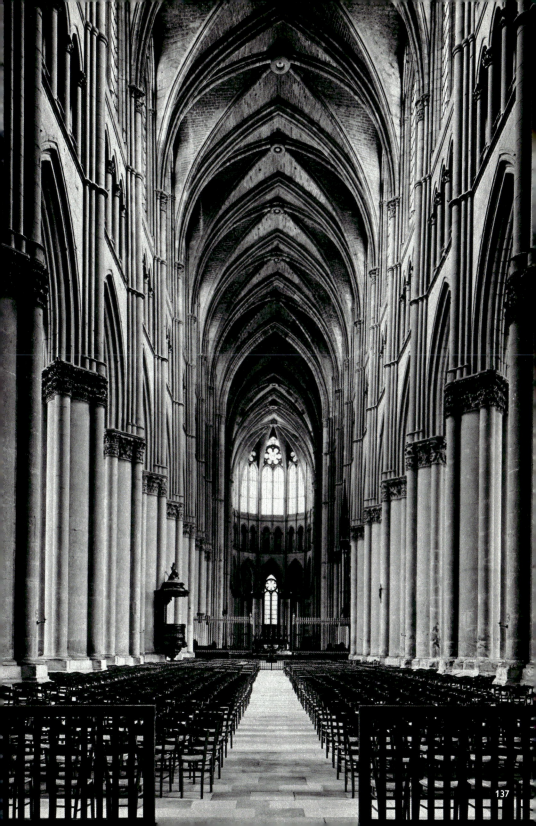

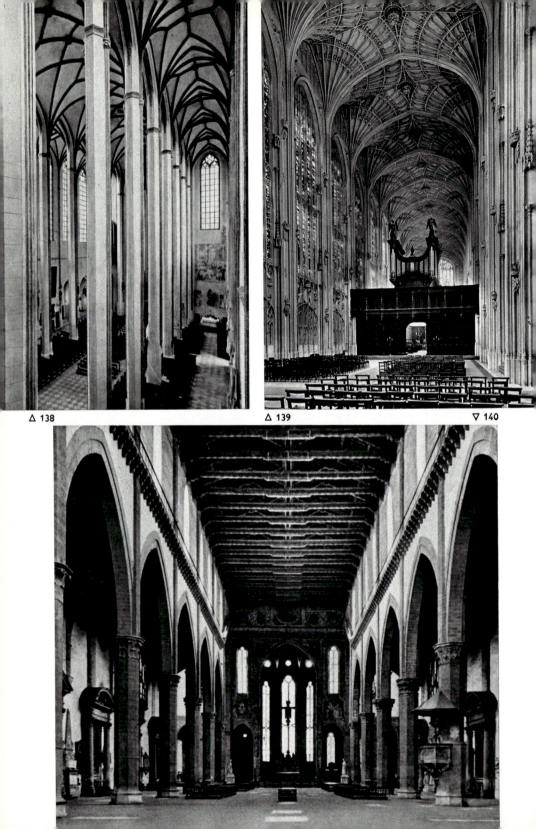

137 RHEIMS CATHEDRAL. East view. 1210–c. 1300.
Sequence of identical spaces marked off by slim,
lofty canopy of grouped pillars and Gothic ribbed
vaulting. Solid walls dissolve in diaphanous detail:
arcaded triforium story and clerestory with
tracery.

138 ST. MARTIN, LANDSHUT. Northeast view. Begun
1387. Hans Stethaimer. Spacious hall; tall, thin
pillars support late Gothic webbed vaulting, which
seems to float above them.

139 KING'S COLLEGE CHAPEL, CAMBRIDGE. East
view. Vaulting, 1446–1528. Long, high, rec-
tangular hall with perpendicular Gothic tracery
windows and roofed with fantastic, decorative fan
vaulting.

140 S. CROCE, FLORENCE. East view. Begun 1294.
Arnolfo di Cambio. Generously proportioned
Tuscan Gothic church; wide arcades, powerful
cornice, and open frame roof emphasize static
quality of broad room. Apse with large windows
and flanking rows of chapels gives impression of
being display façade.

141 ABBEY CHURCH, FONTENAY. Ground plan.
Rectangular shape of choir and flanking chapels
are typically Cistercian Gothic. Basilica-type
building with dimensions based on square of cross-
ing. Clear, mathematical, austere concept
characteristic of this architectural tradition.
(See 135.)

142 ST-PHILIBERT, TOURNUS. Ground plan. Inten-
tional contrast between various building units:
forecourt, basilicalike main body, transept with
apses, and ambulatory choir with rectangular,
radial chapels over crypt. (See 130.)

143 DURHAM CATHEDRAL. Ground plan. Extreme
length typically Norman-English. Nave extends
beyond crossing. (See 136.)

144 RHEIMS CATHEDRAL. Ground plan. Classic
Gothic cathedral with uniform structure: 3 aisles
in nave and transept; 2 bays between transept and
choir. Ambulatory and ring of chapels form spatial
unit. Vault's weight carried on outer buttresses.
Perfectly harmonious proportions. (See 137).

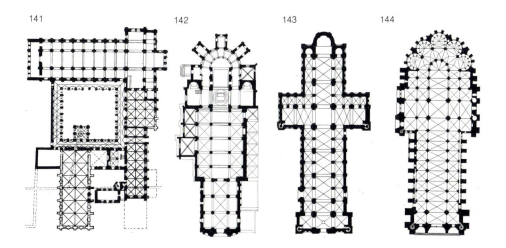

141 142 143 144

ceiling or dome — determine its shape and dimensions, and the way in which the space is di-
vided gives it its formal character. Enclosed space may consist of a single unit, when its floor
plan is based on a simple geometrical form, a rectangle, circle, cross, or square. Most in-
teriors, however, contain a complex of units: a main room or hall may be divided into several
parts by columns or pillars, and the way in which the subdivisions relate to each other has a
decisive effect on the character of the whole interior. This is not only true of the floor plan, but
also of the vertical projection and the proportional relationship of these elements to each

other. The basic formal aspect of interior space and its effect on the beholder can be best expressed in terms of proportions: the relation between length, width, and height, and between intersections or wall space; the relationship of the various parts of the interior to each other, and of all the individual elements to the volume of space as a whole. Whether an interior space gives an impression of quiet harmony or one of restlessness; whether it indicates movement or has a center that draws the attention; whether it can be best experienced by standing still or by walking around; whether it feels like an oppressive cave, a comforting shelter, or a continuous horizontal or vertical flight of rooms — all these variants result, in part, from proportions. To the material factor of proportion is added the immaterial one of light, which gives life to the amorphous body of space and contributes greatly to its character and the quality of its appearance. The effects of light can be manifold and of major importance: light can brighten an interior or shed a subdued glow; it can give all-over brightness or be concentrated on sections of space; it can be diffused or provide color effects or sharp contrasts of light and shade; it can deemphasize or accentuate the importance of walls. Finally, it must not be forgotten that most interiors were designed with color in mind, even those which historical purism has handed down to us in naked stone, as, for instance, Romanesque and Gothic churches. The wide range of basic elements that have contributed — together with the architectural plan — to make works of art of interior space extends from colored stone and marble to painting, mosaics, and sculpture.

The oldest surviving interiors of monumental buildings are those of Egyptian temples. They are syntheses of material and mathematical precision never again attained with such absolute purity: great rectangular blocks, subdivided by angular monolithic pillars; smooth surfaces whose simplicity emphasizes the tremendous weight and massiveness of the stone (116). At a later period, wide, spacious halls with rows of papyrus-shaped columns were added; similar pillared halls of seemingly endless, fluctuating space were also known to Persian architecture.

Greek architects, however, had a completely different concept of interior space: it is always dimensionally limited and does not give the illusion of an infinite expanse; its merits lie rather in architectonic organization. The cella is usually a simple, unpretentious sanctuary for the idol, and only rarely becomes a precious shrine adorned with an inner row of columns (117). Encircling it is a porch supported by columns which, by being somewhat removed from the cella, appears to be a separate hall (118). Interior space, including the articulation of the wall, did not become an artistic problem until Roman days, when it gradually assumed greater significance and often eclipsed the exterior of a building in importance. Distinctions began to be made between types of buildings: temples, law courts, palaces, baths, and villas. Building techniques, dimensions, and designs changed. Ground plans became more intricate: rectangular, circular, and polygonal plans were enlarged by means of crossbeams, exedrae, and niches. Walls, given different articulation and greater importance through combination with column orders and arcades, communicated to the space they enclosed their proportions, rhythms, and artistic character. Greatly improved vaulting techniques contributed to perfect buildings like the Pantheon in Rome — a domed rotunda of mathematical precision and ideal harmony of form. At the same time, cavelike interiors were built, with heavy, coffered vaults resting on short, compact columns (119) or on massive, arched walls. Great halls with several naves —

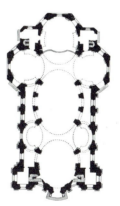

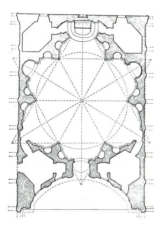

145 S. SPIRITO, FLORENCE. Ground plan. Strict, geometrical cruciform basilica: crossing square repeated in east, south, and north arms, and 4 times in nave; aisles, running around interior walls, consist of squares half the size of crossing square, and one quarter of its size equals radius of chapel niches. (See 150.)

146 S. GIORGIO MAGGIORE, VENICE. Ground plan. Wide, cruciform basilica with 3 bays in front and 1 behind large, domed crossing square. Transept arms end in apses; square chancel with columns opens toward monks' choir. (See 152.)

147 S. IVO DELLA SAPIENZA, ROME. Ground plan. On narrow side of arcaded courtyard by Giacomo della Porta, this star-shaped hexagon, in which concave niches alternate with triangular sections of wall, is integrated into a university building complex. (See 153.)

148 PILGRIMAGE CHURCH, VIERZEHNHEILIGEN, NEAR BAMBERG. Ground plan. Rhythmic, complicated structure. Main aisle consists of 2 ovals and choir of 1 oval. Transept composed of 2 circles joined by oblique pillars and arches. Nave rests on slender supports; aisles are secondary and designed to surround the nave with light. (See 96, 154.)

like basilicas — and with a row of columns either facing the tribune or encircling the inner rectangle, and exedrae emphasizing the transverse axis, were built at the same time as rooms with impressive wall reliefs or heavily ornamented columns *(6, 69)*. Other large halls dispense entirely with architectonic or artistic division of space; their quiet expansiveness is entirely due to their noble proportions and to the horizontal and vertical distribution of rows of windows *(121)*. A basic theme of Roman architecture is the axial arrangement of series of rooms; but while the ordinary Roman house has only small rooms, embellished by wall paintings and ranged around an axis which extended from a semidark atrium to a bright garden peristyle *(120)*, the large baths comprise halls of gigantic proportions, connected by a complicated systems of axes: rooms of continuously varying shape, with barrel, dome, or cross vaulting, and with exedrae and niches, colossal decorated columns, statues, polychrome marble, lighting effects, and surprising vistas *(6)*.

The interiors of Early Christian buildings contrast sharply with those of the richly sensuous Roman era. The generous space of the cruciform basilica is divided into different sections which are all graded in height, width, and degree of lightness, and oriented toward the chancel. No part of this spiritualized, sacred building is significant in itself; even the colonnades and arcades have lost their architectonic function and plasticity and have become secondary; the weightless wall now dominates in its role as source of light and support for mosaic decorations *(122)*. The same principle of hierarchic subordination applies also to the centralized interior, where the light-filled, domed center is surrounded by more dimly lit ambulatories or side chapels. Generally, orientation toward the chancel breaks the artistic unity of composition, and only in the Hagia Sophia in Constantinople is complete harmony of both directional tendencies achieved by channeling the longitudinals of the exedrae into the main axis and leading them back to the domed center. This tremendous building gives an impression of complete weightlessness; arcades and rows of windows lend the marble-faced walls an air of transparency, and the huge, gold-inlaid dome seems to float on an aureole of light *(13, 123)*.

Western buildings of the Middle Ages, however, do not try to deny the weight of matter. Arcaded galleries flanked with columns stand on heavy piers *(124)*; five domed units, forming a cross, are supported by huge pillars whose massiveness is hardly diminished by arcades or archlike openings in the walls *(126, 127)*. Only Tuscan proto-Renaissance architecture achieves structural and optical weightlessness, by arranging columns and pilasters against the walls and thus giving architectonic repose to the octagonal dome *(125)*.

The cruciform basilica with transept, nave, and aisles remains the main theme of Romanesque and Gothic architecture; sometimes, particularly in earlier examples, there is a second choir and a transept on the west side, with a tower or a dome to reinforce and accentuate one or two points of intersection *(14, 141-44)*. The proportional relationship of the various sections to each other and to the walls is responsible for the greatly different character of the interiors of such churches. Many Romanesque churches owe their harmonious proportions to the fact that the square formed by the intersection of nave and transept was taken as module, and all proportions and dimensions derived from it. This system can be interpreted in many different ways: in early Romanesque churches it results in groupings of largely self-contained boxlike units *(14, 131)*; at the height of the Romanesque period the space was segmented by high,

vaulted arches whose unity was emphasized by their solid supports and ribs *(129, 134-36)*. This type of strongly accentuated and molded partitioning corresponds to the massiveness of the stone wall, which is emphasized by the graduated profiles of the arcades, the rows of blind arches, and molded walls. While in those churches the aisles are of secondary importance, despite their wide, rounded arches, in other churches an attempt is made to relate the aisles spatially by erecting very high columned arcades; transverse vaulting gives the structure the appearance of a group of intercommunicating, solid units *(130)*, while tunnel vaulting emphasizes the general orientation toward the altar *(132)*.

Ribbed vaulting made possible new, space-spanning connections between walls, and the walls themselves gained new depth through the use of choir lofts and windowed galleries which, in early attempts, emphasize the quiet solidity of the space they enclose *(133, 136)*. In Gothic cathedrals, however, the law of gravity seems to have been overcome and matter sublimated. Each bay is a weightless canopy and the structural skeleton rises in slim, soaring lines; the walls are like a diaphanous veil, their substance dissolved in the dark shadow of an arcaded triforium and the glowing colors of stained glass windows. The introduction of pointed arches into ribbed vaulting made it possible to build up to a much greater height and allowed the use of transverse arches and ribs of the same height, so that the segments of the canopy are joined in a steady rhythm. Pointed-arch vaulting of all sizes and the integration of separate spaces led to a completely new and infinitely subtle spatial modulation *(137, 144)*. In Late Gothic churches the graduation of space is abandoned in favor of a wide, light-filled hall with delicate ribbed vaulting over very high, slim columns or pillars *(138)*. Particularly in England, the once-solid structural forms were transformed into an intricate network of panels and fantastic fan- or star-vaulting *(139)*. In Italy, however, Gothic lines were quite differently interpreted: a very large, wide space unites nave and aisles; the restful arcades, the quiet horizontal lines of the cornices, the open framework of the roof, the crossing of the transept and the row of small side chapels, give the interior an air of tranquility *(140)*.

In conscious contrast to the irrationality of Gothic architecture, Renaissance buildings and rooms are constructed in accordance with mathematical laws and based on geometrical and stereometrical forms. Walls become, once more, architectonically constructed and intersected surfaces. Ideal laws of proportion, applied in much the same way as those governing the proportions of the human body, systematically relate space and wall organization and the structure of each individual component part. Ground plan and elevation of a cruciform basilica, for instance, are based on the dimensions of one side of the square formed by the intersection of the nave and the transept — an absolutely consistent, ideal system *(145, 150)*. A centralized interior — now the favorite type of interior — is systematically divided according to the golden section; and in order to suggest an ideal cruciform within a rectangular space, wall structure becomes entirely integrated with room structure *(149)*. Subtle rationality and delicate pilaster relief are characteristic of Early Renaissance architecture; later, at the height of the Renaissance, monumentality, pathos, strong accents, and heavy, often massive sculpture take over. The structure of the central section is streamlined into a clear hierarchy of component parts; height and width of the central space find their counterparts in the massive bulk of pillars supporting the dome and in the powerful wall reliefs and generously designed individual

units *(16, 151)*. Soon, however, the balance between these tremendous tensions is broken. The rhythm between contraction and expansion changes, the interrelationship between forms becomes more complicated and conflicts between neighboring forms are sought — as, for instance, between pilasters or columns of different height *(146, 152)*, or between wall and seemingly purposeless, embedded double-columns *(90)*.

These examples, however, show that the walls and the organization of space still adhere to architectonic, static laws. In Baroque architecture, however, walls and rooms are set in motion. By integrating the side niches, a wide, undivided interior is created; walls are alternately convex and concave with each changeover fixed by a pilaster. Walls rise uninterruptedly to the domed roof *(147, 153)*. The height of harmonious, weightless movement was achieved in the late Baroque architecture of southern Germany: oval and circular space alternate, yet their movement can no longer be discerned from the solid walls; only the arrangement of columns and their sharply defined entablatures betray the changes of rhythm. Rising against the light background of the aisles, and contrasting in color with the gallery arches, the columns give the impression of standing free in space supporting the decorated, vaulted ceiling as easily as if it were a tent. Slanting arcades follow the general rhythm, and a web of delicate ornamentation and airy painting is spread across vaulting and structural joints alike *(148, 154)*. The stagelike framing of the high altar through a contraction of the room and the use of decoration is similar to the perspective effects achieved in Italian Baroque interiors. The latter are, however, quite differently organized: the axes of all subsidiary spaces radiate from the octagon of the dome so that the altar, framed by columns and pilasters, is visible from all points; the fact that the side chapels have an ambulatory, and that an independent, domed chancel has been inserted in front of the high altar is noticeable only on walking up to the altar *(155)*.

The interior of a secular building differs from that of a sacred one not so much in formal character as in the disposition of space. The hall of an early Romanesque palace, for example, is a rectangle with open loggias at the narrow sides, but its wall structure and arcades of provincial Roman style and the decorative fluting and medallions, as well as the barrel-vaulted ceiling, resemble 9th-century Spanish church building *(128)*. Communal rooms of Romanesque and Gothic monasteries were designed on the same lines as the interior of churches; these spacious halls, with their star-vaulted ceilings, encouraged the development of the Late Gothic church with its vast, hall-like interior. In many domestic interiors as well as in the interiors of courts and town halls, carved wooden wall and ceiling paneling replaces the heavier stonework. The Mannerists incorporated such paneling into the opulent decoration of long, narrow galleries in French palaces *(156)*. But architectonic handling of wall and ceiling paneling in this type of gallery was only achieved in the later Baroque period *(157)*. In Italian and particularly in German palace architecture, architectural detail, sculpture, ornamentation, and painting combine to produce sometimes opulent, sometimes airily light, playful works of art — just as they do in some of the sacred buildings *(158)*.

After the merging of forms and the interpenetration of spaces during the Baroque period, the late 18th and early 19th century brought a radical change: interiors regain their mathematically calculated shapes and walls their homogeneous consistency; all unnecessary molding and

decoration are discarded. Not all designs are as utopian as Ledoux's spherical house *(53)*; many are based on Classical models, particularly the Pantheon, but now they are interpreted as matter-of-fact, abstract rooms with smooth walls and no articulation other than niches set into the wall at regular intervals *(159)*. Buildings with cell-like units which mirror the pattern made by the façade were erected even before steel construction standardized that procedure (compare *110* and *111*). Art Nouveau, particularly in its ornamental designs, used the elasticity of iron to build bizarre, plantlike indoor supports or the flexible constructions spanning a large area whose direction determines the viewer's impression of a room's shape, letting its true boundaries recede *(160)*. Concrete and steel can stretch over much greater distances and span enormous, transparent interiors with a ceiling of sweeping, imaginative design *(161)*. At the other extreme is a completely different concept of interior space: solid matter hollowed out, with compact yet malleable walls into which openings have been cut in a seemingly haphazard pattern to provide visually effective sources of light *(162)*. The Guggenheim Museum in New York *(163)* is a good example of the freedom with which the contemporary artistic imagination uses today's technical possibilities. Its concrete gallery ramp winding in a wide spiral around the high, hollow center illustrates the gulf that separates this building from the traditional conception of interior space.

149 PAZZI CHAPEL, NEAR S. CROCE, FLORENCE. Northeast view. Rectangular room with square apse whose articulation projects onto walls. Ribbed dome emphasizes hall's centralized character. Walls treated in delicate, clear, pictorial, Classical style. (See 89.)

150 S. SPIRITO, FLORENCE. East view. Begun 1434. Filippo Brunelleschi. Ground plan (145) and elevation, with flat ceiling, central dome, and vaulted aisles, show application of consistent system of ideally harmonious proportions. Relationship of stories 1:1; width of nave to height 1:2. Chapels on both sides repeat arcading of nave with half-columns.

151 ST. PETER'S, ROME. Diagonal view toward center. South transept (1546–64, Michelangelo), nave, (1603–12, Carlo Maderna). Bernini's baldacchino above St. Peter's tomb, 1624–33. Tremendous width and height have structural and aesthetic equivalent in compact massiveness of pillars supporting dome, and in generous proportions of niches set into colossal pilasters of powerful cornices and coffered vaulting. (See 16, 30.)

152 S. GIORGIO MAGGIORE, VENICE. East view. 1566–79. Andrea Palladio. Strong tensions in articulation of pillars and walls, with mighty pilaster and half-column orders and strict rhythm in sequence of narrower and wider spaces and walls. (See 146.)

153 S. IVO DELLA SAPIENZA, ROME. North view. 1642–50. Francesco Borromini. Star-shaped hexagon of ground plan (147) determines conformation of interior up to cupola. Flat, colossal pilasters connect walls' convex-concave swing. Altars, niches, and windows integrated into complicated structural relationships.

154 PILGRIMAGE CHURCH, VIERZEHNHEILIGEN, NEAR BAMBERG. East view. 1743–72. Balthasar Neumann. Perfectly undulating hall: lively, harmonious interior, delicate and light in structure as well as in decor and color. Basic mathematical relationships can be gleaned only from socles and cornice framework. Space widest and light brightest around Gnadenaltar (1763, J.J. Küchel) in foreground. Contraction of space and walls toward main altar adds effect of stage prospect. (See 96, 148.)

155 S. MARIA DELLA SALUTE, VENICE. East view. 1631–56. Baldassare Longhena. Octagonal church with ambulatory and side chapels on axis with center. Colossal half-columns in each of octagon's corners. Main altar in separate, domed space; behind it is rectangular choir.

156 FONTAINEBLEAU PALACE. Gallery of Francis I. 1533–40. Rosso Fiorentino. Long, narrow room with detailed, rich paneling, painting, and stucco sculpture ornament.

157 LOUVRE, PARIS. Galérie d'Apollon. 1663. Charles Le Brun. Every second bay recedes in this strictly geometrical wall articulation. Strong cornice spanned by barrel-vaulted ceiling with sculptured figures and ornaments and painted cartouches.

158 RESIDENCE, WÜRZBURG. Kaisersaal. (Imperial Hall). 1720–41. Balthasar Neumann. Oblong rectangle with high, vaulted ceiling with frescoes by G. B. Tiepolo and stucco work by Antonio Bossi. Decorative exuberance somewhat mitigated by wall articulation with embedded columns and cornice, deepset windows with rounded arches, and niches with statues.

159 DESIGN FOR ROTUNDA, BANK OF ENGLAND. LONDON. 1788. John Soane. Smooth, even planes with delicate profile and ribs link wall and dome.

160 THEATER, COMMUNITY CENTER, BRUSSELS. 1897. Victor Horta. Supporting iron skeleton shaped into ornamental, room-spanning device, behind which theater's true boundaries recede.

161 STAZIONE TERMINI, ROME. Ticket Hall. 1947–51. Eugenio Montuori and others. Dominating inside as well as outside, roof's seemingly weightless double curve pierces transparent walls. Transformation of construction's weight into aesthetically ideal curve.

162 NOTRE-DAME-DU-HAUT, RONCHAMP. 1950–55. Le Corbusier. Interior interpreted as hollowed-out form of massive, abstract sculpture. Irregular ground plan, height, inclination, and curvature of walls and ceiling.

163 SOLOMON R. GUGGENHEIM MUSEUM, NEW YORK. 1947–59. Frank Lloyd Wright. Gallery ramp's massive spiral winds upward around large, hollow center.

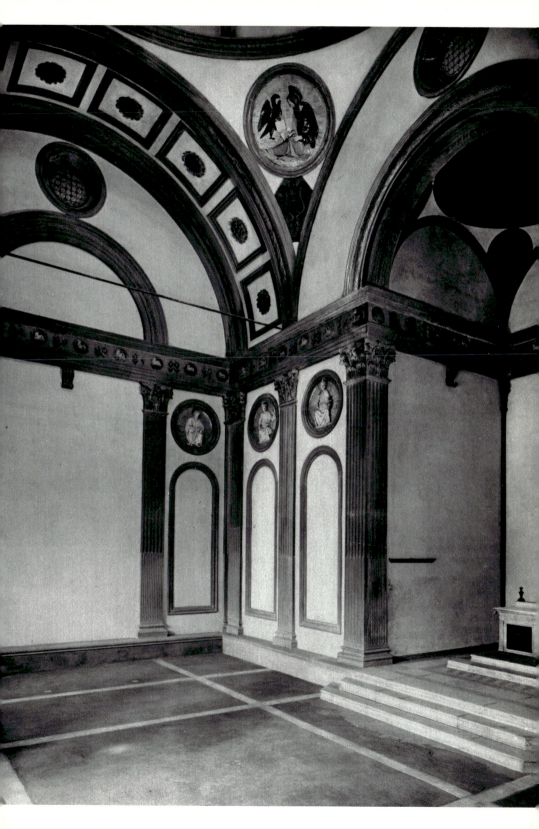

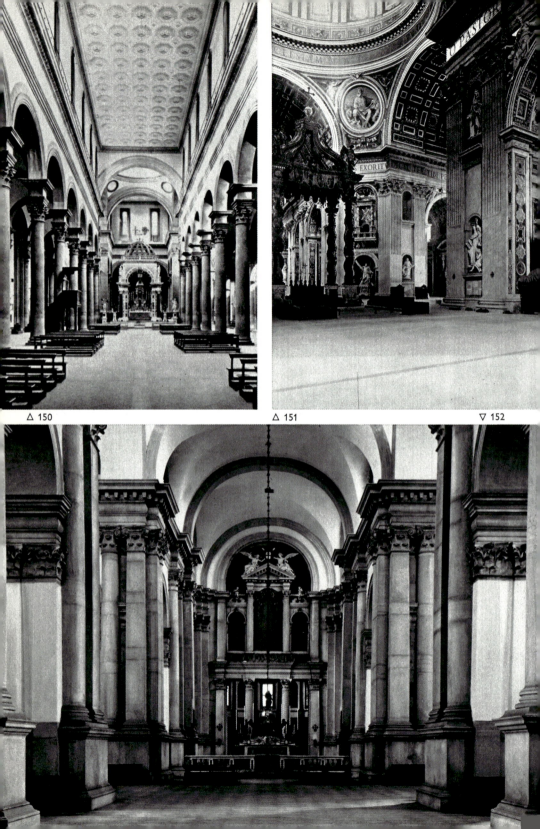

△ 150 △ 151 ▽ 152

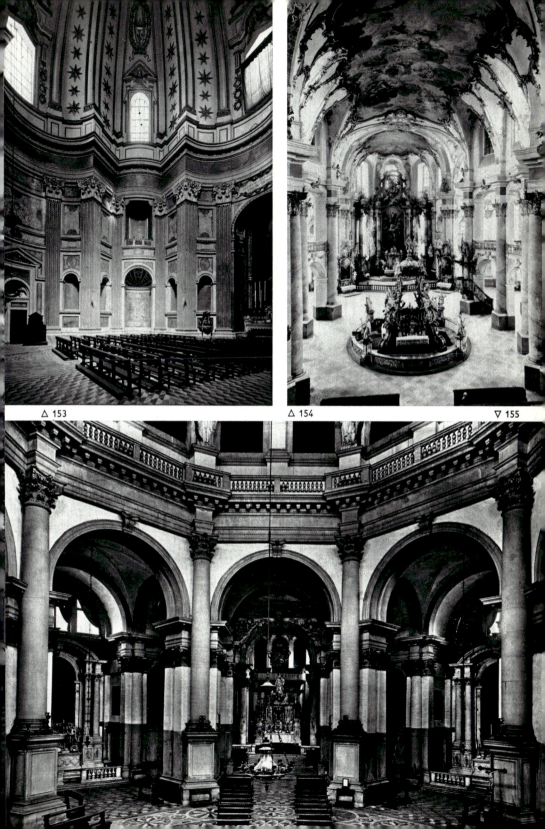

△ 153 △ 154 ▽ 155

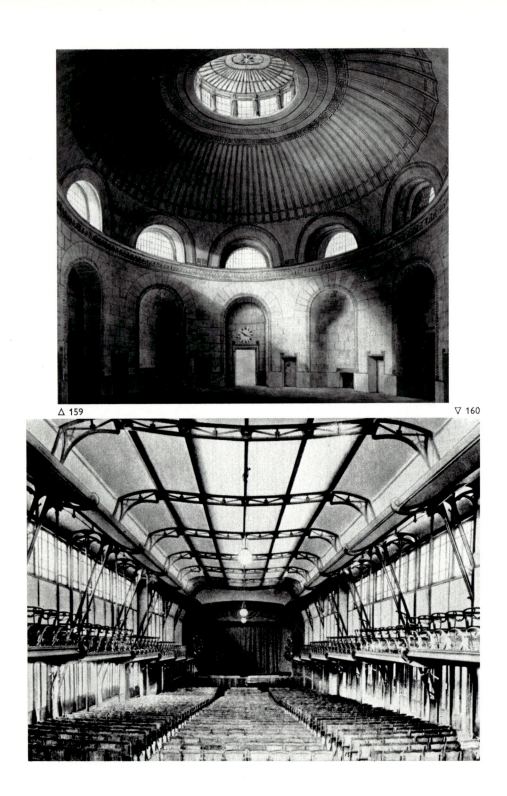

△ 159

▽ 160

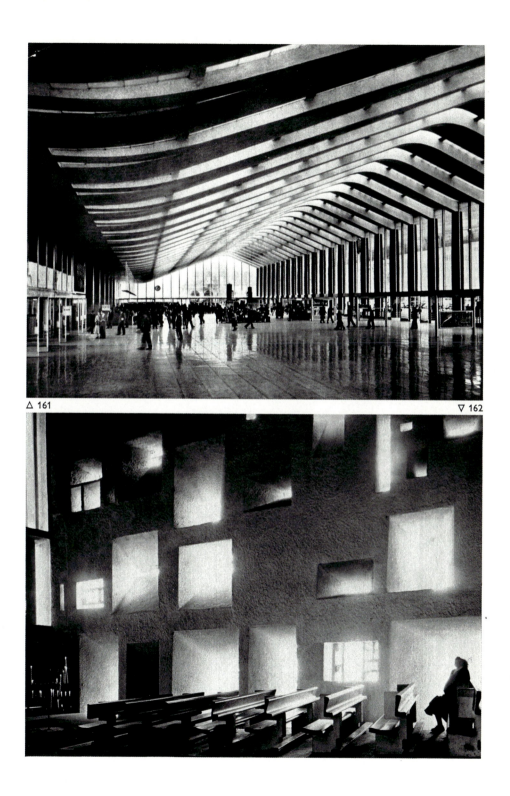

△ 161

▽ 162

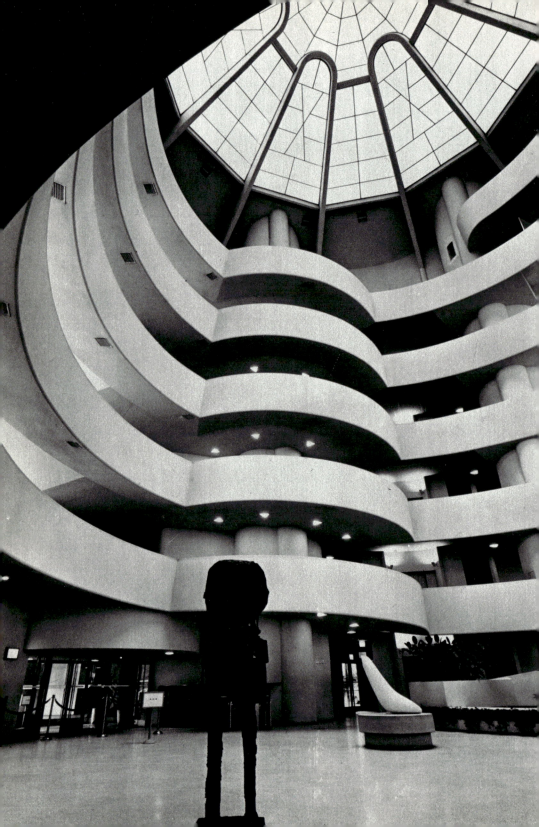

SCULPTURE: THE STATUE

The statue has traditionally been a representation of man himself. No other art form appeals so directly to man's instinctive awareness of his own physical form and to the visual and tactile experience of the human form. Even when a statue does not portray an identifiable image and shows only a few symbolic features of man, or when radical abstraction dispenses with all outward likeness, certain characteristic elements remain, which awaken associations: the statue's physical presence within a given space, its upright position, and suggested movements such as stepping forward, rising, falling, reaching, or embracing. These are the basic characteristics of a statue, irrespective of its artistic shape, its iconographic meaning, or its spiritual and emotional content. These specific traits, together with the special relationship between statue and beholder, have deeply influenced the history of sculpture. A statue might be a representative of a person or an idea portrayed: a king, a god, a dead person, a hero. It guarantees the permanent presence of a king or a god and the continued existence of the dead. A magic bond exists not only between the statue and the person or idea it expresses, but also between the statue and the beholder, who either pays homage or rejects what it represents: the statue of a deposed ruler falls with the man it portrays. This was true in the magic-oriented past as much as during modern revolutions. In ancient cultures and in Classical antiquity statues had great significance: they served the cult of gods and kings; were given to the dead at burial; and were erected to the memory of heroes and men and women who had achieved greatness. Only religions that reject any tangible concept of their deity — Judaism, early Christianity, and Islam — also reject the graven image, the artistic representation of God. In the Middle Ages, Christianity restored the statue's importance, but it never again became an idol in the strict sense of the word.

A statue is a three-dimensional body, but few epochs meant their statues to be viewed from all sides. They are often integrated into the fabric of a building, for example, in portals of Romanesque or Gothic churches. But even when a statue is not actually built into another, larger unit, it is usually made to fit into its environment in such a way that it can only be viewed from one, or, at best, from a few angles — for instance, the idol in the cella of a temple and statues in niches, or on pedestals or columns, oriented toward a square or a street. A person looking at such a statue will experience it as a complete work even if certain physical details are not actually visible, or even executed, as is frequently the case.

A statue's formal appearance is, of course, greatly influenced by the material from which it is made. A form hewn out of massive stone will look much more solid and corporeal than a figure cast in metal the smooth surface of which softly reflects the play of light; marble left rough will have a harder, coarser look than polished marble with its fine, expressive, lifelike veins; sandstone and stucco lack the sensuous, warm glow of wood. The characteristics of a given material are often blurred or changed by painting, but whatever material is chosen, it is only one factor in the artist's creative act.

The origins of the standing figure can be found in the small magical idols fashioned in prehistoric times and in primitive cultures of almost every period *(165)*. With their archetypal simplification and emphasis on specific parts of the body, they are not images but rather sym-

bols of the human form. Monumentalized and erected for worship, they become statues, and the anonymous, abstract versions gradually evolve into more physical images of individual human beings. A tendency toward representation is already apparent in the Mesopotamian "praying" figures *(164)*.

In the Old Kingdom of Egypt, the statue gained individual character with its naturalism and its emphasis on personal traits *(166)*. The stereometric basic form, however, remained valid for many more centuries: as a cylinder in Mesopotamia, or as a square block in the Nile Valley. In both cases the strictly frontal approach remained obligatory, or at best, a pure profile was offered.

The concept of the statue in Western civilization derived from Greek art. The Greeks succeeded in shaping a perfect likeness of the human body out of stone or metal, distributed proportions and weight correctly, indicated the play of the muscles beneath the surface, and made the face a mirror for emotions *(167)*. When at the height of the Classical period the statue was completely freed from the rigid block of material from which it was made, it took on life and movement, and the ideal of the three-dimensional statue had been fully achieved *(168)*. Later, in Hellenistic art, the strict rules of proportion and the smooth surface texture of the Classical statue give way to more dynamic effects through an exaggeration of subjective features and an often violent expression of emotion, action, and movement.

Italic Roman art modified the concept of the Greek statue by giving primary importance to the idea embodied. The Republican orator *(169)* in its contained form represents the quiet effectiveness of sober argument; the deified emperor *(170)* follows Classical models with his victorious pose and richly decorated and perfectly carved appearance. A later ruler *(171)* demonstrates his power not only in solid massiveness, but also in an almost stereometric simplification of the different parts of the body, all of which enhance his magical power. Again the aspect is strictly frontal. The figure is constructed for visual effect and no longer gives the impression of a living, moving body.

Linear figures confined within a solid block continue in the few monumental statues that have come down from the time of Charlemagne *(172)*. The stucco figures, pressed flat against the wall, seem inspired by rows of painted saints rather than by three-dimensional, living and moving human bodies. In the later Middle Ages, the free-standing figure disappears almost completely and statues become subjected to architecture, posed as columnal figures against French cathedrals *(173)* or standing in niches in Italy *(174)*. The slender proportions of Gothic statues, with their willowy, weightless bodies, which seem to be floating rather than standing, give them a visionary character; this quality of ethereal weightlessness does not change when, at a later period, rich draperies, modeled on Classical examples, are added *(176)*. The reinterpretation of Classical draperies merely give a flowing movement to the body, curving around the vertical axis without sacrificing the figure's structural stability. The elegant fall of the folds dominates the figure's outward appearance *(175)*, and in Late Gothic examples draperies take on a decorative painterly, three-dimensional, and unorganic life of their own *(178)*. In contrast to the Gothic style north of the Alps, the Italian statue retains the more solid, anatomically correct physical proportions of Classical antiquity *(174, 177)*.

Scientific preoccupation with Classical antiquity and with the anatomical structure of the

human body encouraged a rebirth of the freestanding, independent, sculptured figure during the Renaissance. The naturalistic differentiation of the various parts of the human body is offset by strictly applied rules of proportion and a smooth, uniform surface, so that statues become idealized copies of nature *(179)*. While the Renaissance statue dominates its environment through volume, Mannerism tried to establish a relationship between a piece of sculpture and its surroundings. An elongated figure may twist into space in a complicated movement so that its torsion can only be gauged by walking around it *(180)*. Compared with such free figures of extreme lightness or extreme massiveness, the Baroque statue appears more disciplined and more organic, without, however, sacrificing movement. The drama and tension expressed by a figure's action is also reflected in every detail; the surface is dissolved into mobility and the strong contrasts of light and shade *(181)* give the statue a painterly character, which is even retained in less mobile figures — those, for instance, made for niches, façades, and gables *(182)*. Rococo sculpture tends to exaggerate preciousness and endows even a monumental figure with playful lightness *(184)*. Such tactile qualities, such mannered movement, sensuous surface appeal, and narrative detail are succeeded by the ceremonial seriousness of Neoclassicism, which adheres strictly to the themes and proportions of Classical

164 STATUETTE FROM UR. 2600–2300 B.C. Alabaster. Height 44 cm. Staatliche Museen, Berlin. Eyes were inset with colored material, thus giving lifelike effect, despite cylindrical stiff skirt.

165 FEMALE IDOL. 2300–2000 B.C. Marble. Height 23.5 cm. From Kumasa, Crete. Iraklion Museum. Symbol of fertility, figure was placed in tomb to accompany dead. Almost abstract simplification with graphic details.

166 VILLAGE OFFICIAL. c. 2440 B.C. Wood, originally covered with stucco and painted. Height 1.1 meters. From Saqqara. National Museum, Cairo. Realistic portrait maintains traditional Egyptian frontal approach with rigid axes.

167 YOUTH FROM ANARYSAS (Attica). "Kroisos Kouros." c. 530–520 B.C. Parian marble. Height 1.94 meters. National Museum, Athens. Stiff, frontal approach enlivened by arms drawn slightly away from body and heels raised from ground. Body's heavy plasticity softened by delicate muscle play and vibrant surface texture.

168 PRAXITELES, HERMES WITH DIONYSOS. c. 340 B.C. Parian marble. Height 2.15 meters. Olympia Museum. Roman copy of Greek original, or original remodeled by Roman artist. Idealistic conception of idyllic, intimate scene. New harmonious, free movement of relaxed body.

169 AULUS METELLIUS, THE ORATOR. Last quarter of 1st century B.C. Bronze. Height 1.7 meters.
Museo Archeologico, Florence. Etruscan-Roman work with expressive portrait head; plain body held in simple pose of orator.

170 EMPEROR AUGUSTUS, FROM PRIMA PORTA, NORTH OF ROME. c. 14. Marble. Height 2.04 meters. Modeled on Polykleitos's *Doryphoros*. Musei Vaticani, Rome. Political program expressed in relief of breastplate: Peaceful reign over the whole world. Technically perfect, but cool, impersonal representation.

171 ROMAN EMPEROR. First half of the 5th century. Bronze. Height 5.11 meters. S. Sepolcro, Barletta. Legs and forearms restored. Blocklike simplification of body; flat, geometrically distributed relief; designed to be seen from distance. Reflects trend away from Classical toward more abstract medieval conception of sculpture.

172 THREE SAINTS. End of 8th century. Stucco. Height 2.3 meters. S. Maria in Valle, Cividale. Figures extremely elongated and organically unarticulated; carved surface design superimposed on nucleus of rather amorphous bodies.

173 OLD TESTAMENT KINGS. c. 1140. Sandstone. Chartres Cathedral, center portal, right section. Integrated into cathedral's architecture, figures' cylindrical shape determined by columns from which they protrude.

174 BENEDETTO ANTELAMI, DAVID. 1184–96. Cathedral, Borgo S. Donnino, west façade.

Freestanding sculpture in niche represents return to antique ponderation of figure, but still blocklike form of body, and delicate, graphic surface treatment.

175 ADORATION OF THE MAGI (detail). c. 1380. Sandstone. Maria am Gestade, Vienna. Soft movement flowing around axes of body and quiet elegance of contours.

176 VIRGIN MARY OF THE VISITATION. c. 1240. Bamberg Cathedral. Follows Classical models in the contrapposto and handling of drapery; Gothic lightness about almost floating balance created by effects of light and shade on lively relief of folds.

177 DONATELLO, "POGGIO BRACCIOLINI." 1415–20. Marble. From the Campanile. Museo dell'Opera del Duomo, Florence. Emphatic contrapposto and heavy drapery provide natural, organic, firm stance.

178 VEIT STOSS, ST. ANDREW. c. 1500. Wood. Height c. 2 meters. St. Sebald, Nuremberg. Body contours disappear beneath ample, free-moving folds of drapery, whose sculptural plasticity dissolves into optical, painterly effects.

179 MICHELANGELO, DAVID. 1501–4. Marble. Height 4.1 meters. Accademia, Florence. Return to complete autonomy of freestanding sculpture. Perfect balance between Classical influence and study from nature. Combines realism and idealism, strength and elegance.

180 GIOVANNI DA BOLOGNA, MERCURY. 1580. Bronze. Height 1.87 meters. Museo Nazionale, Florence. Achieving apparent suspension of gravity was feat of technical virtuosity. Body's torsion integrates figure and space.

181 GIANLORENZO BERNINI, DAVID. 1623. Marble. Height 1.7 meters. Galleria Borghese, Rome. Intended to be seen from several angles. Movements projected into space without sacrifice of static balance. Richly sculptured surface provokes lively play of light and shade.

182 FRANÇOIS DUQUESNOY, S. SUSANNA. 1629–33. Marble. S. Maria di Loreto, Rome. Statuesque tranquility achieved by balance of contrasting body movements and flow of drapery. Niche serves as shadow background.

183 BERTEL THORVALDSEN, HEBE. 1806. Marble. Height 1.5 meters. Thorvaldsen Museum, Copenhagen. Academic Neoclassicism: impersonal coolness, smoothness, and symmetry.

184 IGNAZ GÜNTHER, ST. KUNIGUNDE. 1762.

Wood. Height 2.3 meters. Benedictine monastery, Rott-am-Inn. Playful lightness despite monumental proportions; richly decorated surface with tactile appeal.

185 AUGUSTE RODIN, THE AGE OF BRONZE. 1876. Bronze. Height 1.75 meters. Musée Rodin, Paris. Realistic, individual effect achieved by soft, subjective surface modeling.

186 EDGAR DEGAS, LITTLE DANCER. 1880. Bronze and cloth. Height 99 cm. Posthumous cast from original model made of wax, dress material, and hair. Ny Carlsberg Glyptotek, Copenhagen. Momentary pose is held; use of unconventional materials emphasizes objectivity.

187 ARISTIDE MAILLOL, POMONA. 1907–10. Bronze. Height 1.61 meters. Louvre, Paris. Voluminous body has cubic compactness and dominates surroundings. Structurally pure, generous contours.

188 ALEXANDER ARCHIPENKO, WOMAN STANDING. 1920. Artificial stone. Height 1.8 meters. Hessisches Landesmuseum, Darmstadt. Analogous to works of analytical cubism in construction out of geometric units, and in interrelationship between positive and negative form; latter provides opening into space.

189 HENRY MOORE, STANDING FIGURE. 1950. Bronze. Height 2.21 meters. Private collection. Skeleton forms confine space, which is integrated into sculpture.

190 HENRI LAURENS, LITTLE AMPHION. 1937. Bronze. Height 50 cm. Galérie Louise Leiris, Paris. Mythical lyre player assumes shape of his instrument in lithe, organic movement. Differentiated outer and inner contours.

191 ALBERTO GIACOMETTI, THE CHARIOT. 1951. Bronze. Height 1.63 meters. Galerie Maeght, Paris. Figure elongated to point where it becomes weightless line.

192 GEORGE SEGAL, SIDNEY JANIS WITH MONDRIAN COMPOSITION OF 1933. 1967. Plaster cast. Life size. Museum of Modern Art, New York. Plaster's amorphousness gives ghostly quality to ostensible objectivity and substantiality of commonplace, momentary gesture.

193 FRITZ WOTRUBA, WOMAN STANDING. 1958/59. Stone. Height 1.92 meters. Collection of the artist, Vienna. Archaic, primeval concept of upright, standing figure, expressed in heavy, unpolished stone with angular, cubic forms.

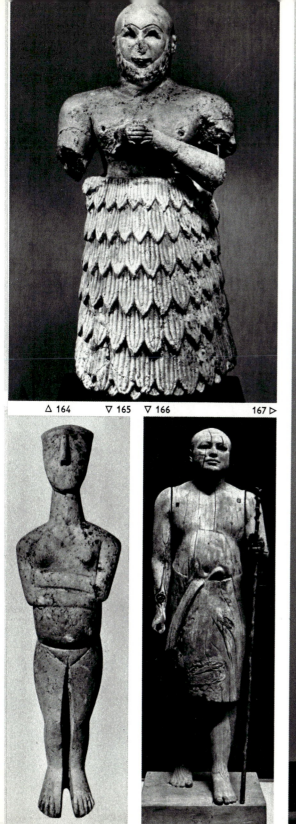

△ 164 ▽ 165 ▽ 166 167 ▷

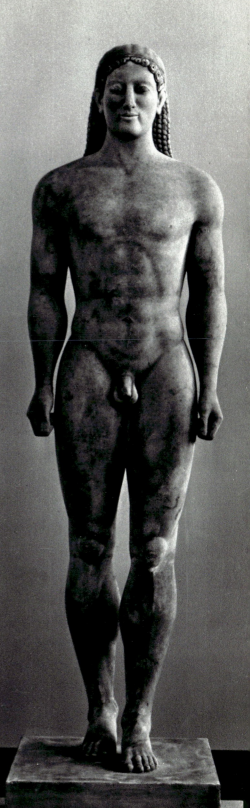

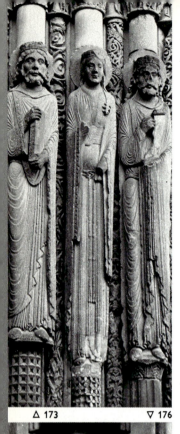
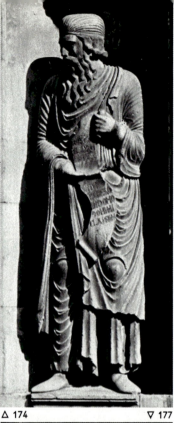
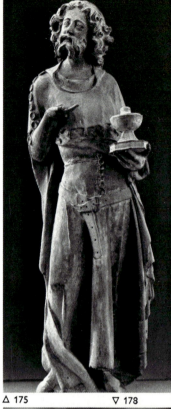

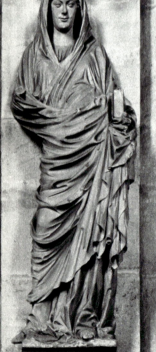
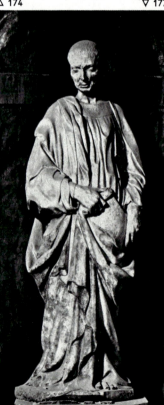

△ 173 ▽ 176 △ 174 ▽ 177 △ 175 ▽ 178

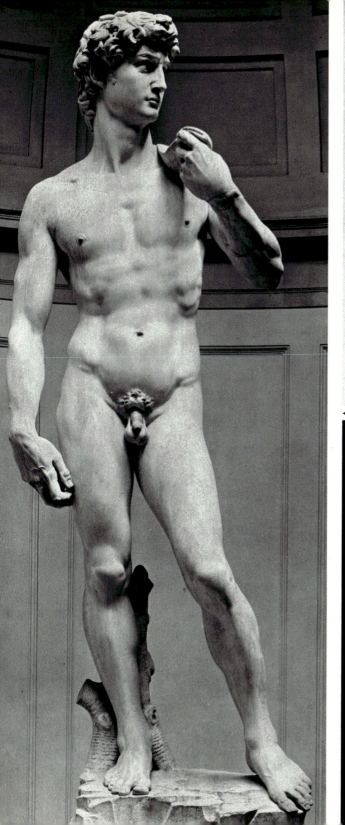

◁ 179 △ 180 ▽ 181

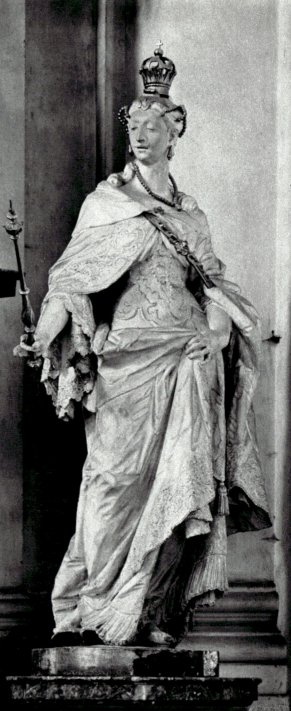

△ 182 ▽ 183 184 ▷

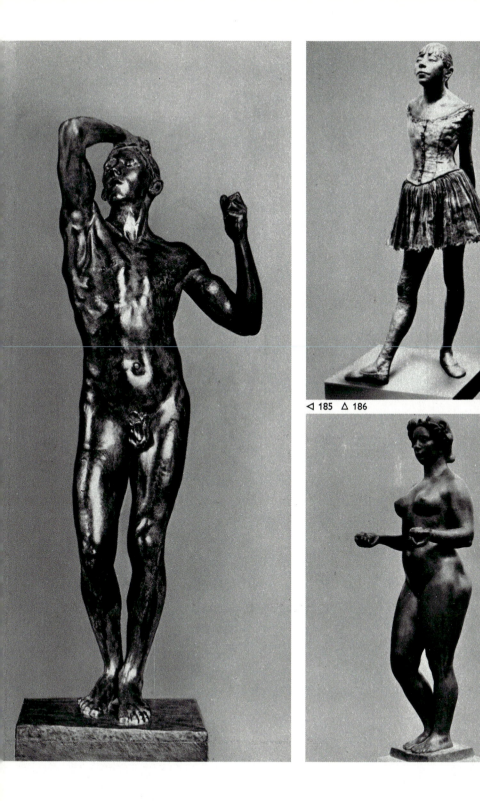

◁ 185 △ 186 ▽ 187

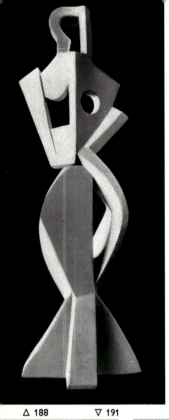
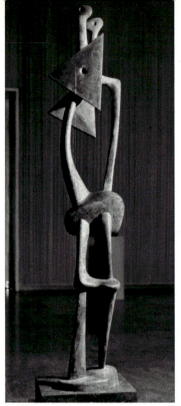
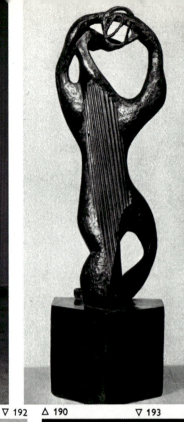

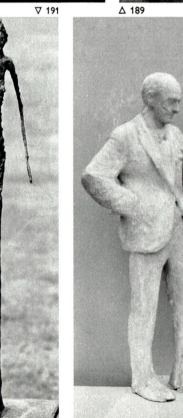
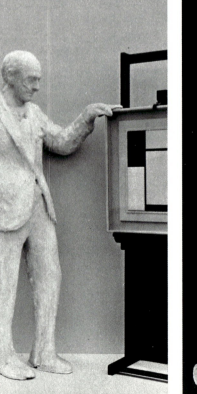

△ 188 ▽ 191 △ 189 ▽ 192 △ 190 ▽ 193

antiquity. But such imitative preoccupation with idealized Classical models produced only carefully polished figures of cool, impersonal character *(183)*.

In the second half of the 19th century, sculptors again sought direct contact with the natural appearance of the human figure and, at the same time, borrowed the forms of historical styles. Subjective surface treatment of emphatically realistic figures achieved a painterly, lifelike effect *(185)*, sometimes heightened by the addition of naturalistic detail *(186)*. The reaction to this visually oriented sculpture during the first decades of the 20th century has been to reemphasize volume. The human form appears again in all its physical heaviness and turns again into a tactile experience *(187)*. The 20th century added a new dimension to the art of sculpture, which had until then been limited to the figure and its effect on surrounding space. Now, instead of the figure intruding into space, space intrudes into the figure and creates negative forms. Sculpture turns from the portrayal of nature to symbolism *(189)*, abstract constructions *(188)*, and vegetative formulation *(190)*. The possibilities of modern statues extend from complete negation of matter, which evokes through linear qualities an emotional withdrawal from all physical substance *(191)*, through architectonically constructed forms *(193)*, to the provocative banality of a plaster cast *(192)*. Finally, the use of new materials at an artist's disposal and unfamiliar juxtapositions of found objects make possible a variety of forms, ideas, and aesthetic values in the creation of the freestanding sculpture unknown in any previous era.

RELIEF

Relief is related to sculpture because it is tangible and three-dimensional, but being visually and materially embedded in its background, it lacks the independence of freestanding sculpture and cannot be viewed from several sides. In high relief individual figures are sometimes entirely detached from their background, although visually they remain attached to it.

Being dependent on a background, relief shares characteristics with painting and drawing, but only in a limited sense, as conditions differ greatly: color differentiation and the illusion of space through light and atmospheric perspective, and of bodies moving within that space, cannot be achieved in relief. Paintings and reliefs resemble each other closely in that both present pictorial, compositional units, enclosed in a frame. Like a painted picture, a free standing relief which is not part of a building or of any other object is an autonomous work of art.

The themes of reliefs and paintings have many similarities and, in theory at least, the iconographical representations in paintings are equally suitable for reliefs; but in practice, themes from sculpture, which is to say the human figure and groups of figures, dominate in relief art. Except at certain times, there are almost no reliefs in which human figures are associated with landscapes and still lifes. Non-objective compositions, on the other hand, are being increasingly executed in relief by modern artists, as the traditional art forms and media merge more and more.

Generally speaking, two differently oriented formal concepts of relief art exist: "pure relief," which is closer to sculpture in that it emphasizes the plasticity of figures and dispenses with illusionary effects of perspective without denying its dependence on the background, and "painterly relief," which resembles painting by making use of contrasts of light and shade and thus visually "dissolving" the solid forms. Pictorial relief takes on the same themes as painting and uses linear means in depicting space; it also uses — apart from a central perspective — a "figural perspective": plasticity is most pronounced in foreground detail, while figures and objects become progressively flatter and more linear as they recede into the background. Preference for one or the other of these two has varied considerably during different periods in the history of art and reflects clearly the general preference of an epoch or region for a more tactile or more painterly style.

It is unimportant in this context whether a relief is carved out of a basic block of material or built up onto a base. Choice of technique will largely depend on the artist's material: stone, wood, and ivory are used in the subtractive method; clay, plaster, and the resulting bronze cast for an additive method.

The material, in turn, is mainly determined by the place the relief is to occupy. In contrast to sculpture, relief is always attached to its background. But in addition and more so than painting, relief is also in most cases part of a larger unit: it may decorate the inside or outside of a building, or a throne, a door, a piece of furniture, or a vessel. Material and technique are therefore largely prescribed in advance by whatever purpose a relief is to fulfill — in other words, on the background against which it will appear.

Reliefs of ancient Egypt *(194)* are so closely related to painting that they seem like flat pictures. The subjects and their accompanying inscriptions have the same formal value and

are embedded in their material base simply for greater clarity and durability. This close relationship to painting also explains Egyptian inverse reliefs, which are sunk into the surface instead of being embossed upon it *(en creux* or *cavorilievo).* Also, the negative relief (intaglio) appears in the New Kingdom but in other civilizations is known only in stone or gem cutting.

Reliefs of Mediterranean *(196)* and Mesopotamian *(195)* cultures, on the other hand, are based on a more sculptural concept in which the figures stand out sharply from a neutral background. In Minoan reliefs this leads to great movement, soft, curving lines, avoidance of empty spaces, which result in tightly packed imagery covering the whole of the surface. The same concept applied to Assyrian reliefs *(195)* results in a strictly hieratical ordering of rows of isolated figures.

Early Greek reliefs *(197)*, with their rigorously geometrical structure, show a closer relationship to vase paintings, while the style of Late Classical reliefs *(198)* is inspired by sculpture and has great plasticity. Artists of later epochs have again and again drawn inspiration from such examples of harmonious composition, perfect proportions, and balanced relationship between figure and background.

In Hellenistic work, Classical balance gives way to exaggeration: agitated figures, admirable in the technical perfection of their naturalistic detail, become common. The fact that the figures project strongly from their background, their deeply molded shapes and opulent garments throwing dark shadows, negates the connecting background and dissolves the visual unity of the composition *(199).* Despite or perhaps because of their exaggerated plasticity, these reliefs give an overall painterly impression that is characteristic also of representations of more subdued content and formal expression *(200).*

The first conscious regression to the strict relief style of Classical Greek art was made in the Augustan era around the time of the birth of Christ *(201).* But in contrast to the original models, these reliefs indicate great reluctance to leave empty spaces. Figures are arranged in

194 HIPPOPOTAMUS HUNT. c. 2400 B.C. (5th Dynasty). Painted limestone. Tomb of Ti, Saqqara. Flat bas-relief with very little plasticity. Drawing emphasized through indentation of background—stylized picture of riverbed and papyrus reeds, ornamentally filled with naturalistically drawn animals and fish. Haphazard proportions; little overlapping; several surface layers; no indication of space.

195 OBELISK OF SHALMANESER III. 830 B.C. Upper portion (detail). Assyrian bas-relief. Black alabaster. Width 48 cm. British Museum, London. Narrative strip: against neutral background, flat, isolated figures stand out; rounded contours.

196 HARVESTERS' VASE, FROM THE PALACE OF HAGIA TRIADA (Crete). Late Minoan, 1550–1500 B.C. Black steatite. Maximum diameter 11.5 cm. Iraklion Museum. Projecting bas-relief. Obliquely graded overlapping of figures

achieves depth, but no representation of space. Background ornamented with sheaves and tools.

197 THE TROJAN HORSE. Relief on the neck of an amphora. Cycladic, c. 670 B.C. Clay. Width 38 cm; height of amphora 134 cm. Mycenae Museum. Graphic relief in frame. Certain details emphasized by being projected from neutral background.

198 TOMB OF MNESARETE. Attic, c. 380 B.C. Marble. Height 163.5 cm. Glyptothek, Munich. Resting in pose of idealized tranquility, figures set in high relief in front of flat architectural detail. Clearly related to space, despite material attachment to surface.

199 NEREUS AND DORIS IN BATTLE AGAINST THE TITANS. c. 180–160 B.C. Altar of Zeus from Pergamon. Northern staircase wall of west side. Marble. Height 2.3 meters. Staatliche Museen. Berlin. Figures modeled in such high relief that

they are almost freestanding sculptures. Staircase used as basis for action, thus blending sculptural scene and reality. Exaggerated movements and modeling. Shadowy depths give pictorial effect. (See 8.)

200 POSEIDON AND AMPHITRITE IN THE NUPTIAL CHARIOT. 115–100 B.C. Domitius Ahenobarbus Altar. Narrow side (detail). Pentelic marble. Height 78 cm. Possibly from Asia Minor workshop. Glyptothek, Munich. Slanting position and differentiated modeling of foreground figures against bas-relief background give illusion of space. Soft modeling on surface planes. Shell horn has erroneously replaced original double flute.

201 SACRIFICIAL PROCESSION. 13–9 B.C. Frieze from the Altar of Augustus ("Ara Pacis"). Marble. Height 1.55 meters. Lungotevere in Augusta, Rome. 2 layers of figures, differing in plasticity, so tightly crowded that little remaining neutral ground cannot impart feeling of space. Severe ideality and delicate, if rigid, surface treatment lean deliberately toward Classical Greek style.

202 SARCOPHAGUS OF HOSTILIUS ("LUDOVISI BATTLE SARCOPHAGUS"). 251. Marble. Height 1.53 meters. Museo Nazionale Romano, Rome. Principal figure, larger and more 3-dimensional, floats above tightly packed battle scene. Overlapping of warriors meant to convey depth. Modeling of limbs creates strong contrasts of light and shade.

203 THEODOSIUS I AND VALENTINIAN II RECEIVING PERSIAN TRIBUTE. Base relief on Obelisk of Theodosius. c. 390. Marble. Height 2.4 meters. Former Hippodrome, Istanbul. Block's dominance emphasized by strict, symmetrical, frontal figure arrangement, indicating representation rather than narration. Details carved into compact masses of bodies rather than worked out of them into sculptured shapes.

204 ANASTASIUS OR JUSTINIAN AS TRIUMPHATOR ("BARBERINI DIPTYCH"). Early 6th century. Ivory. Height 34.1 cm. Louvre, Paris. Middle section projects into space and beyond frame. Marks return to Classical antiquity's understanding of body and space, but with greater consideration for relationships of surface planes.

205 VIRGIN MARY WITH JOHN THE BAPTIST AND ZACHARIAH. c. 810. Back cover of the Lorsch Evangeliary. Ivory. Height 38.5 cm. Victoria and Albert Museum, London. Bas-relief with linear design used to project plasticity. Perspective indicated in slanted side panels and in buildings in nativity scene. Revival of Classical influence by intermediary of Early Christian-Byzantine reliefs, yet closer relationship to contemporary book illustration.

206 NOLI ME TANGERE (detail). Before 1015. Bronze. Hildesheim Cathedral. Figures of strong plasticity projecting from plain background contrast with flat design of architectural components. Composition concentrates on expressive interrelationship of protagonists. Disposition of subjects simple and without spatial effects.

207 LAST JUDGMENT. c. 1130. Autun Cathedral, tympanum of main portal. Bandlike sections dominated by Christ's outsized figure. Individual figures against neutral background carved to same depth; hence, plasticity increases with decrease in size. Spatial depth indicated by graduation of figures.

208 LAST JUDGMENT. 1225–36. Amiens Cathedral, tympanum of portal of west façade (detail). Figures sculpted almost in round. Relief framed by architectural detail. Almost equal size of figures in each section independent of their importance. Background recedes in deep shadows.

209 NICCOLÒ PISANO, BIRTH OF CHRIST. 1260. Marble relief on pulpit. Baptistry, Pisa. Organic conception of figures relates directly to sarcophagus reliefs of Classical antiquity. Relief tightly packed; attempts at spatial perspective; but depth largely expressed by overlapping of figures. Self-contained composition in simple frame.

210 MASTER OF NAUMBURG, ST. MARTIN DIVIDING HIS CLOAK ("BASSENHEIM RIDER"). c. 1235—40. Sandstone. Parish church, Bassenheim. Figures of great plasticity project from deeply recessed background beyond relief's frame. Complicated movements of organic, naturalistically sculpted bodies. Early example of a "Northern Renaissance."

211 LORENZO GHIBERTI, BAPTISM OF CHRIST. Between 1403 and 1424. Bronze door panel at north entrance of baptistry, Florence. Figures with mannered movements in landscape. Protruding beyond ornamental frame, background and secondary figures bring third dimension into composition.

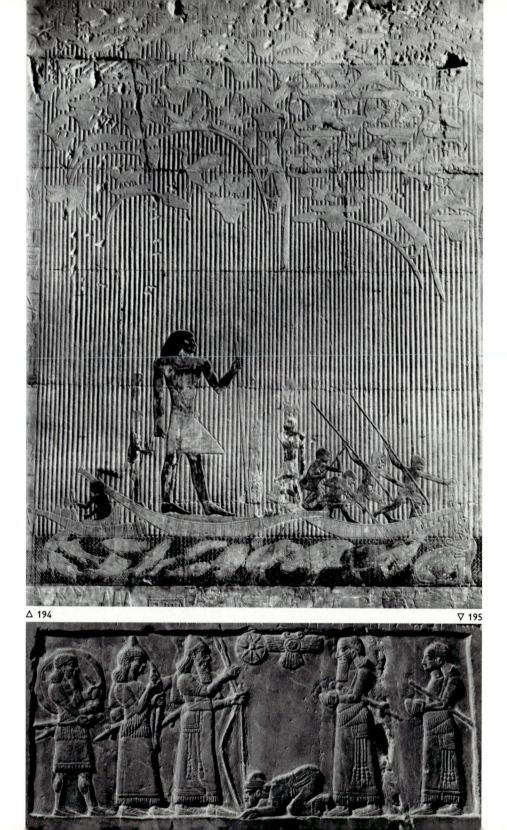

△ 194

▽ 195

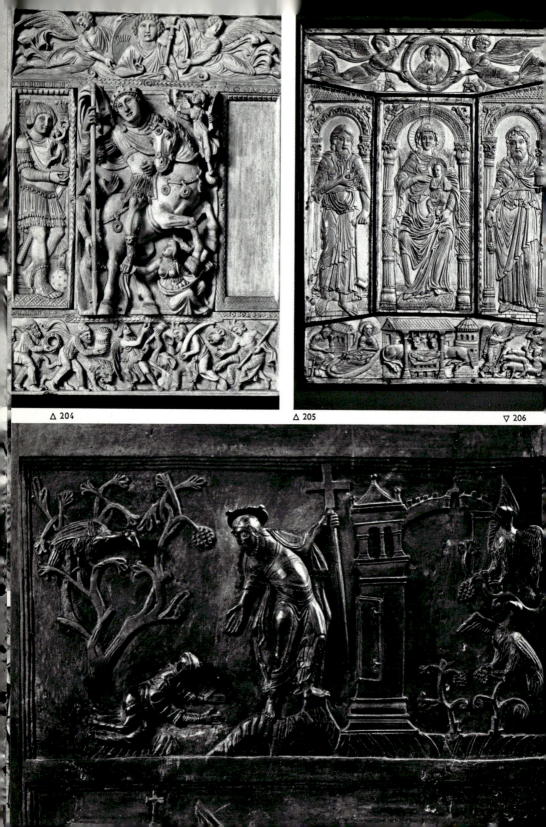

△ 204 △ 205 ▽ 206

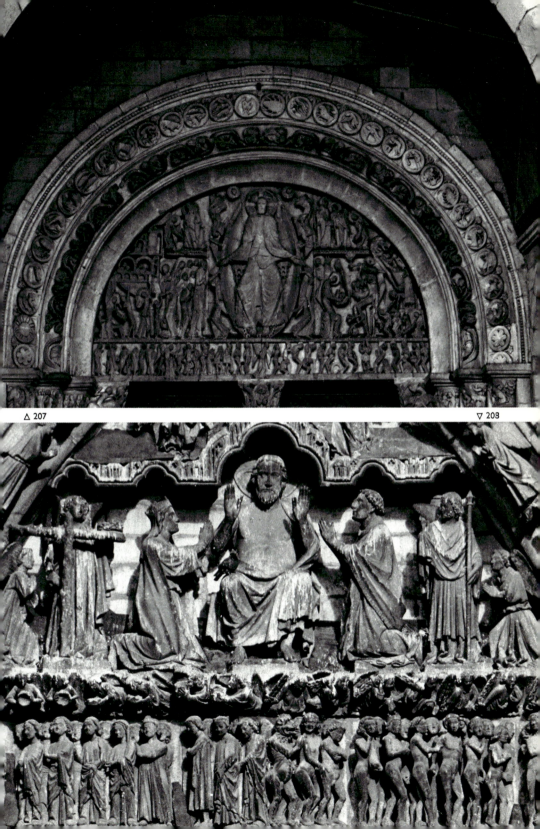

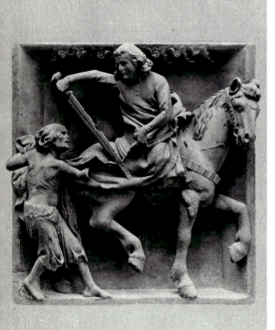

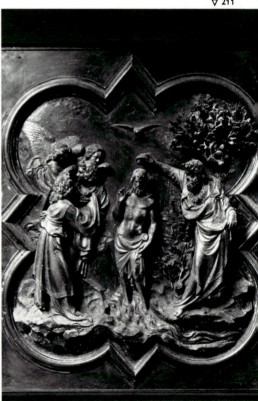

△ 209 ▽ 210 ▽ 211

two levels, one behind the other, covering most of the surface. Late Roman relief rejects empty space completely and the whole surface is covered with dynamically moving, tightly packed and interlaced figures *(202)*, their shadowy depth achieving a highly painterly effect.

Early Christian reliefs differ principally in concept by borrowing from late antiquity a hierarchic perspective and a strictly frontal approach *(203)*. Cubic blocks and compactly contained shapes dominate. The framed middle section has an appearance of linear projection rather than sculptural modeling.

This spiritual, desensualized style was altered in the era of Justinian by renewed recognition of the classical Greeks' profound understanding of plasticity *(204);* but figures, though organically constructed and full of movement, maintained their hieratic solemnity and frontal orientation, and, despite the significant plasticity of some parts, there was still an overall tendency toward a planar effect.

During the Carolingian renaissance, three centuries later, the tendency toward flatter, more pictorial representation became even more pronounced *(205)*. A close relationship to the art of book illumination and the sharing of workshops brought such new elements to relief as approximate perspective and pictorial representations of landscapes and buildings. Modeling is flat, as if superimposed on the surface rather than carved. Classical antiquity's understanding of anatomy has been replaced by an emphasis on surfaces.

For several centuries, relief carving remained a subdued art, and then, around A.D. 1000, also in relief, a new style with figures of great plasticity emerged *(206)*. Figures stand out in varying degrees from an undifferentiated background plane, but elements of landscape or iconographically important architecture remain flat. The significance of the subjects depicted determines their degree of plasticity and governs the composition, which is organized in simply framed planes and directed entirely toward the expressive protagonists. Reliefs of the Romanesque period also appear as if superimposed on a flat surface *(207)*, and the size and position of the figures are determined by their iconographical importance. After an absence of many centuries, reliefs of monumental dimensions reappear in an architectural context. The development of a new concept of sculpture, characteristic of Gothic statuary, gives to relief more organically disposed figures with bodies of greater plasticity and movement, and, with fully developed high relief, the borderline between relief and freestanding sculpture is reached *(208)* — an evolution again strongly influenced by Classical antiquity, especially by the sarcophagus sculpture of late antiquity. Direct influence is particularly noticeable in the south of France and in Italy *(209)*, but a few astonishing examples of such Classical *renovatio* exist also north of the Alps *(210)*.

Although the art of Classical antiquity inspired architects and sculptors of the Renaissance, and the vision of an ideal rebirth included relief sculpture, Renaissance relief took a completely different stylistic course. In contrast to Classical compositions of figures against a neutral surface, Renaissance relief showed pictorial impressions in illusionary settings. This was achieved with the help of a centralized perspective, the gradation of figures, and a representation of landscape that went far beyond iconographic necessity. In Renaissance relief the compositions and intentions of painting are translated through the techniques of sculpture and the various types and styles of painting are faithfully reflected in every detail. The projection of

212 DONATELLO, THE MIRACLE OF THE UNBELIEVER'S MULE. After 1433. Bronze panel on high altar, S. Antonio, Padua. Perspectively constructed picture in bas-relief. Figures' proportions correspond with those of surroundings. No neutral background, but illusory effect as in contemporary painting.

213 TILMAN RIEMENSCHNEIDER, ST. KUNIGUNDE'S TEST OF VIRTUE. 1499–1513. Stone. Tomb of Emperor Henry, Bamberg Cathedral. Figures arranged in architectural space with central perspective, which they dominate with their great plasticity and disproportionate size. Massive bodies with large heads overlap, thus overwhelming background's much flatter, illusionistic relief.

214 ADRIAEN DE VRIES, ALLEGORY OF RUDOLF II'S VICTORIES OVER THE TURKS. 1603. Bronze. 71 x 88.5 cm. Kunsthistorisches Museum, Vienna. Pictorial composition with view of wide landscape. Pronounced modeling in foreground and important central scene. Much movement in manifold detail; figures dissolve pictorially into the background. No neutral relief background.

215 EDME BOUCHARDON, PROCESSION OF ST. CHARLES BORROMEO. c. 1735. Palace Chapel, Versailles. Layered bronze frieze with foreshortening: heads maintained at same level by incline in terrain; plasticity decreases toward back. Flat and linear background architectural design. Subdued pathos, relatively strong surface movement.

216 ALESSANDRO ALGARDI, POPE LEO I AND ATTILA. 1646. St. Peter's, Rome. Large marble relief panel used as altarpiece. Strong compositional movement emphasized by play of light and shadow and rapid graduation of modeling from bold foreground figures to delicately traced background. Figures projecting beyond contrasting frame increase feeling of depth.

217 EGID QUIRIN ASAM, ALLEGORICAL FIGURE REPRESENTING THE OLD TESTAMENT. 1733. Wooden door panel. St. John Nepomuk, Munich. Playfully agitated figure within ornamental frame. Naturalistic detail: tassels, tree trunk, wing feathers. Delicate surface molding.

218 PHILIPP JAKOB SCHEFFAUER, GENIUS OF DEATH. 1805. Marble. 87 x 46 cm. Staatsgalerie, Stuttgart. Return to severe Classical concept of relief sculpture: ideal stylization of naturalistic figure against neutral background.

219 FRANÇOIS RUDE, LA MARSEILLAISE. 1833–36. Arc de Triomphe, Paris. Stone. Frameless sculpture on its own socle against the southeast wall. Tightly arranged figures move in several directions. Baroque pathos in concept and execution. Expansive overlapping gestures give illusion of depth. Great plasticity and contrasts of light and shade heighten visual effect.

220 AUGUSTE RODIN, THE GATES OF HELL. 1880–1917. Bronze. 6 x 4 meters. Musée Rodin, Paris. Arrangement of decorative, framing elements, relief panels, and 3-dimensional groups of figures. Clustered narrative content much altered and enriched over the years. Can no longer serve as door. Strong contrasts designed to be seen from distance, but details discernible only close at hand. Extreme painterly dissolved effect.

221 WANDER BERTONI, MIRROR I (back). 1963/64. Brass. Diameter 63 cm. Collection of the artist, Vienna. Uses play of light on gleaming metal. Pronounced contrast between curved planes and calm, restful lines. Full abstraction emphasizes effect of surface full of movement.

222 JEAN (HANS) ARP, CONFIGURATION. 1927/28. Painted wood. 145.5 x 115.5 cm. Kunstmuseum, Emanuel-Hoffmann-Stiftung, Basel. Stratification of pure planes: third dimension and monochromatic overpainting help clarify abstract forms. Translation of painting into another medium.

223 JOHN ERNEST, MOSAIC RELIEF NO. 6. 1966. 1.22 x 1.43 meters. Charles Hamann Collection, Bristol. Aluminium and cellulose fabric joined in severe, geometrical arrangement. Different colors make different layers distinct.

224 ZOLTAN KEMENY, BRASS RELIEF. 1962–63. 3.9 x 2.9 meters. Technische Hochschule, St. Gallen. Honeycomb arrangement of geometric elements awakens associations of urban conglomerations. Irregular repetition of shapes provides vividly ornamental character.

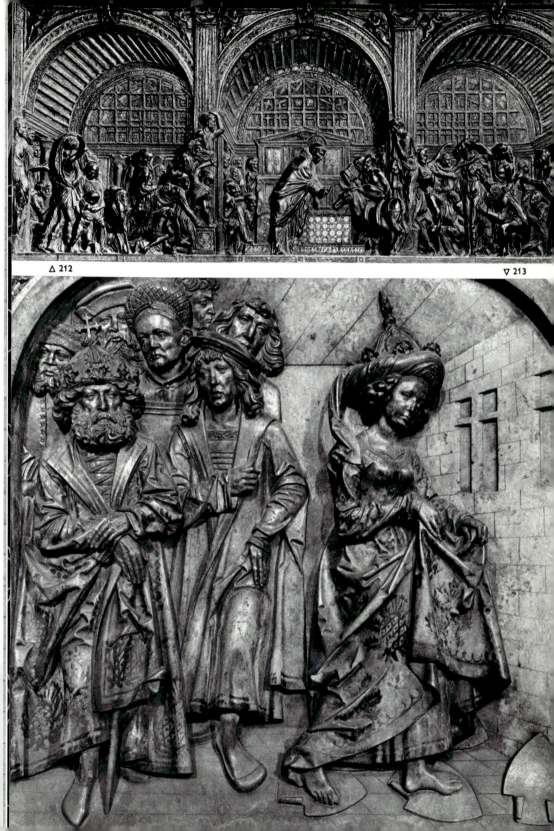

△ 212

▽ 213

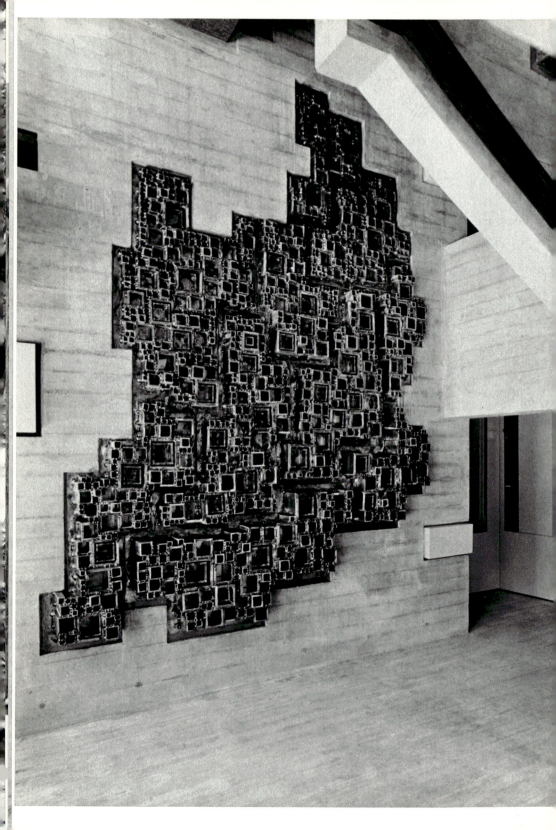

space is dominant in Italy's Quattrocento reliefs *(211, 212)*, while north of the Alps the Late Gothic tradition is upheld and figures remain dominant even in structured space *(213)*; but clarity of narrative and an orderly arrangement of space had now become important, and a scientific striving for objectivity and faithful, naturalistic portrayal can be detected everywhere. Drawing the line between relief and painting once and for all, the Renaissance relief sculptors emphasized the illusion of space through graded modeling — that is to say, making the modeling deeper in the foreground and flatter toward the background.

Mannerist reliefs show an even closer relationship to painting: they are painterly in the visual transformation of plastic elements; in their organized surface, with its manifold detail and movement, the individual figure is submerged in a vivid play of light and shadow, which gives the whole composition a highly pictorial appearance *(214)*. With this development, many achievements of the late Renaissance were lost, and it was the aim of Baroque reform to recapture them on a new basis. The pictorial character of the relief remained dominant; so much so that a relief could easily substitute for a painting *(216)*. Despite the exaggerated expressiveness of composition and figures, however, modeling still retained its importance. Naturalistic effects were often heightened by color. This rather severe Roman Baroque style was followed by lighter, rather more precious variants *(217)* or, particularly in France, by a more Classical conception, which again approximated the original character of relief *(215)*.

Neoclassicism chose Greek antiquity as the exclusive model for its themes and style. Reliefs are executed on neutral surfaces, figures are dominant, and there is no borrowing from the art of painting; the execution, however, with its obvious academic naturalism and conscious smoothness of surface, is typical of the situation around the year 1800 *(218)*. Deviating from Classical usage, reliefs become detached from architecture or objects and stand as independent, individual works of art, as had been the case with easel paintings much earlier. The "historical style" of the 19th century, by leaning on Hellenistic, Roman, and above all Baroque models, favors a more painterly concept *(219)*. Technical virtuosity and revivals of past styles determine the effect of rather overloaded narrative reliefs. This development leads again to a highly painterly concept and to a detailed organization of the surface, in which the contours of countless agitated figures become blurred by strong contrasts of light and shadow *(220)*.

The 20th century offered new possibilities for the art of relief sculpture: it could be hung on the wall like a painted picture, and it was again used in architecture. The specific qualities of the relationship between carved form and surface plane are exemplified most clearly in abstract relief; strict accentuation of forms and layers *(222, 223)* can be achieved as easily as a highly flexible differentiation of structured surfaces *(221, 224)*. With the diffusion of the various new art forms (collage, assemblage, sculptural architecture), all having some of the characteristics of relief, wider fields open up, particularly in the realm of more visually oriented concepts.

PAINTING

Of all the visual arts, painting has the widest scope in the choice of themes, and the fact that tools and execution are comparatively simple opens up great opportunities for application and expression. Painting has accompanied man from his earliest days throughout history, but its tasks and functions have varied greatly: it has played a subsidiary role in adding color to buildings or sculpture; it has functioned as partner of other art forms, as, for instance, in decorating the interior of Early Christian or Baroque churches, palaces and houses; finally it has been used to create works of art in their own right, as framed pictures on walls, in illuminated manuscripts, in stained glass windows, and, above all, as autonomous easel painting.

The developments in the history of style could be traced solely by looking at painted pictures, for they often reflect the moods and intentions of other art forms. They mirror the ideals, pursuits, customs, and political ambitions of the ruling classes. Ideas and ideals chosen as worthy themes appear as form (contour) and surface (color). These basic formal elements of painting can be extended to include perspective, which enables the painter to probe the problem of representing three-dimensional bodies, space, and depth on a two-dimensional plane. The following chapters take up two themes, chosen because they exemplify the principal problems of form most clearly: the human figure in enclosed space (that is to say, the relationship of figures to interiors) and the human figure in the open space (that is to say, the relationship of figures to landscape).

THE HUMAN FIGURE IN ENCLOSED SPACE

The realistic portrayal of man within an interior has been a formal problem of Western painting only since the 14th century. The different ways of portraying figures in their proper relationship to space developed with a growing desire to express physical reality and were only then recognized as problems of perspective and illusionistic projection.

For ancient civilizations, as well as for the Middle Ages, perspective was of no great importance because artists aimed not at portraying physical reality but at portraying ideas and concepts. It did not matter whether a picture showed sacrifices made to gods, or subjects paying tribute to a ruler, or even an historical event; the underlying meaning of the scene represented was more important than the realism with which it was illustrated. This basic concept meant that formal problems of rendering space and the relationship between figure and space were irrelevant as long as theme and meaning were clearly and unequivocally expressed. It is true that Greeks were concerned with empirical perspective in the 6th century B.C. and with central perspective two centuries later. They also knew about modeling with light and shade and about painting with the various hues of one color. This is shown by literary evidence as well as by the imprint Greek art left on Roman art. Hardly any portrayals of human figures in interiors have survived from Classical antiquity, however. The reason is probably that, as a subject, interior space played a minor role: mythical episodes and scenes from real life considered worthy of representation were enacted out of doors, in the open landscape or in front of buildings. Views of figures against interiors, even if the interiors are rendered in correct perspective, as they often are, retain the character of actors against a theatrical backdrop, reflecting the *scenae frons* and protagonists of real stage performances. Despite the prevalence of architectural elements, the message of the painting is carried by the figures *(225)*.

The importance of subject matter becomes even greater in the early Middle Ages when space is mainly background framing the figures. In Carolingian pictures, concepts of physical space are often translated into insignia of rulership irrationally reminiscent of the illusionism of antiquity *(226);* the broad, full figures and the modeling and design of their garments also resemble antique models. However, the solemn, symmetrical representation so typical of the Middle Ages, the flat perspective, the gradation of the size of the figures according to their importance, the diminishing plasticity, and the attendant disappearance of light and shade effects, are stronger than any remnants of antique tradition, even when they are consciously evoked.

The transition from illusionism to emphasis on thematic content is particularly apparent in the relationship between the proportions of figure and space. While in antiquity this relationship was more or less realistic, it now was changed in favor of a dominant figure. Interior space is no longer inhabitable in a realistic sense, but has become a narrow frame, a mere hint that the scene is taking place in a particular locality. Individual elements can symbolize the whole of the interior and may be used as and where they fit into the meaning of the picture, rather than strictly according to their physical reality. The exterior of a building, minus its front wall, for instance, indicates an interior without actually portraying it.

225 APOLLO JUDGING PHOSPHORUS AND HESPERUS. c. 70. Fresco. Casa d'Apelline, Pompeii. Fantastic stage architecture background with baldacchino and tabernacles rendered in perspective. Figures have diffused softness; colors match gold tone of architectural elements, enhanced by background's warm, neutral color.

226 PORTRAIT OF CHARLES THE BALD ENTHRONED. Codex Aureus of St. Emmeram. 870. 42 x 33 cm. Bayerische Staatsbibliothek, Munich. Portrait of ruler, seated in canopied arcade. Attempts to project space by showing canopy's underside, throne-room floor, slanted architraves, in contrast to flat symmetry of canopy's and arcade's superstructure, framing the figures, whose size varies with importance. Bold drawing. Colors related to purple, symbolizing emperor's majesty.

227 THE CALLING OF ST. MATTHEW AND THE LAST SUPPER (detail). Codex Aureus Epternacensis. Echternach, c. 1030. Germanisches National-Museum, Nuremberg. Architectural elements only define locality. Picture plane dominates despite tight arrangement of graduated figures and slanted table and bench. Significance of gestures (particularly Christ's hands) indicated by exaggeration. Bright, metallic colors.

228 THE HEALING OF THE MAN POSSESSED BY DEVILS. Before 1089. Fresco. Lambach Abbey, Austria. Former west choir. Interior architectural details subordinated to figures and indicate rather than exactly represent locality. Figures' grading and overlapping does not greatly enhance feeling of space. Byzantine influence in modeling. Mostly light colors fill in contours, modeling of garments in light and dark shades of primary colors.

229 THE LAST SUPPER (detail). Page from a breviary. Paris, c. 1287. Stadtbibliothek, Nuremberg. Painted background frame gives picture character of framed relief and replaces delineation of space. Frontal view; depth given by staggered figures and objects (Judas-table-John-Christ) and overlapping of figures on frame at bottom. Sense of depth muted by purely decorative, flat gold background. Graceful, puppetlike figures. Bright colors; red and metallic shades dominate.

230 GIOTTO DI BONDONE, THE LAST SUPPER. 1305–7. Fresco. Scrovegni Chapel, Padua. First post-Classical attempt at 3-dimensional projection through use of perspective. Figures clearly seated in building whose front and side walls are omitted. Scene is viewed from fairly natural angle – a striking innovation. Broad, strongly modeled figures with well-defined contours are cut off from view in places by architectural details. Drapery falls naturally.

231 DIRCK BOUTS, THE LAST SUPPER. 1464–67. Holy sacrament altar, central panel. Oil on wood. 178 x 147 cm. St. Peter, Louvain. Centralized perspective. Room viewed from above. Details realistic at close range. Each slim figure with firm contours is fitted separately into perspective system. Strong, natural, gemlike colors.

232 DOMENICO GHIRLANDAIO, THE LAST SUPPER. 1480. Fresco. Former refectory of Ognissanti, Florence. Interior perspective extended by view into garden. Symmetrical, rational composition: viewpoint parallel to picture plane; realistic details; colors bright with shadowy depths.

233 TINTORETTO, THE LAST SUPPER. 1592/94. Oil on canvas. 365 x 568 cm. S. Giorgio Maggiore, Venice. Dynamic expansion of space achieved through vanishing diagonals and supernatural apparitions adorning paneled Renaissance hall. Impression of irrationality heightened by light effects, including halos with own source of light. Figures in agitated poses arranged according to strict but extreme perspective. Uniform, subdued colors.

234 CARAVAGGIO, CHRIST AT EMMAUS. c. 1600. Oil on canvas. 139 x 159 cm. National Gallery, London. Illusion of depth and plasticity of figures achieved through realistic light and shade effects. New, more disciplined conception of composition and realistic colors.

235 NICOLAS POUSSIN, THE LAST SUPPER. 1647. Oil on canvas. 117 x 178 cm. National Gallery of Scotland, Edinburgh. Monumental hall and dining style indicate return to ideals of Classical antiquity. Depth achieved by arrangement of figures. Light from central source, diffused over the figures, softens their orderly distribution. Subdued complementary colors.

236 REMBRANDT VAN RIJN, CHRIST AT EMMAUS. 1648. Oil on wood. 68 x 65 cm. Louvre, Paris. In high room with massive stone walls, the apselike niche behind Christ and pillars behind disciples link group of figures to surrounding space. Scene spiritualized through use of warm colors and manipulation of light.

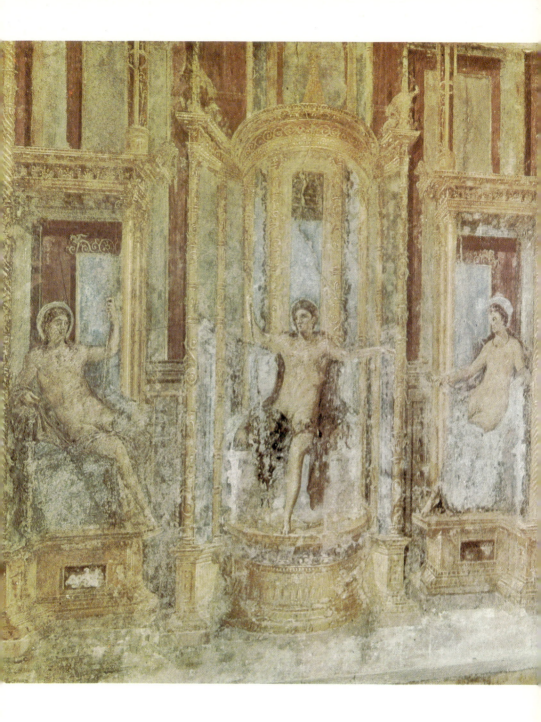

◁ 226 △ 227 ▽ 228

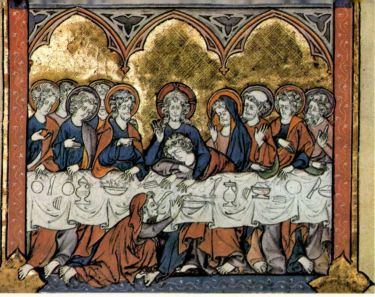

◁ 229 ▽ 230

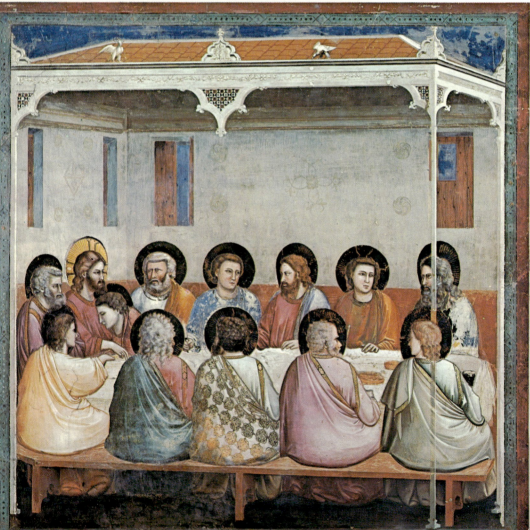

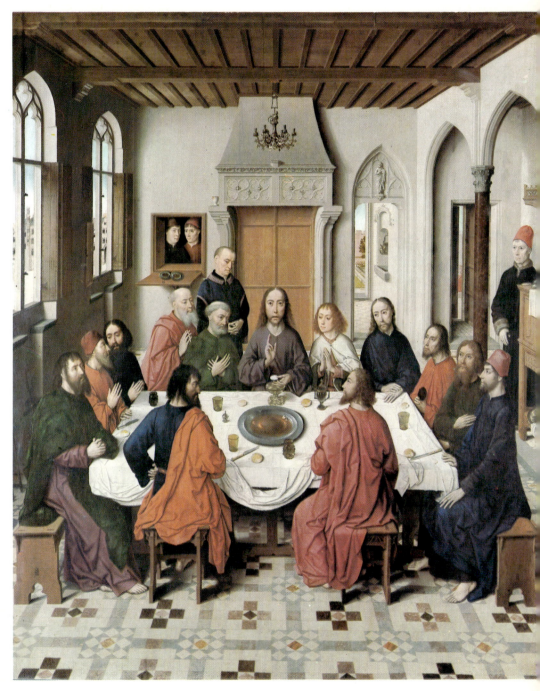

231

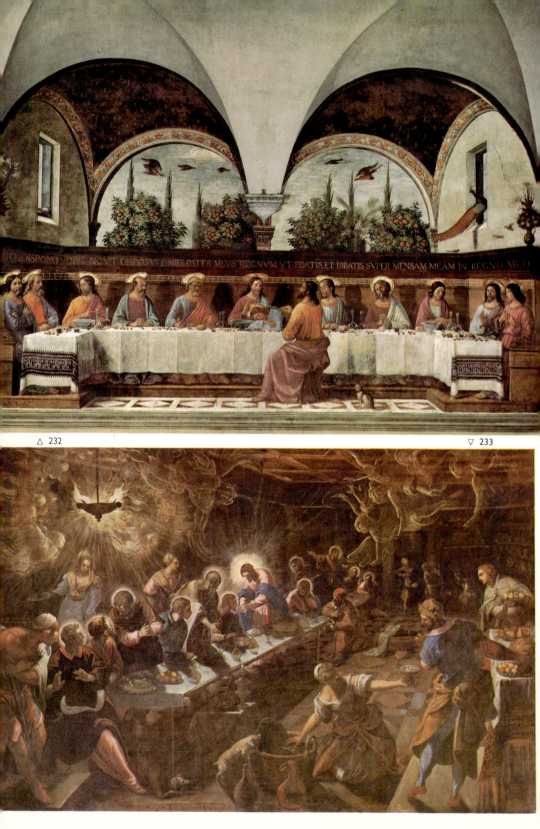

△ 232

▽ 233

O DISPONO VOBIS SICVT DISPOSVIT MIHI PATER MEVS REGNVM VT EDATIS ET BIBATIS SVPER MENSAM MEAM IN REGNO MEO

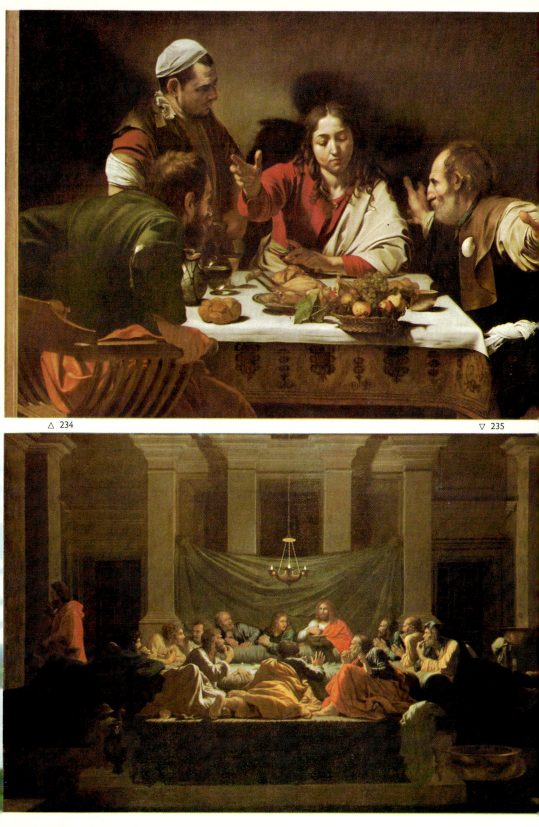

△ 234

▽ 235

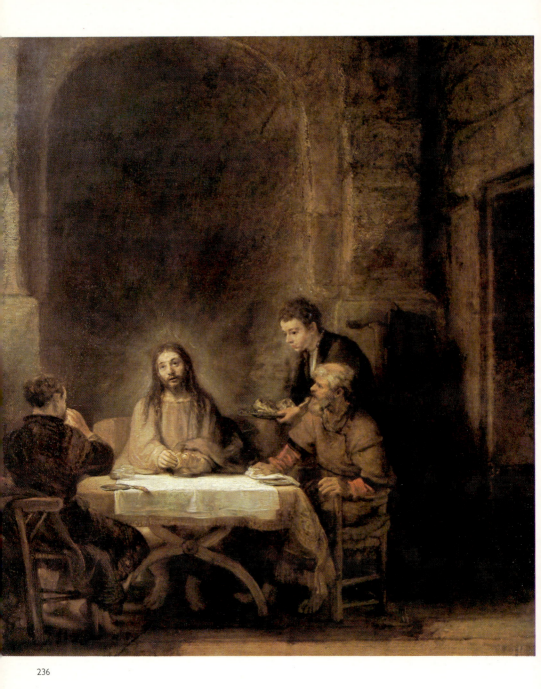

236

A similar distortion of relative proportions as occurs between figure and surrounding space can also be observed within the figure itself. The face, and particularly the eyes, are emphasized and gestures exaggerated; pointing or gesturing hands with expressive, elongated fingers become the narrators of the events portrayed. At the same time the modeling still noticeable in pictures of the early Middle Ages *(226)* is superseded by a linear, compartmented surface, each compartment filled in with a color *(227)*.

This basic linear concept remained valid even when Romanesque painters, influenced by Byzantine art, reintroduced some antique concepts of figure and space. Architectural elements, often necessary for narrative reasons, were added like movable scenery to compositions of figures. Space-enhancing effects — such as views from above or below and buildings represented in an oblique position — were used to elucidate the situation rather than provide illusory space for the scene, which remains confined to shallow, staggered planes. The same is true of the modeling of the figures: although they are painted with often astonishingly brilliant technique, in which traditions of Classical antiquity survive, they do not stand out very markedly from the background. Only within the firm, still boundaries of each figure are certain limbs and garments allowed relieflike modeling *(228)*.

The Gothic period carried the linear picture to its ultimate consequence: body and space were no longer problems of form; the linear design, the colors which fill a space but do not model, and the insubstantial gold which does not add plasticity demonstrate a concept of body and space diametrically opposed to that of Classical antiquity. This is also exemplified by an entirely different treatment of the decorative border framing a picture: figures or other components of the narrative often cut across it, and architectural elements seem to be attached to it; but impulses toward differentiation of space are neutralized by the dominant relationship of composition, color, and linearity to surface values *(229)*.

Considering the concept of painting during that period, it is easy to understand why Giotto's rediscovery of the relation between three-dimensional figures and space should have so profoundly overwhelmed his contemporaries. The opening of the flat, linear surface to spatial depth — initially a narrow, stagelike strip of space — constructed with the help of a near-to-central perspective, and coupled with the idea that a figure should have volume and plasticity determining its contours, was one of the most momentous developments in the history of art *(230)*.

Painters of the 15th century studied the world they lived in with an almost scientific interest and aimed at reproducing their sensory impressions as objectively as possible *(231, 232)*. This is shown in their preference for geometrically constructed space, the perspective of which is exaggerated by space-widening views from above and below, and in the minute and realistic detail with which they represented all objects. Netherlandish painters, in particular, with their highly developed technique of working in oils, present an additive, naturalistic panorama of the visible world, describing it exactly and giving it firm boundaries *(231)*. The Italian masters, on the other hand, aimed at combining their impressions of the physical world with an idealistic concept of the representative, autonomous picture *(232)* — an intention perfectly realized in the Renaissance. A favored subject dealing with interior space, the Last Supper, found its most masterful expression in Leonardo da Vinci's famous fresco in the refectory of the church of S.

237 JAN VERMEER, LADY AND GENTLEMAN DRINKING WINE. 1658/60. Oil on canvas. 65 x 77 cm. Staatliche Museen, Gemäldegalerie, Berlin-Dahlem. Clearly defined part of room is setting for seemingly casual arrangement of figures. All objects given same value by composition and balance of complementary colors.

238 JACOB JORDAENS, JUPITER AND MERCURY VISIT PHILEMON AND BAUCIS. c. 1645. Oil on canvas. 109.5 x 140 cm. Museum of Art, Raleigh, N.C. Interior delineated in detail forms "stage" for action with "wings" on either side. Well-defined, strongly molded figures linked by gestures and combine pathos and genrelike naturalism. Strong, sometimes exaggerated natural colors.

239 DIEGO VELÁZQUEZ, THE REPAST. c. 1619. Oil on canvas. 96 x 112 cm. Museum of Fine Arts, Budapest. Room's depth indicated only by foreshortened table and arrangement of figures. Feeling of space heightened by sharp, realistic manipulation of light. Specific, natural colors in warm, related tones.

240 JEAN BAPTISTE SIMEON CHARDIN, GRACE. Oil on canvas. 1739–40. 49.5 x 41 cm. Louvre, Paris. Genre scene in bourgeois setting. Diagonal arrangement of figures, with light following same path, and proportional relationship of figures to environment, combine to form defined, believable space. Subtle colors enhance intimacy.

241 ANTOINE WATTEAU, THE SHOP OF THE ART DEALER GERSAINT. 1720. Oil on canvas. 182 x 307 cm. Charlottenburg Palace, Berlin. Imagined view from street into shop. Very wide canvas, specially commissioned, necessitated division into 2 panels unified by central vanishing point. Great narrative content and much detail. Bright, delicate, yet definite coloring softly shapes elegant figures.

242 CARL BEGAS, THE PAINTER'S FAMILY. 1821. Oil on canvas. 76 x 85.5 cm. Wallraf-Richartz Museum, Cologne. Realistically delineated room is "stage" for individual portraits. Clarity of line and emphasis on plasticity of figures dominate relieflike composition. Clear, cool colors subordinated to strong contour drawing.

243 FRIEDRICH MENZEL, BANQUET AT SANS-SOUCI. 1850. Oil on canvas. 204 x 175 cm. Nationalgalerie, Berlin (missing since 1945). Rendition of atmosphere creates illusion of interior space. Color differentiations dissolve contours.

Picture plane unified by preimpressionistic brushwork.

244 EDOUARD MANET, CAFÉ CONCERT. 1874. Oil on canvas. 46 x 38 cm. Walters Art Gallery, Baltimore. Locality's atmosphere captured by rendering only small section, apparently chosen at random. Differentiation of color in light and shaded parts gives figures life and substance. Picture plane predominates over spatial depth and plasticity of bodies.

245 PAUL CÉZANNE, CARD PLAYERS. 1890/92. Oil on canvas. 45 x 57 cm. Louvre, Paris. Section of interior rendered without perspective. Depth of space and substance of bodies indicated by borders between colors, color stratification, and subtle shading. Individual sections given firmness through intensification of color, particularly at edges of planes.

246 EMIL NOLDE, WHITSUNTIDE. 1909. Oil on canvas. 83 x 100 cm. Private collection. Dimensions can be ascertained only from arrangement of figures. Effect of spatial depth mitigated by abrupt juxtaposition of colors. Solemn, masklike faces — intensified by strong colors — express spiritual values.

247 ERICH HECKEL, TWO MEN AT A TABLE (after Dostoevsky's The Idiot). 1912. Oil on canvas. 97 x 120 cm. Kunsthalle, Hamburg. Depth created by walls with paintings and diagonally arranged furniture directed back to picture plane by backs of chairs and large painting hanging on far wall. Graphically linear concept. Strongly subjective effect through conscious ugliness of faces and hands.

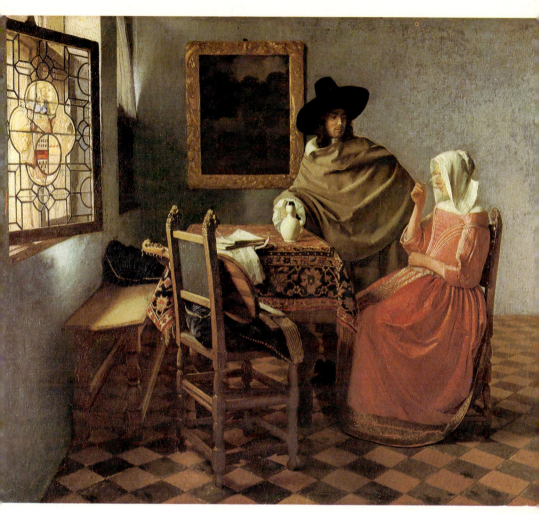

237

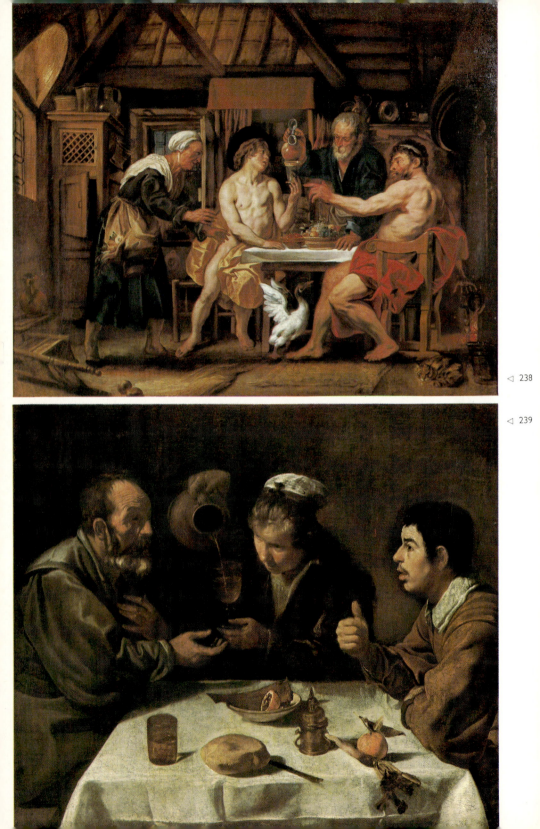

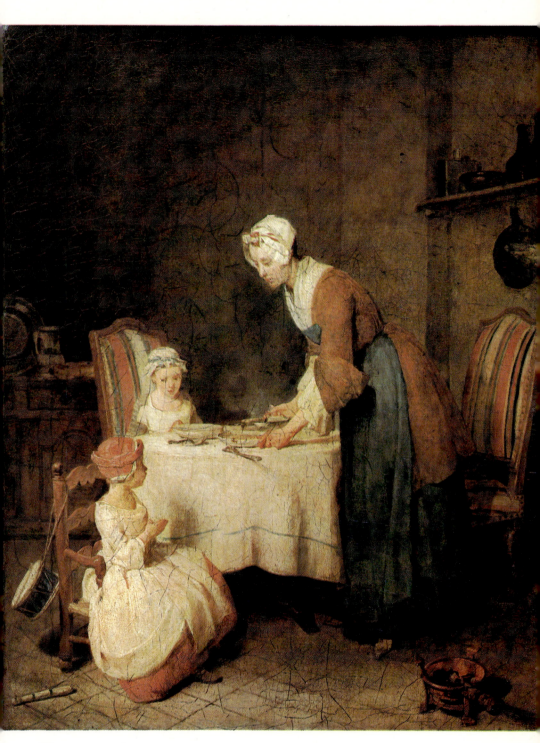

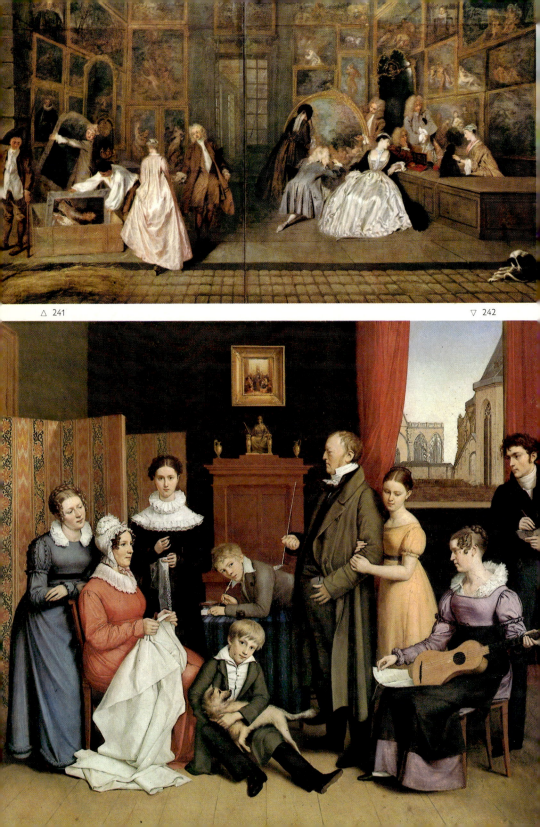

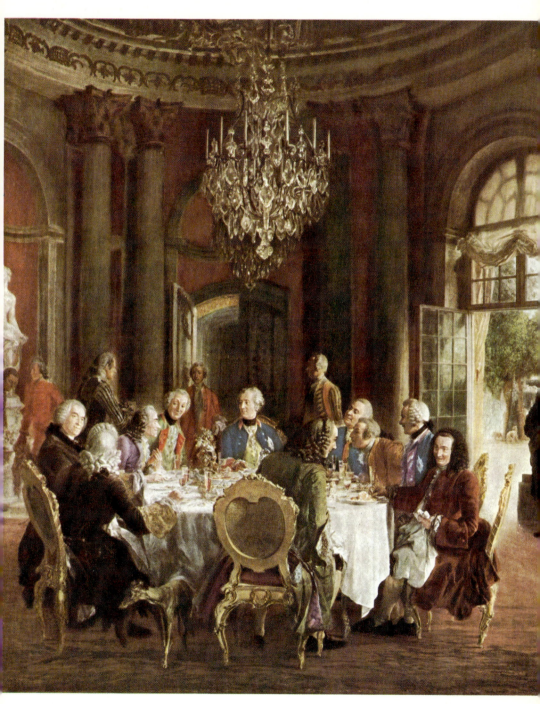

243

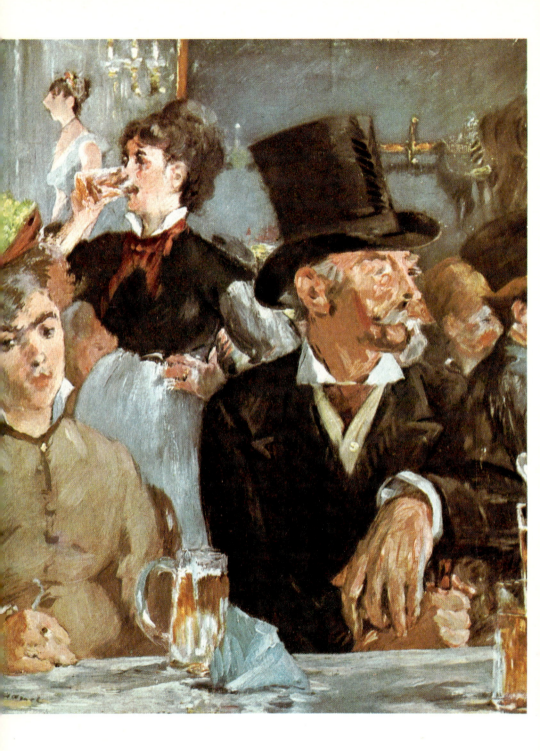

◁ 244 △ 245

△ 246

▽ 247

Maria delle Grazie in Milan. In this painting an illusionary widening of physical space, and with it a direct confrontation between picture and beholder, has been perfectly realized.

The treatment of space in Mannerist painting appears as a sharp reaction to the objectivity and harmony of the High Renaissance. Its vanishing diagonals, exaggerated foreshortenings, and irrational viewpoints make the Mannerist paintings seem to be supernatural visions rather than renditions of real localities *(233)*. The figures too are interpreted in a subjective way and become strange, elongated creatures with distorted proportions, performing highly compli- cated movements. They are either stonily statuesque or dissolved in diffuse fluidity. The rela- tionship between figure and space is subject to a willful disproportion that expresses almost measurably the tension characteristic of Mannerist works.

Some elements from this rich field of experimentation are taken into the quieter, more formal vocabulary of 17th-century art and distinguish the "austere Baroque" from the Classical Renaissance and from Roman antiquity, despite its conscious orientation toward both these periods. Once more the figure becomes dominant and determines a picture's theme and proportions. The impression of space is not conveyed by illusionistic construction of interiors, but by the volume, attitude, and movement of the figures which provoke the illusion of a third dimension around them. In addition, a fresh feeling of space and plasticity is achieved by a newly awakened, intense interest in the play of light and shade. The sharp contrast between light and shade can have such a compelling effect on the illusion of space that the actual portrayal of physical space becomes unnecessary. Space opens up simply through the inter- relationship of individual, important features in figures and objects. The illusion of space is therefore no longer created by objective projections, but induced in the beholder's mind by pointing up associations *(234, 235)*. Apart from this extremely visual approach, the artistically fertile 17th century also introduced a topographically descriptive presentation of interior space, in which calculated effects of light and color relate the room to the figures *(237, 238)*. Rembrandt's interiors appear to be a synthesis of these concepts: unobtrusive in contour and color, they enfold the minor figures that mark the outlines of space and, with increasing brightness, focus the attention on the central theme of the picture, which is also the apparent source of light *(236)*. Despite the differences between the plasticity of contours and the differ- entiations of natural colors, on the one hand, and the dissolving of contours and merging of colored shapes, on the other, there is a common approach to the depiction of space that informs all Baroque painting.

In the late Baroque, the pictorial qualities of dissolved contours and merging shapes acquire utmost refinement. The predominance of the figures in a composition is toned down propor- tionately. Narrative details and still-life subjects are added, enriching the picture, without robbing individual objects or themes of their relationship to the whole. Uniting these components are the bright, carefully harmonized colors, and the light brush strokes that outline individual figures and objects and, at the same time, help them to merge into their bright, sometimes diffused surroundings *(240, 241)*.

Neoclassicism and Romanticism, although contrasting in motivation and effect, shared some techniques of composition: the contours of figures and objects alike are rendered in a precise, explicit linear manner. Depth is rarely achieved, and the relatively flat stage of action,

enclosed by relieflike walls running parallel to the picture plane, gives the figures just enough freedom of movement to line up in friezelike order. While Renaissance compositions are used as models, they are interpreted in a more realistic approach. Accuracy of detail becomes all important *(242)*.

As can be seen, the attempt to reproduce interior space as it appears to the eye has been a basic theme since the early Renaissance, varied only in its interpretation, and this theme, in principle, was not questioned in pre-Impressionist and Impressionist paintings. In the second half of the 19th century, however, while official paintings still leaned toward historical models, some artists began to neglect the basic element of drawing in favor of differentiation through color, translating modeling with light and shade into a surface projection of diverse color effects *(243)*. Figures become less corporeal, without, however, losing their individuality; space is captured through atmosphere rather than composed in depth. Linear and aerial perspective are abandoned in favor of the optical system of primary colors, whose pure intensity mirrors figure and surroundings, foreground and background, light and shade with equal validity *(244)*.

"The end of scientific perspective" (Fritz Novotny) begins with Paul Cézanne. Despite perfect clarity of form and subject, his paintings give greater importance to surface than to the illusion of perspective. Slight displacements of diverging lines, distortion of angles, the replacement of linear contours through differentiations of color makes his preoccupation with surface planes clear, without abandoning the impression of figure in space *(245)*. On the strength of these discoveries and with the knowledge of the formal concepts of past centuries, modern painting has a wide range of possibilities — insofar as it accepts the problem of the human figure in interior space at all — which includes the exploration of imaginary as well as real space and figures composed of color planes or of graphic symbols that stand for volume *(246, 247)*. Illusionistic space and simulated plasticity of the figures, however, no longer have idealistic value in today's artistic concepts.

THE HUMAN FIGURE IN THE OPEN

The representation of a human figure in an enclosed space shows man in a world of his own creation. The portrayal of a human figure in the open shows man confronted by an environment he can change but never create. Such changes, and the way in which they are made, can tell us a great deal about the attitude of an artist toward his natural environment. For all we know, pure landscape paintings may have existed in antiquity. As a theme, however, landscapes without figures have gained importance only in fairly recent times. For this reason, we shall limit ourselves to discussing representations of man in the open and the relationship between figure and landscape.

In the paintings of antiquity, landscapes are scenes of mythical events as well as personifications of cosmic powers. They portray not just an objective local happening but also the emotional atmosphere ruling the event. The environment fits the theme, be it bucolic, dramatic, or heroic. This close relationship between action and scenery, figure and landscape is achieved mainly with color and the loose brush strokes that detail the individual aspects of each landscape and each object. This is only an apparent "impressionistic" technique, because modeling with light and shade is not achieved with complementary colors, but with grades of local colors and superimposed white highlights. The same applies to the representation of figures: they correspond to the landscape in size and color, but they are arranged in a formalized and constrained manner *(248)*. Only in some Roman landscape painting are there figures that merge into the atmosphere of the surrounding countryside in an impressionistic manner.

In the Late Antique and early Christian periods, emphasis on content became more pronounced and was formally expressed by a shift in the space-figure relationship in favor of the figure, and in an endeavor to give increasing clarity to the parts of a picture that carry its meaning. Landscape, therefore, was no longer seen as open space and it was reduced to a few characteristic features: a house, a tree, a strip of land, a mountain. Figures occupy the foreground, thrust together and disproportionately large; groups are arranged in strict, orderly categories, with attention given to symmetry, size according to rank or narrative importance, and frontal aspect. Even within each individual figure, particularly expressive features — head, eyes, hands — are emphasized. Certain painting techniques from antiquity endured, however, such as differentiating the colors of the background, for instance, which gives the picture a feeling of depth; the nuances of light and shade which lend plasticity to the figures; loose brushstrokes, or, in mosaics, a many-faceted pattern of color without strong contours *(249)*.

The process of clarification of theme and meaning led in Western and mid-European art to an anti-illusionist tendency that produced dominant figures in a neutral environment characterized only by a few isolated, stylized sections of landscape. A flat arrangement of figures one above the other replaced the spatial arrangement of figures behind each other. The problem of realistically imaginable space and depth of perspective was no longer considered, nor was that of the plasticity of figures. Precisely delineated figures, objects, and elements of architecture or landscape are set flatly on the surface of the picture *(251)*. In Italian art, Classical landscape themes and the softer painting techniques of antiquity are more obviously preserved, although

the basic concept is the same as in all Romanesque paimting *(250)*. English painting of the same period, by contrast, shows a distinctly linear style with sharp contours and strongly colored planes; glimpses of ornamental landscape and ecstatic, elongated figures are arranged as calligraphic features in relationship to one another; the suggestion of space has been superseded by a pure and equally suggestive order of planes *(252)*.

The dominance of linear design is characteristic of Gothic miniatures, in which the representation of space is replaced by a uniform gold background on which appear isolated and formalized elements of landscape. The distribution of figures, trees, and hills on the picture's surface gives no illusion of space; nor do linear design or color modulations bring plasticity to figures and objects. Spatial relationship is indicated merely by the gradation of figures, a shifting of angles, and the intersecting of planes. Even then the effect is diminished by perspectives which enlarge the principal figures disproportionately *(253)*.

Emphasis on surface and linearity is so strong that models showing differentiation of space and plasticity of figures, as realized in Giotto's paintings, were interpreted quite differently north of the Alps. The graduation of figures and landscape formations, and the diagonal perspectives of some architectural elements indicate a basic difference between such concepts and purely linear paintings, but depth and plasticity were not dominant concerns *(254)*.

It is the merit of the painters of Siena to have been the first to portray their own environments as landscape. Even the earliest examples of their painting have an astonishing amount of accurately observed detail. In the "portrait" of Tuscan landscape, the spacious scenery, constructed with high horizon offering a perspective, is represented with great directness. It not only gives insight into the activities of the inhabitants, but also expresses a new general outlook, flowing from a greater awareness of the physical world. Accuracy of detail, sharply drawn contours, and natural colors are retained unchanged, but a new element, the middle plane, is introduced as a means of achieving a staggered progression of spatial depth. Proportions, movements, and foreshortened views of figures scattered across the landscape demonstrate the new feeling for plasticity and organic movement that had arrived with Giotto; but for the time being, landscapes remained spread over a picture's surface planes; illusionistic space with projection into depth had not yet been created *(255)*.

North of the Alps, comparable landscapes did not appear until two generations later. When they did, they showed topographically correct scenery and even depicted such atmospheric phenomena as the lightening of the sky toward the horizon, although without the resulting aerial perspective. Foreground and middleground are continuously linked on a slightly tilted plane, but the figures that are seen pursuing their characteristic occupations are conceived in the ephemeral, weightless Gothic mode *(256)*.

Gothic idealization attains a late culmination in the highly decorative and detailed International Style. Graphic elegance and rich colors determine the mood of the pictures; the aid of a slightly tilted perspective plane facilitates the painstakingly detailed description as well as the rhythmic harmony of the lines. Figures, objects, and space are all absorbed into the surface plane and merge to form a sumptuous tapestry *(257)*.

Art in the 15th century is characterized by the confrontation of traditional formal styles with new tendencies. The general aim was to offer a faithful mirror of nature, but Italy and the

northern countries pursued this in different ways. In the south, particularly in Tuscany, and there especially in the works of Masaccio, reproduction of reality proceeded from the physical perception of self-contained, solid, organic bodies. These space-displacing objects, figures, buildings, or elements of landscape evoke the environment as a stage for action. Spatial dimensions are built up in a logical, objective, and convincing way from these corporeal elements, and such compositional aids as perspective foreshortening or proportional diminishing of size only add support (258). The organic relationship between solid bodies and space is underlined by color harmonies, while the illusion of distance is created by color contrasts (262).

In the north, interest was focused on an exact and detailed realization of the perceptible world. Making full use of the comparatively new technique of oil painting, northern artists gave each object its full value. The space of a picture is composed by adding individual elements, acutely observed and remaining accurately characterized even in the farthest distance. A low horizon can give depth and breadth to a picture, but the traditional "near-sighted" view is still favored, although now greater experience with the use of perspective has contributed to proportionately graduated objects. Figures are inserted into these world landscapes as independent elements, rather like movable props in front of a backdrop, but the close relationship of all the elements in the picture to each other as well as to the composition as a whole is never neglected (259). This principle is also valid for the topographically true representations of concrete landscapes, so that it is difficult to decide whether the figures dominate the environment or are integrated into it: on the one hand, the landscape appears as an independently conceived unit, which could well exist on its own; on the other, the figures in their positioning in space and their surface pattern represent a factor that cannot be isolated from the composition as a whole (260).

A similar connection can be observed in Venetian Quattrocento pictures; but here the soft brightness of color, uniting the figures and the interlocking spatial planes, tones down the strong perspective composition of the foreground (261).

Leonardo da Vinci developed a new type of cosmic landscape, which, based on studies of natural history, represented the creative process itself. It therefore contrasts not only outwardly with the descriptive world landscapes of the Christian tradition. The transition from a realistic description of the subjects in the foreground to the farthest background is made with the aid of sfumato, which softens the contours as if with a slight haze. Thanks to the same technique, the pyramid of figures is organically linked to the surrounding space (263).

At the same time, attempts at formally concentrating and unifying the space occupied by landscapes were also beginning to be made north of the Alps. Although the "near-sighted" accuracy of every detail, even of objects in the far distance of a landscape, becomes weakened by the use of aerial perspective, the treatment of each element, whether figure or object, remains differentiated. A concept more graphic than pictorial, complemented by strong natural colors, especially in groups of figures in the foreground, adds to the relative individualization of separate elements (264).

The Classicism of the Renaissance is limited to Italy and lasted only a few years. Its influence in the Mannerist permutation, however, determined the art of the whole of Europe. Once

more there were differences between the concepts and techniques of the south and the north. In Germany the elegant linearity and precision of detailed Gothic painting remained predominant *(265)*, and even the more pictorial styles of Grünewald and the painters of the Danube School retain a graphic, ornamental brushwork. Sections of environmental space are allotted to figures in the foreground, and windowlike openings bring the distant landscape of the Middle Ages into view. In the Netherlands, this tradition was modified by a greater objectivity in the description of a landscape. The figures correspond to a section of a seemingly naturalistic landscape that widens without transition from the foreground to the horizon. The attention given to the differentiation of perspective and color creates spatial depth in a way that prepares the ground for the landscape paintings of the 17th century *(267)*. In Italy, however, the relationship between landscape and narrative content of the picture was more subjective. Landscapes act as dramatic, heroic, or idyllic scenery for the figures and their story and correspond to them in mood as well as in composition. Owing to their highly developed technique, the Venetian painters in particular attain a perfect unity of landscape and figures *(266)*. Quite different is El Greco's style, which exaggerates the proportions and torsion of figures and sets them in sharp contrast to landscapes rising abruptly, but realistically, in the background. Yet the unity of the composition is never destroyed, since the colors in the landscape correspond to those of the figures and enhance their ghostly character *(268)*.

In Baroque painting, there is a return to an objective relationship between environment and figures. This is true of the largely autonomous landscape paintings with their small figures and of portrayals of the human figure in relation to open space. A new realism, taking into account not so much the quality of objects but the sensual appearance of the whole picture, is noticeable in all national and regional Baroque styles, although there may be characteristic variations. In the Roman and Flemish Baroque this forms the basis of agitated picture structures, in which the figures are embedded in the landscape, the individual planes of the composition merge into one another, and single elements of a landscape, seen close-up, contrast with views into the far distance *(269)*. In French painting the interest is focused on quiet solemn representation, even in the portrayal of man in open space, while Dutch Baroque painting offers an intimate and accurate description of the actual environment and an arrangement of the various planes and the figures in them in clearly graduated order next to and behind each other *(270)*. In these highly disparate paintings, whether static or dynamic, the pictures are structured in similar manner, and equal value is given to space, figures, and surface.

In the Late Baroque and Rococo periods, space and figure are largely dematerialized by means of soft, loose brushwork and bright colors. The atmospheric veiling of spatial depth and the dissolving of plasticity through the play of light and color give pictures a high degree of visual illusion that defies objective examination and linear description *(271)*.

Neoclassicism brings a sharp contrast: plasticity is strongly emphasized by means of accurate basic drawing, which gives the illusion of measurable space and of figures with measurable weight. The sculpture and architecture rather than the painting of Classical antiquity are taken as models for figures and scenery. Contrasting light and dark shades of natural colors in well-defined areas and large surfaces express the pathetic content of the scene *(272)*.

Romanticism brought a completely new experience of space by extending the environment into cosmic realms. Man is confronted by the infinite; this new dimension defies description in the hitherto accepted forms of perspective, and so they are replaced by a hazy, indistinct aerial perspective *(273)*. The Impressionists let man and landscape merge. Space, objects, and figures, light and shade are treated as optical projections and expressed with a new technique of short brushstrokes in pure colors of equivalent value; only the sum of these strokes reveals the content of the picture *(274)*. Van Gogh's larger strokes give greater intensity to color values and contours, and hence his pictures have a more dynamic effect. The technique also makes his images appear more closely related to the surface plane, without, however, completely denying illusionistic space or the plasticity of the figures *(276)*. That denial was made by his successors, who subordinated space and the figure much more firmly to the surface plane by distorting relative proportions and viewing space and the figure from various angles *(277)*. Gauguin emphasized the value of the surface plane as well, but his silhouettelike contours of terrain and figures allow a reconstruction of space, without representing it in an illusionistic sense *(275)*.

The most significant realization of the surface-oriented picture, without loss to the character of space and figure, was achieved by Cézanne. The formal severity of his style has in many respects become a model for 20th-century painting. Cubism is directly related to it, and the German Expressionists, for instance, recognize the importance of relating objects to their environment by means of a dense network of formal connections as Cézanne did *(279)*. Illusionistic space with its seemingly solid figures was replaced by the juxtaposition of many surface planes, and this process often led to the complete dissolving of a picture's subject. The abstract surface pattern at most awakens associations with the original theme in the mind of the beholder *(281)*. Another concept of spatial dimensions is expressed in the extension of the unity of time and space by arranging realistic elements in an unrealistic manner; with the assimilation of associations, dreams, and narcotic fantasies, the conception of man in the landscape found a new dimension *(280)*. The predominant tendency in the 20th century has been, despite great variety of expression, definitely anti-illusionistic. Emphasis on surface structure and on color as a value in itself, the invocation of realms of imagination and knowledge beyond the visible world, and an acknowledgment of the symbolic value of objects, are characteristics of modern painting, and in some of Picasso's works they are united *(278)*.

248 RESCUE OF ANDROMEDA. 40–50. Fresco. House of Amandus, Pompeii. Narrative set in fantastic, rocky landscape: Perseus meets Andromeda's father and Andromeda is freed. Psychological content expressed in landscape's dramatic wildness and sinister atmosphere, while protagonists remain expressionless, puppetlike figures. Illusionistic painting: color and aerial perspective absorb plasticity of figures and objects. Rich color scale includes strong contrasts.

249 THE ISRAELITES REBELLING AGAINST MOSES. 432–44. Mosaic. S. Maria Maggiore, Rome. 2 rows of pictures depict consecutive scenes. Figures dominate; landscape limited to a few objects: ground is strip of color beneath atmospheric background. Echoes paintings of Classical antiquity with shadows and warm, glowing colors.

250 CHRIST IN THE HEAVENLY CITY OF JERUSALEM. End of 11th century. Fresco. S. Pietro al Monte, Civate. Illusionistic representation less important than iconographical description of Garden of Eden, surrounded by walls of Jerusalem rendered without perspective. Entrance gates represent 12 tribes of Israel. Christ's figure dominates. Within sharply defined contours, limited range of colors used schematically. Only trees show traces of traditional, Classical composition.

251 THE HEALING OF THE BLIND MAN. c. 980. Codex Egberti. Stadtbibliothek, Trier. No attempt at illusion of space. "Landscape" consists of few iconographically necessary elements and horizontal bands of color as atmospheric background. Narrative significance intensified through exaggerated gestures of flatly projected figures, rendered in strong colors.

252 GETHSEMANE. Before 1123. Albani Psalter. St. Godehard, Hildesheim. Completely abstracted landscape; illusionistic space and plasticity are renounced. Figures arranged in flat, linear composition. White heightens strong color contrasts between sharply contoured shapes.

253 WOMEN AT THE TOMB (detail). c. 1200. Ingeborg Psalter. Musée Condé, Chantilly. A few landscape elements clarify scene, rather than indicate depth. Elegant drawing and strong, bright, metallic colors dominate.

254 NOLI ME TANGERE. 1331. Reverse side of Verdun Altarpiece. Tempera on wood. 108 x 121 cm. Canon's Chapter, Klosterneuburg Abbey, Austria. Contrast between spatially neutral gold ground and spatially differentiated sarcophagus and strip of earth based on Giotto's idea of "spatial stage." Figures distributed in flowing, expressive line. Excellent example of Giotto-inspired composition translated into Gothic style using luminous, gemlike colors.

255 AMBROGIO LORENZETTI, THE RESULTS OF GOOD HUSBANDRY (detail). 1338/39. Fresco. Palazzo Pubblico, Siena. Bird's-eye view of extensive landscape: new way of portraying nature, based on direct observation. Every detail, even in farthest distance, faithfully reproduced; natural colors accentuated.

256 THE LIMBOURG BROTHERS, THE MONTH OF JUNE. c. 1416. Calendar picture from Les Très Riches Heures du Duc de Berry. Musée Condé, Chantilly. With a wealth of topographic detail, artist depicts, in background, Paris with Palais de la Cité and Sainte-Chapelle. Faithfulness of architectural portrait and realism of activities taking place on field in foreground even more important than unity of perspective and atmospheric clarity. Clear, bright, natural colors dominate. Elegant, weightless figures have Gothic grace.

257 UPPER RHENISH MASTER. THE GARDEN OF EDEN. c. 1410. Oil on wood. 26.3 x 33.4 cm. Städelsches Kunstinstitut, Frankfurt. Walled meadow is background for several scenes of the hortus conclusus, symbolizing the Virgin. Composition, open perspective, and lively colors give ornamental effect of a tapestry. Details copied from nature, and figures idealized.

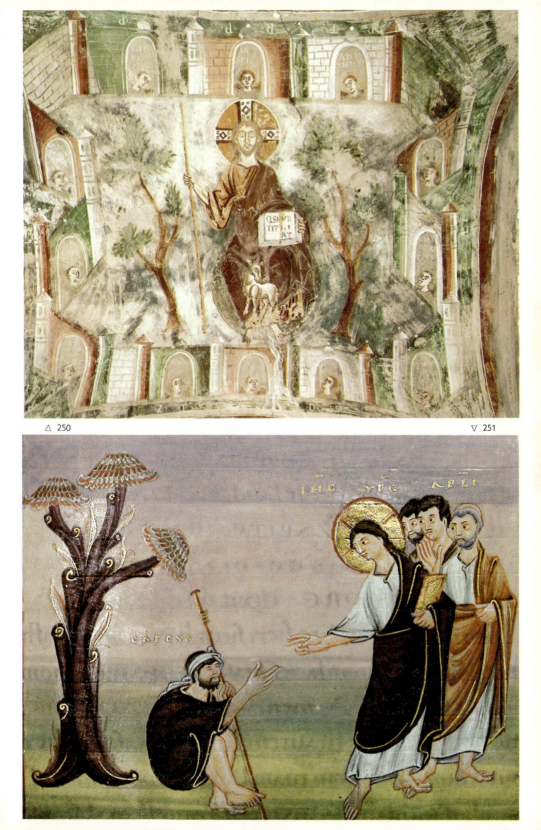

△ 250 ▽ 251

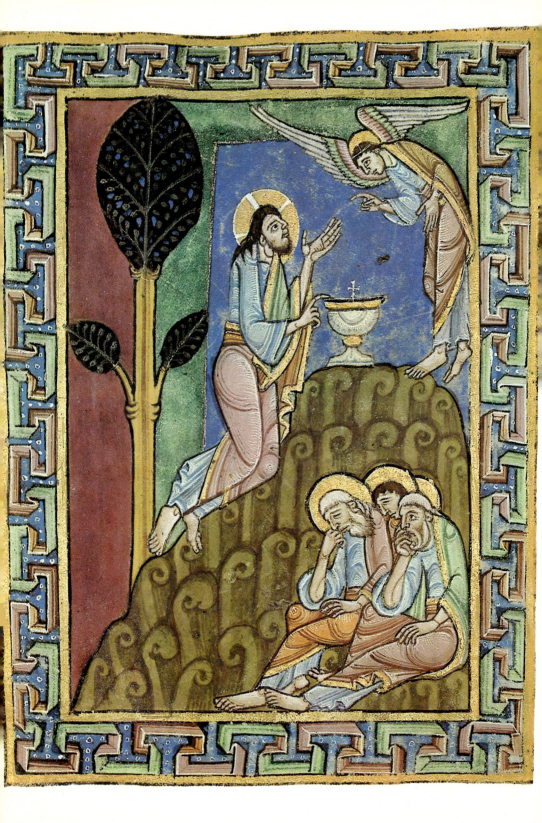

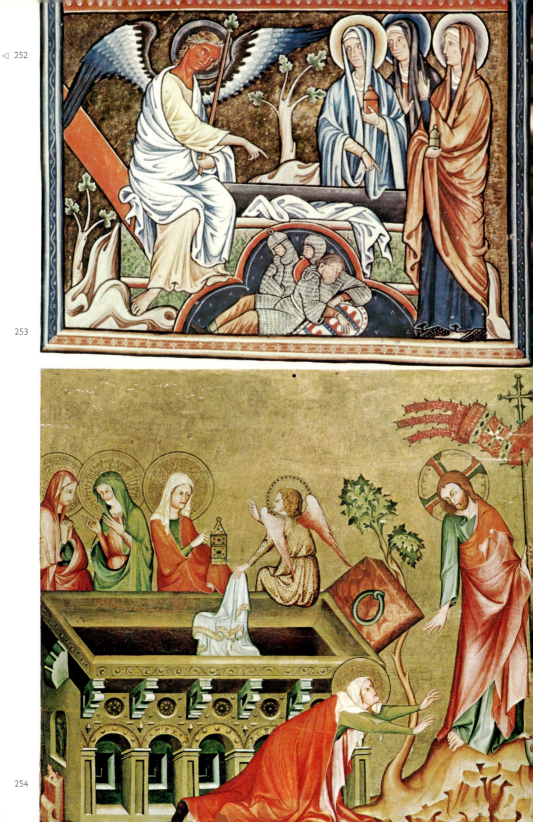

253

254

257

COLOR

There is one very important element of painting for which a comparative history of style is possible only with certain reservations, and that is color. The obstacles to exact, comparative analysis of colors are manifold. The opportunity to view originals is usually limited, and reproductions are unsatisfactory, despite highly developed techniques, because their diminished size means that color values have been simplified. Other difficulties lie in color itself and in the way it is used. Different techniques of application, varying psychological effects of color, and the peculiarities and changes in its symbolic meaning have different effects on the character of individual pictures, groups of pictures, and whole artistic eras. The intensity of color in a fresco will differ radically from that in a miniature, and the color scale of both will differ from that of an oil painting. Even the same shade of color can have entirely different effects according to the way in which it is used: it can shape or dissolve forms, fill in planes or create a linear design; and in each of these variations it will have a different relationship to its neighboring colors. The symbolic meaning of colors or groups of colors — for instance, purple as the emperor's color, blue and red as the sacred colors of the robes of the Virgin Mary — form the basic color scale around which the remaining composition has to be completed.

Within these limitations, however, it is possible to determine characteristic features that allow color comparisons to be made on a larger scale than those that have already been made between individual painters and epochs. The point of departure must not be an individual color in itself, but rather the role it plays in the composition as a whole. By determining whether a color has been used to portray something, or simply as a color in its own right, we can learn a great deal about how the painter saw that color. Usually its role lies between these two extremes; it is an element in the construction of a picture, clarifying or even creating the shapes in it.

Paintings surviving from antiquity are obviously products of a late period, concluding an extended development, as can be seen from the often virtuoso use of color. The strong, plane-filling colors of frescoes, of which Pompeian red is one, and the strong colors of objects can alternate with infinitely delicate shades, which dissolve the forms into the atmosphere *(225, 248)*.

Early Christian painting is characterized by a bright colorfulness. In Mediterranean countries the natural color emanating from the object is diffused into the atmosphere *(249);* in paintings influenced by Irish-English art, on the other hand, color has a decorative value of its own and the accent is on a simple, surface-filling red-green composition. In miniatures of the early Middle Ages color seems strangely lustreless and heavy but it is used more often for modeling. Apart from purple, various shades of red and a darkish blue dominate *(226)*. In the following Ottonian epoch, the technique of modeling with color, which still follows the antique tradition, was abandoned in favor of a linear concept with smooth, close, subtly mixed pigments heightened with white, in combination with metallic gold, giving the picture a supernatural character *(251)*. Bright, strongly contrasting colors were one of the main characteristics of Romanesque painting. Combinations of vivid colors — often to the point of gaudiness — fill the contours and white or a darker value of one of the colors frame the scene. In this richer palette blue and red predominate *(227, 228, 250, 252)*.

258 MASACCIO, ST. PETER DISTRIBUTING ALMS (detail). c. 1427. Fresco. Brancacci Chapel, S. Maria del Carmine, Florence. Strongly accentuated, cubistic architecture links distant landscape with stage of action in foreground. Fully modeled figures occupy foreground in staggered group. Subdued natural colors, modulated by light and shade.

259 VAN EYCK BROTHERS, THE HOLY PILGRIMS (detail). Righthand panel of the Ghent Altarpiece. Completed 1432. St. Bavo, Ghent. Transition from concept of world landscape with high horizon to view into distance with low horizon. Dominating foreground seen from above gives spatial depth to figures; landscape begins behind them. Realistic details and quite strong natural colors.

260 KONRAD WITZ, THE MIRACULOUS CATCH OF FISH (OR CHRIST WALKING ON THE WATER). 1444. Oil on wood. 132 x 155 cm. Geneva Museum. Actual landscape of Lake Geneva. Silhouetted, brightly colored figures contrast with landscape into which each seems to have been inserted, occupying its own spatial zone. Pure, defining colors prevail even in farthest distance.

261 GIOVANNI BELLINI, ALLEGORICAL SCENE. c. 1490. Oil on canvas. 73 x 119 cm. Uffizi, Florence. Depth achieved by linear and color perspective. Casual distribution of idealized, tranquil figures across wide foreground stage. New pictorial sensuality in depiction of nudes. Subdued, complementary colors.

262 PIERO DELLA FRANCESCA, THE QUEEN OF SHEBA VISITING KING SOLOMON (detail). c. 1452. Fresco. S. Francesco, Arezzo. Balanced relationship between landscape and figures, as well as warm, softly modeled colors give this well-designed picture festive solemnity.

263 LEONARDO DA VINCI, MADONNA AND CHILD WITH ST. ANNE. 1501–1505/8. Oil on canvas. 168.5 x 130 cm. Louvre, Paris. Cosmic landscape symbolizes the Creation. Each individual compact pyramid maintains an unstable equilibrium. Soft modeling, atmospheric *sfumato,* and harmonious colors link figures with environment.

264 ALBRECHT DÜRER, THE LAMENTATION. c. 1500. Oil on wood. 151 x 121 cm. Alte Pinakothek, Munich. Richly detailed "world landscape" distinctly set apart from staggered group of figures in foreground. Principal group forms flat, disc-shaped composition, its significance heightened by tiny figures of donors shown in foreground. Solid, natural colors predominate.

265 LUKAS CRANACH THE ELDER, RECLINING WATER NYMPH. 1526/30. Oil on wood. 36 x 51 cm. Thyssen-Bornemisza Collection, Lugano/-Castagnola. Mystical landscape is background for elegantly elongated female figure in primarily linear composition. Cool colors (note diaphanous veil) applied with technique of miniaturist.

266 TITIAN, NYMPH AND SHEPHERD. After 1570. Oil on canvas. 150 x 187 cm. Kunsthistorisches Museum, Vienna. Sunset landscape is heroic backdrop for idyllic genre scene. Same texture and harmonizing colors unite bodies with surroundings.

267 PIETER BRUEGEL THE ELDER, THE BLIND LEADING THE BLIND. 1568. Tempera on canvas. 86 x 156 cm. Museo Nazionale Capodimonte, Naples. Realistic figures, arranged in dramatic diagonal, act out biblical parable in objectively observed landscape. Each figure shows one phase of general movement toward inevitable fall. Muted natural colors of same tone intensify compositional relationship between figures and landscape.

268 EL GRECO, LAOCOON. c. 1610. Oil on canvas. 137.5 x 172.5 cm. National Gallery, Washington, D.C. An actual landscape — Toledo — in subjective interpretation is background for elongated, twisted figures, which form vibrating, ornamental ensemble. Cool but highly expressive colors dominate.

269 PETER PAUL RUBENS, THE HOLY FAMILY UNDER AN APPLE TREE. 1630/32. Outside panel of the Ildefonso Altarpiece. Oil on wood. 253 x 231 cm. Kunsthistorisches Museum, Vienna. Realistic detail and generous brushwork enliven this section of an idyllic, pastoral landscape. Composition unites voluminous figures and environment. Warm red suffusing different elements stresses their equal importance.

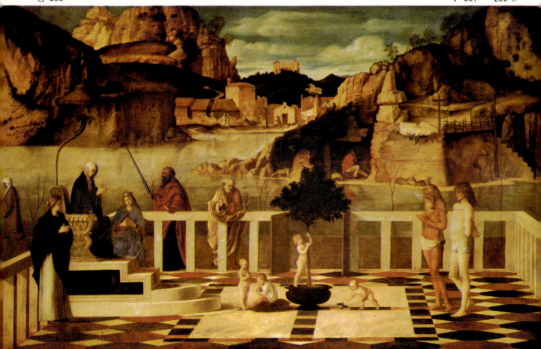

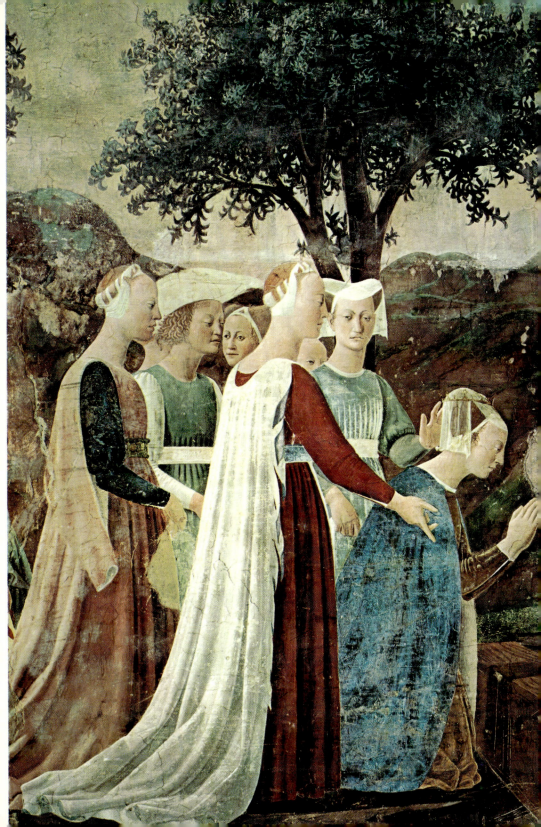

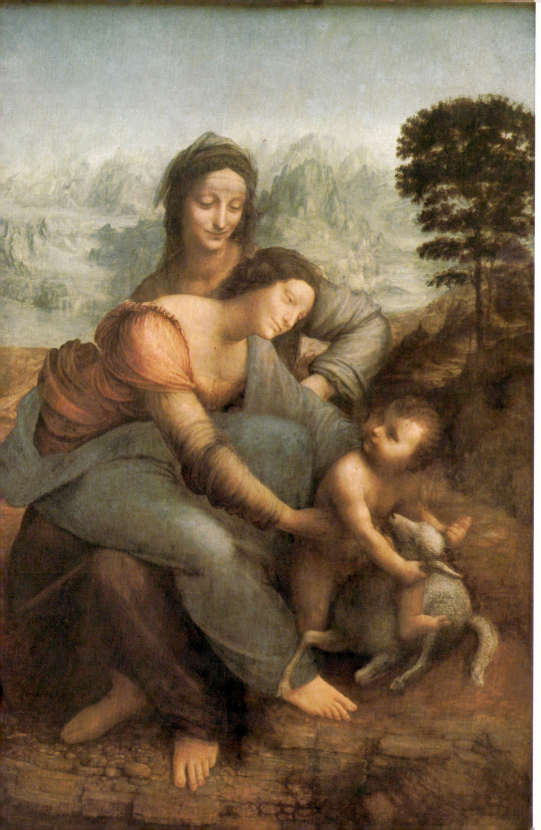

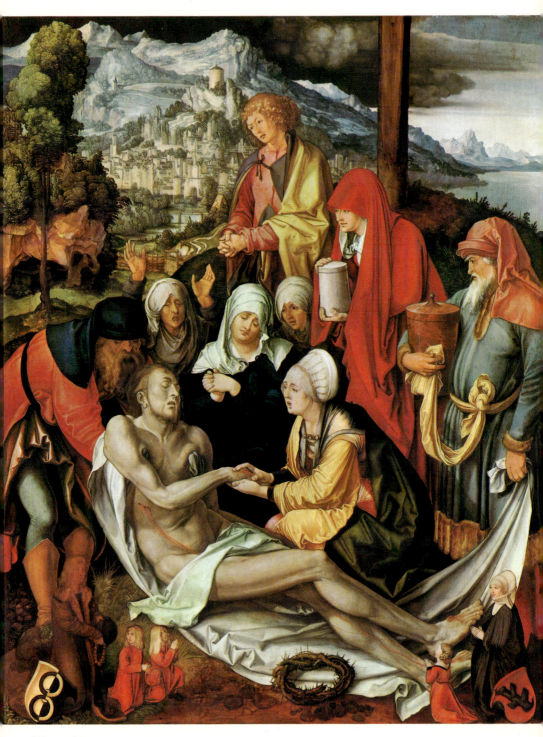

FONTIS NYMPHA SACRI SOMNVM
NE RVMPE QVIESCO.

△ 265

▽ 266

△ 267 ▽ 268

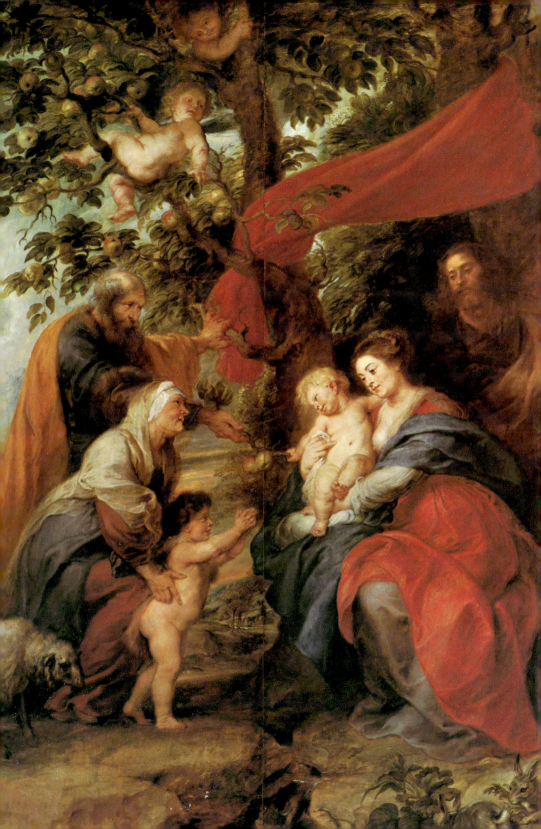

A sonorous red-blue chord is struck in Early Gothic painting *(229, 253)*. A culmination of the use of color for its own sake was reached in the stained-glass windows of Gothic cathedrals, where it seems to be almost the matter from which the windows are made. The overall impression left by 14th-century paintings is determined by increasingly effective secondary colors and the metallic glitter of gold *(254)*. This tendency increased until, finally, color values took on the character of precious metalwork in the style of court painting around 1400 *(257)*. Already a century earlier, this glorification of color was confronted by a totally different approach in Giotto's works, in which form is given clarity and plasticity through color, and space is defined by the differentiation in the colors of objects *(230)*. The same use of color can be observed in the paintings of Masaccio, based on his close study of nature and the deliberate composition of his pictures: the three-dimensional modeling of figures and objects is done entirely with color *(258)*.

The literal transcription of nature, first achieved in the 14th century, led to a greater differentiation of natural colors *(231, 256, 259, 260)*. In the Netherlands and in Germany, the grouping of relatively elementary, bright colors dominated until the 16th century. In Italy, a tendency toward a certain color realism is noticeable as well, except that here color composition, which can modify the natural color of objects and unite them through their common tonal values, was given greater importance *(232, 235)*. Leonardo's *sfumato* dissolves contours as well as the object-related boundaries of the colors into soft, atmospheric transitions *(263)*. A similar concept, in which a single set of color values dissolving forms dominates in each picture was characteristic of Venetian art *(261, 262)*. With Titian we meet unquestionably the most accomplished colorist, who replaced the bright hues of 15th-century paintings with colors that blend into each other and who, particularly in his later work, made his own pictorial world in which colors were used to create phenomenal effects of light *(266)*. He was followed by the Mannerists with their strong contrasts of light and shadow and daring color combinations in which secondary and subdued colors replace the Classical red-blue accord *(233, 268)*. Tuscan Mannerists use a sharper delineation of color planes and a cruder approach in their choice of colors with a preference for colder shades. Their contemporaries north of the Alps maintained a stronger link to the bright-colored Gothic tradition *(264)*.

The 17th century returned to an objective appreciation of natural colors without reverting to small-patterned colorfulness. It was a century of great painters with forcefully expressed individual characteristics. The strong-colored realism of Caravaggio is heightened in his earlier works by his particular technique of using decisive highlighting effects *(234)*; this, however, becomes more subdued in later paintings. Rubens threads a unifying, vital red through his pictures *(269)*. Velázquez worked in the tradition of Venetian color composition *(239)*, and Poussin tamed the exuberant color sense of the Baroque into a quieter harmony *(235)*. The Dutch painters developed a specific style of their own, with undramatic, subtly balanced colors *(237, 270)*, while Rembrandt expressed dramatic psychological tension in subtle nuances of warm shades *(236)*. The solid color of the High Baroque, almost always object-oriented, was replaced in the 18th century by a much lighter, looser painting technique. Contours of figures and space interlock by means of color, and light and shade are distinguished through different color values *(240, 241, 271)*.

Neoclassicism and, following it, the Nazarene and Biedermeier styles brought a sharp reaction to High Baroque color values by reintroducing firmly contoured color planes and by using a strict, little modulated, mostly cool color scale *(242, 272)*. Romanticism was increasingly concerned with atmospheric phenomena and arrived at a tempered glow with predominantly subdued colors *(273)*. The Impressionists saw the visible world as a color phenomenon and used the spectrum of pure colors in small unconnected dabs, so that their pictures have shape only in the eye of the beholder *(244, 274)*. This method, based on the scientific realization of optical laws, was developed into an intellectual system by the Pointillists: color, by taking over the task of lines, can create the composition of the picture itself *(276, 277)*. Cézanne used an immensely rich, subtly differentiated palette to model his forms and replaced lines by boundaries between colors, by different layers of color, and by relating colors to each other *(245)*.

In 20th-century painting, colors are used as values in their own right, without necessarily serving an objective purpose *(278, 279)*. As a modulator of formal composition, color determines the character of a picture and, owing to its psychological effect, widens the choice of subject to include themes beyond the confines of the objective, visible world *(246, 280)*. Finally, colors can become the subject of a painting and then stand on their own as never before *(281)*.

270 PIETER DE HOOCH, DUTCH FAMILY. c. 1662. Oil on canvas. 114 x 97 cm. Gemäldegalerie der Akademie der Bildenden Künste, Vienna. Open door gives view of world outside picture's limited environment. Composition uses linear perspective; pull toward vanishing point moderated by walls running parallel to picture plane. Apparently casual but actually carefully planned grouping emphasizes feeling of tranquility, as does relatively limited scale of subtly balanced colors.

271 JEAN-HONORÉ FRAGONARD, THE SWING. Before 1760. Oil on canvas. 119.5 x 94 cm. Thyssen-Bornemisza Collection, Lugano/Castagnola. Landscape is section of overgrown park. Foreground and view of distant landscape clearly separated. Figures and landscape elements carefully coordinated. Plasticity of forms decreases to dissolve in atmosphere with help of manipulation of light and shadow. Bright, diffuse colors.

272 JACQUES-LOUIS DAVID, BELISARIUS BEGGING IS RECOGNIZED BY SOLDIERS. 1781. Oil on canvas. 288 x 312 cm. Musée des Beaux-Arts, Lille. Town from Classical antiquity with monumental architecture fixes location and frames central scene. Figures of great plasticity

and dramatic gestures are frozen into heroic statues with precise linear contours. Chiaroscuro emphasizes 3-dimensional effect. Rather cool color scale.

273 CASPAR DAVID FRIEDRICH, MONK AT THE SEASHORE. 1808/9. Oil on canvas. 110 x 171 cm. Charlottenburg Palace, Berlin. Atmospheric landscape: monotony of heavy sky above endless, almost motionless expanse of sea and almost uniformly colored beach express tension between wide horizontals and solitary vertical of tiny human figure, and symbolize spiritual tension between isolated man and infinite space.

274 PIERRE-AUGUSTE RENOIR, CHESTNUT TREE IN BLOSSOM. 1881. Oil on canvas. 71 x 89 cm. Staatliche Museen, Nationalgalerie, Berlin. Equal value given to all motifs stressed by short, regular brushstrokes and even lighting. Bright, unblended colors fuse into shapes only through beholder's act of perception.

275 PAUL GAUGUIN, RIDERS ON THE BEACH. 1902. Oil on canvas. 73.5 x 91.5 cm. Stavros Niarchos Collection, Paris. Picture's plane emphasized by high horizon and distribution of sharply contoured, shadowless figures, which never overlap. Action stabilized by parallels of

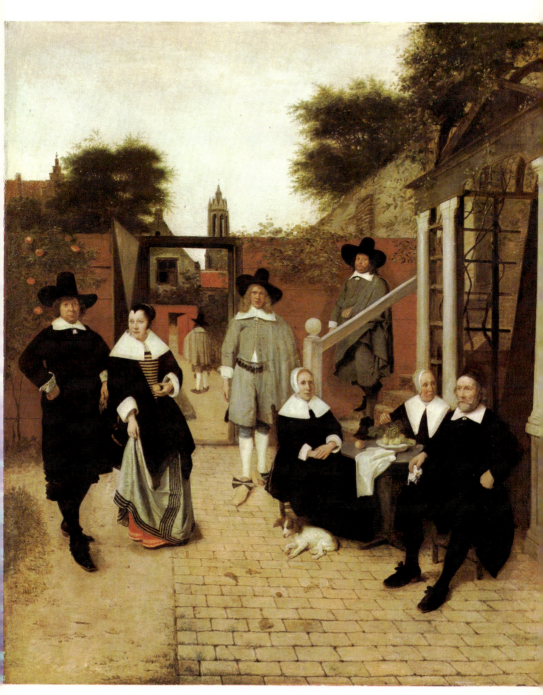

270

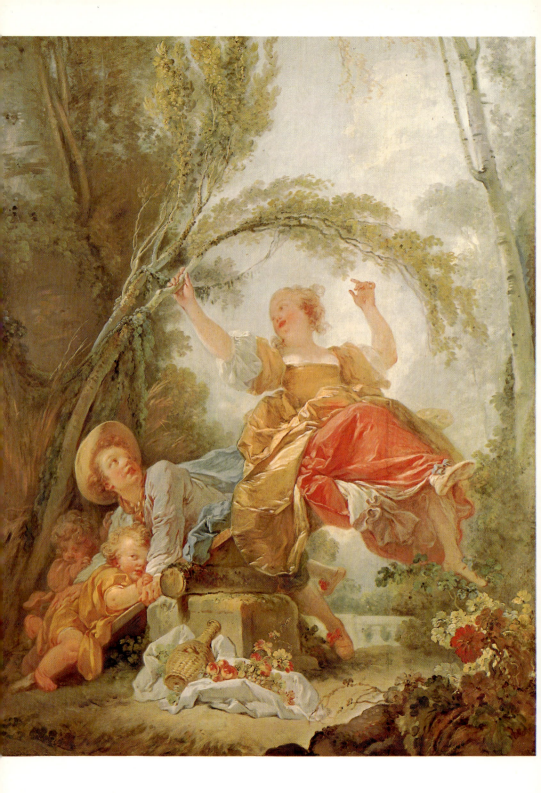

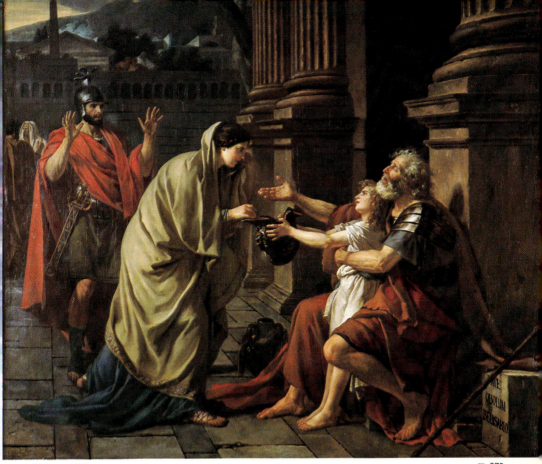

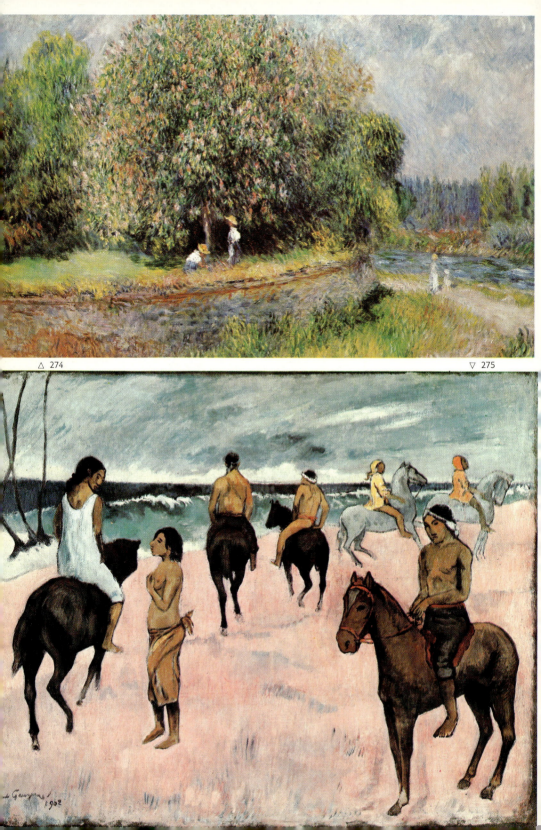

△ 274

▽ 275

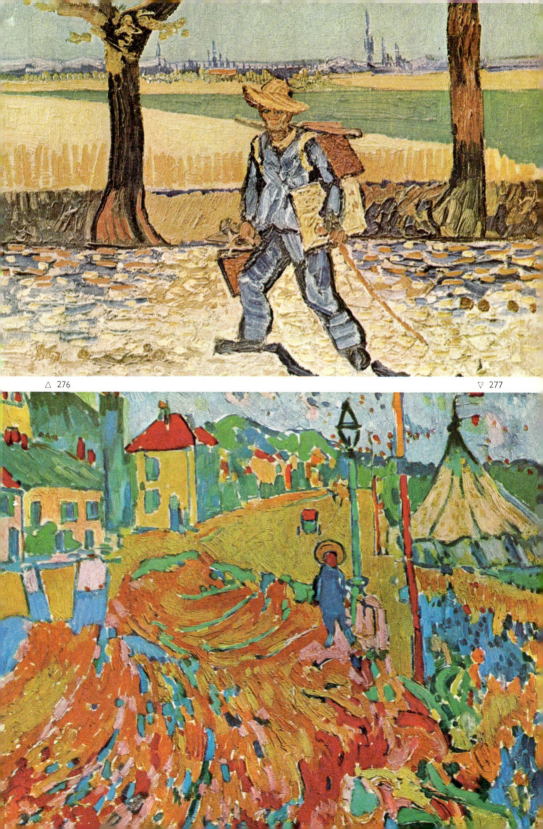

△ 276 ▽ 277

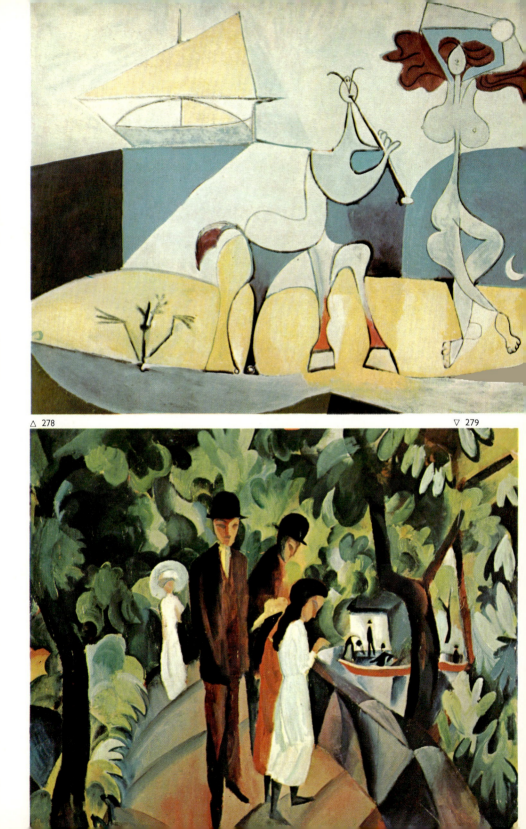

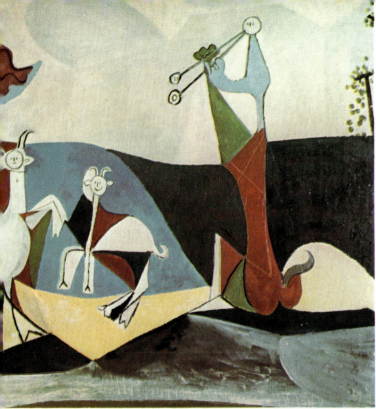

△ 280

horizon, waves, beach, and curve formed by riders. Intensity and lack of differentiation of colors within contours show influence of "primitive" cultures.

276 VINCENT VAN GOGH, THE PAINTER ON HIS WAY TO WORK. 1888. Oil on canvas. 44 x 48 cm. Magdeburg Museum. Emphatic system of horizontals and verticals creates balance between spatial depth and picture plane. Brushstrokes of varying size and direction — characteristic of Impressionists — render dynamic the neutral subject. Shadows used as compositional elements, not to create illusion. Strong color accents stand on own.

277 MAURICE DE VLAMINCK, THE CIRCUS. 1906. Oil on canvas. 60 x 73 cm. Private collection, Berne. By having beholder look up at foreground of suburban landscape, picture plane gains dominance. Exaggeration of Van Gogh's expressive brushwork and color values is carried to point of stridency.

278 PABLO PICASSO, LA JOIE DE VIVRE. 1946. Oil on canvas. 120 x 250 cm. Musée Grimaldi, Antibes. Harbor landscape motifs and mythological figures combined in rhythmically divided planes. Light and cool colors within their linear contours; little or no modeling of various forms, whose significance is more important than representation of subject.

279 AUGUST MACKE, A WALK ON THE BRIDGE. 1912. Oil on canvas. 86 x 100 cm. Hessisches Landesmuseum, Darmstadt. Space and figures linked by similarities in shapes. Network of similar lines, planes, and colors for different subjects underlines unity of forms.

280 MARC CHAGALL, THE FALLING ANGEL. 1923/33/47. Oil on canvas. 148 x 189 cm. Kunstmuseum, Basel. Suspended unity of locality and action. Composition scattered, yet thought out; elements linked by unnatural colors. Psychological values expressed by figures, forms, and colors.

281 NICOLAS DE STAËL, FIGURE ON A BEACH. 1952. Oil on canvas. 161.5 x 129.5 cm. Kunstsammlung Nordrhein-Westfalen, Düsseldorf. Color planes indicate, but do not represent, content of this architectonic composition. Space and figure, light and shade are translated into shades of warm and cold colors.

BIBLIOGRAPHY

The following selection contains, in addition to general works, publications dealing wlth the specific problems treated in this book. For an exhaustive bibliography, refer to the individual volumes in this series.

Albers, Josef. *Interaction of Color*. New Haven, Conn.: Yale University Press, 1963.

Arnheim, Rudolph. *Art and Visual Perception*. Berkeley, Calif.: University of California Press, 1954.

Baumgart, Fritz. *History of Architectural Styles*. New York: Praeger, 1970.

Bernheimer, Richard. *The Nature of Representation*. New York: New York University Press, 1961.

Birren, Faber. *The Story of Color: From Ancient Mysticism to Modern Science*. Westport, Conn.: Crimson Press, 1941.

Bland, David. *A History of Book Illustration: The Illuminated Manuscript & the Printed Book*. Berkeley, Calif: University of California Press, 1969.

Chevreul, Michel Eugène. *The Principles of Harmony and Contrast of Colors and Their Applications to the Arts*. New York: Reinhold, 1967.

Fisher, Howard T., and Carpenter, J.M. *Color in Art*. Cambridge, Mass.: Fogg Art Museum and Harvard University, 1974.

Fleming, John and Honour, Hugh. *Style and Civilization*. Harmondsworth: Penguin, 1967ff.

Goldwater, Robert, and Treves, Marco. *Artists on Art*. New York: Pantheon, 1945.

Gombrich, E.H. *Art and Illusion*. Princeton, N.J.: Princeton University Press, 1961.

— *The Story of Art*. London: Phaidon, 1972.

The Great Centuries of Painting. 12 vols. Geneva: Skira, 1951–58.

Libby, W.C. *Color and the Structural Sense*. Englewood Cliffs, N.J.: Prentice-Hall, 1974.

Malraux, André. *The Metamorphosis of the Gods*. Garden City, N.Y.: Doubleday, 1960.

— *The Psychology of Art*. New York: Pantheon, 1949–50.

— *The Voices of Silence*. Garden City, N.Y.: Doubleday, 1953.

Novotny, Fritz. *Painting and Sculpture in Europe*. Harmondsworth: Penguin, 1973.

— *Paul Cézanne*. London: Oxford University Press, 1937.

Panofsky, Erwin. *Idea: A Concept in Art Theory*. Columbia, S.C.: University of South Carolina Press, 1968.

— *Meaning in the Visual Arts*. Garden City, N.Y.: Anchor Books, 1955.

— *Renaissance and Renascences in Western Art*. Stockholm: Almqvist & Wicksell, 1965.

Pelican History of Art and Architecture. Harmondsworth: Penguin. 1953ff.

Pevsner, Nikolaus. *An Outline of European Architecture*. Harmondsworth: Penguin, 1960.

Kunstgeschichte und Propyläen. 18 vols. Berlin: Propyläon, 1967–74.

Read, Herbert. *The Meaning of Art*. Belmont, Calif.: Pitman, 1969.

— *The Origins of Form in Art*. New York: Horizon, 1965.

Rood, Ogden N. *Modern Chromatics: Students' Textbook of Color with Applications to Art and Industry*. New York: Van Nostrand Reinhold, 1973.

Treves, Marco. "Maniera: The History of a Word." *Marsyas,* Vol. I, New York, 1941.

White, John. *The Birth and Rebirth of Pictorial Space*. London: Faber and Faber, 1957.

Wittkower, Rudolf and Margot. *Born Under Saturn: The Character and Conduct of Artists*. London: Weidenfeld & Nicolson, 1963.

INDEX

Descriptions of the illustrations are listed in boldface type

189